W9-CME-414

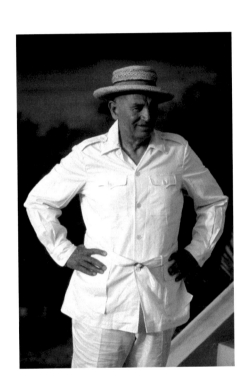

Romare
Bearden
The Caribbean Dimension

BY THE SAME AUTHORS (selected books in English)

by Sally Price
 Caribbean Contours (edited with Sidney W. Mintz)
 Co-Wives and Calabashes
 Primitive Art in Civilized Places

by Richard Price
 Maroon Societies: Rebel Slave Communities in the Americas (edited)
 The Birth of African-American Culture (with Sidney W. Mintz)
 First-Time: The Historical Vision of an African American People
 Alabi's World
 The Convict and the Colonel

Jointly authored
 *John Gabriel Stedman's Narrative of a Five Years Expedition
 Against the Revolted Negroes of Surinam* (edited)
 Two Evenings in Saramaka
 Equatoria
 On the Mall
 Enigma Variations
 Maroon Arts: Cultural Vitality in the African Diaspora
 The Root of Roots: Or, How Afro-American Anthropology Got Its Start

© 2006 Sally Price and Richard Price
All rights reserved

Except as otherwise noted, all works of art by Romare Bearden are
© Romare Bearden Foundation / Licensed by VAGA, New York, NY.

Published by
University of Pennsylvania Press
Philadelphia, Pennsylvania 19104-4112

ISBN-13: 978-0-8122-3948-5
ISBN-10: 0-8122-3948-2

A Cataloging-in-Publication record is available from the Library of Congress
Excerpts from Romare Bearden, "An Artist's Renewal in the Sun" and "Magic Mountains, Clouds in the Living Room" Copyright © Romare Bearden. Reprinted by permission.
"To Romare Bearden" by Derek Walcott © Derek Walcott. Reprinted by permission.
Photographs by Frank Stewart copyright © 2004 (frontflap, frontispiece, finis page and on pp. 36, 49, 52, 60, 61, 66, 68, 69, 71, 103 and 113)
Frontispiece: Romare Bearden in St. Martin, ca. 1980 (Photographer Frank Stewart)
Information on Bearden paintings (dates, media, dimensions, ownership) is often incomplete, and sources are often contradictory. Corrections and additions will be included in the captions in subsequent printings.
Every effort has been made to locate copyright holders for the photographs used in this book. Any omissions will be corrected in subsequent printings.

PRODUCTION AND CONCEPT:
© Vents d'ailleurs,
La Roque-d'Anthéron, France
www.ventsdailleurs.com

PROJECT MANAGER AND EDITOR:
Jutta Hepke

DESIGN AND LAYOUT:
Gilles Colleu

REPRODUCTIONS:
David Barel

COVER:
Romare Bearden, *In a Green Shade* (1984). Detail of Fig. 59.

PRINTING AND BINDING:
EBS, Verona – Printed in Italy

Sally Price & Richard Price

Romare Bearden

The Caribbean Dimension

PENN

University of Pennsylvania Press
Philadelphia

Contents

Acknowledgments

This book, eight years in the making, has given us an opportunity to make many new friends and has benefited from the contribution of a wide range of artists, writers, photographers, and other art lovers in the Caribbean and beyond.

The Romare Bearden Foundation, which moved into its official home in Manhattan just as we began the project, provided generous access to images, documents, and personal reminiscences. We are particularly grateful to the Rohan sisters who launched the Foundation – Dorothe Rohan Dow, Evelyn Jackson, Marie L. Rohan, and Sheila Rohan. Later on, Diedra Harris-Kelley joined her aunts at the Foundation and continued in the same cooperative spirit. As should be clear from the captions, the Bearden Foundation provided the bulk of the images included in this book.

In 2003, Eric Halpern and Peter Agree at the University of Pennsylvania Press, and Jutta Hepke and Gilles Colleu of Vents d'ailleurs (publishers of the English and French editions, respectively) took the project on, and have carried it to fruition with energy in tracking down funding, creativity in producing the book itself, and reassuring confidence in its importance as an intellectual contribution. We thank both our literary agent Faith Childs and Bearden's manager June Kelly for sticking with us throughout the trajectory. Leah Price made helpful comments on the manuscript as it developed.

We are grateful to Myron Schwartzman for giving us access to his tape-recorded interviews with Bearden (as well as a phone interview with Derek Walcott), and to a number of Bearden friends and associates for sharing reminiscences – Richard Clarke, Nicholas Ekstrom, Harry Henderson, June Kelly, Richard Long, Al Murray, Jane Shapiro, Frank Stewart,

Joseph Thomas, Derek Walcott, and E.T. Williams.

In St. Martin, our understandings about Bearden's life on the island were enriched by conversations with Fabian Badejo, Elsje Bosch, Ruby Bute, Josianne Fleming, Marty and Gloria Lynn, Ras Mosera, Louis Richardson, Roland Richardson, and Lasana Sekou. For useful contacts in St. Martin, we wish to thank all of the above, as well as George Lamming and Jose Speetjens.

We are particularly grateful to photographers Manu Sassoonian (for sharing his 1983 images of Bearden in St. Martin) and Manuel Diego van der Landen (for providing photos of other St. Martin artists). Special thanks to Wendy and Westley Chapman, Martha Henry, June Kelly, Keny Galleries, Marty and Gloria Lynn, Jerald Melberg, Elizabeth Rindskopf Parker, Franklin Riehlman, E.T. Williams, and the Walter O. Evans Collection of African American Art and Literature for generously providing photographs of Bearden artworks. We also thank Fabian Badejo, Josianne Fleming, and Louis Richardson, who made paintings available to be photographed for this book, and Myriam Huet, without whose last-minute help in St. Martin this book would have been four paintings poorer.

This publication would not have been possible without the generous financial support of the College of William & Mary, the Reed Foundation, and Robert and Karen Kinser.

Preface

Beginning in the 1970s, aqueous washes of tropical color saturate paintings with Caribbean themes and seep into Romare Bearden's portrayals of Harlem and the U.S. South, imbuing them with a new luminosity. Diaphanous faces mark a state of deep trance, and the farmyard roosters of Mecklenburg County give way to the fighting cocks of the French/Dutch island of St. Martin. Yet relative to the rest of his oeuvre, the Caribbean paintings, mainly in watercolor, have received little attention. Bearden's lengthy obituary in the *New York Times* makes no mention of them.[1] The 2003 Bearden retrospective at the National Gallery of Art included only a half dozen of his Caribbean works, and the accompanying catalogue treats his Caribbean experience only minimally. Two explanations suggest themselves.

First, in the hierarchy of the fine arts establishment, watercolors lack the prestige of oils or collages. But a more interesting reason has to do with the image of the Caribbean in the American mind. In the *New York Times* obituary, the only reference to the Caribbean is that "Mr. Bearden's other home was in St. Martin, the Caribbean birthplace of his wife, Nanette" – the mention of his semi-pro baseball career when he was in college is several times longer. Likewise, in the detailed entry on Bearden in the 1999 *Africana* encyclopedia edited by Kwame Anthony Appiah and Henry Louis Gates, Jr., there is no mention at all of the Caribbean. And when Charles Rowell conducted a long interview with the artist in his St. Martin home shortly before his death, the only question that had anything to do with the Caribbean was a cryptic "Why

1. The obituary states that between 1970 and 1980, "Mr. Bearden made 342 collages, 128 oils on paper, 24 drawings, 25 prints, 5 tapestries, 4 murals and mosaics, and illustrations for film and theater, magazine covers, book jackets, banners and quilts" but makes no mention of watercolors, the medium that dominated his Caribbean output.

do you do watercolor here?" Even Albert Murray, the closest of Bearden's many friends and as serious an American intellectual as one could hope to meet, falls into the trap: "I would say Romie's Caribbean stuff is mostly amusement, doing something while he's relaxing... 'Cause he thought about eating, he thought about seafood, he thought about the surf, and all that."

Derek Walcott – acutely aware of his homeland's "sun, sea, and sex" image in the American imagination – protests with a tone of impatient passion: When you come to the Caribbean, he argues, "people feel that what you're doing is making an exotic move. But Romare came here to the Caribbean to learn what he could from it. He didn't come to illustrate it!"

The American difficulty with accepting the Caribbean as a site of serious culture has created a void in the art world's vision of Bearden. Among the large number of people – critics, biographers, friends – who have written about him, the only one other than Walcott to have focused on his relationship with the region was Bearden himself. And he was explicit that, for him, the Caribbean was vital: "Art will go where energy is. I find a great deal of energy in the Caribbean. ... It's like a volcano there; there's something underneath that still smolders." Throughout the final fifteen years of his life, when he was dividing his time between New York and the island of St. Martin, all of Bearden's art was imbued with the rhythms of the Caribbean, with the energy of that smoldering volcano.

This book has two goals. The first is simply to introduce Bearden's little-known Caribbean paintings and explore the context of their creation. But more importantly, the book constitutes an argument that an understanding of Bearden's Caribbean experience permits a critical reassessment of all the art he produced during the final fifteen years of his life, whether in St. Martin or New York.

Before engaging Bearden's Caribbean years, we offer two introductory chapters. The first, a summary biography, is intended for readers unfamiliar with Bearden's life. The second, based on a respect for Bearden not only as a hands-on artist but also as a serious critic and intellectual, explores his ideas about painting and the role of the artist in society. Together, these two chapters set the stage for our exploration of the Caribbean dimension of Bearden's art.

Romare Bearden: A Life in Art

We begin rolling the documentary footage with a scene from something over a decade into the twentieth century, imagining it in sepia tones and with an old upright playing ragtime in the background. There, Fred Romare Howard Bearden is born into a comfortable four-generation family in Charlotte, North Carolina.[1] His great-grandfather is a prominent member of the community, both parents are college educated, and his mother Bessye, "a vigorous, outspoken woman," devotes special attention to the upbringing of her "baaby," a blue-eyed child with soft blond curls. |▶1|

Then Harlem, from the age of three, where Bessye is the New York correspondent for the *Chicago Defender*, a social hub of the community, an active participant in the worlds of politics, education, music, theater, and art, and hostess to a constant stream of visitors – Mary McLeod Bethune, Fats Waller, Countee Cullen, Duke Ellington, Langston Hughes, Federico García Lorca, Paul Robeson, Marcus Garvey, Arna Bontemps, W. E. B. Du Bois, Aaron Douglas, Eleanor Roosevelt, and a variety of relatives. A year in Canada where his father works as a railroad steward... living with his grandmother in Pittsburgh for a year in elementary school and two more in high school ... childhood summers in North Carolina, creating a store of memories, impressions, images... and a teenage summer in Pittsburgh, working in the dust and din of a steel mill. College (Lincoln University, Boston University, New York University), studying mathematics as well as art education. Political cartoons for the BU *Beanpot* and the NYU *Medley*. Varsity pitching for BU, then semipro ball with the Boston Tigers (once pitching against Satchel Paige), a summer with

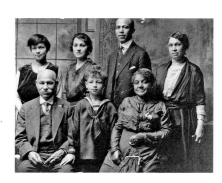

1. Family portrait, Charlotte NC, ca. 1917. RB stands between his great-grandparents, H.B. and Rosa Kennedy. Behind them, left to right, are his aunt (Anna Bearden), his parents (Bessye Johnson Banks Bearden and Richard Howard Bearden), and his grandmother (Catherine "Cattie" Kennedy Bearden). *Photograph courtesy of Romare Bearden Foundation.*

1. The matter of the name: Al Murray told us his name was pronounced "Rome-ery," but that his wife and her sisters always called him "Ro-mare." Murray described how RB would call him on the phone and say: "Hi, Al. It's Ro-mo!" So, Murray said, he was either Romie or Rome-ery (or, intimately with him, Ro-mo). But Richard Long, another good friend of Bearden's, told us that though the relative he was named after pronounced his own name "Rome-ery," most people called Bearden "Ro-mare."

the Pittsburgh Crawfords of the Negro League (where his teammates called him "Schoolboy" because he was still in college), and a chance to play in the majors if only he'd been willing to pass for white.

Bearden's main man, Al Murray, describes "the Harlem that was Bearden's briar patch and stamping ground as a schoolboy and young adult," noting that "when Ellington's *It Don't Mean a Thing if It Ain't Got That Swing* came out, Bearden was eighteen and very much the fly cat about town and on campus as well."

Such celebrated stride time piano players as James P. Johnson, Willie "the Lion" Smith, and Lucky Roberts, among others, were not only immediately recognizable as everyday figures on the sidewalks of the neighborhood, but were in most instances also instantly identifiable by the personal nuances that were their signatures as artists. ... When the Savoy Ballroom opened at 140th Street on Lenox Avenue,

about ten blocks away Bearden was not quite twelve years old. But even before that, the patterns of sound coming from such not faraway spots as the Renaissance Casino, Small's Paradise, and the Nest Club were no less a part of the local atmosphere than were the voices of the woofers and jive shooters and tall tale tellers and signifiers in the various neighborhood lunch counters, poolrooms, and barbershops.

Then almost as if overnight the big orchestras of Fletcher Henderson, Duke Ellington, Chick Webb, Cab Calloway, Charley Johnson, Claude Hopkins, Jimmie Lunceford, McKinney's Cotton Pickers, and the Savoy Sultons had either evolved on the scene, or had come to Harlem from elsewhere. Thus, during the time of the now-epical battles of the great bands and jam sessions, Bearden was a very curious, gregarious, and devilishly mannish adolescent of good standing in most social circles in Harlem; and not only was impeccable musical taste an absolute requirement for growing up hip, urbane, or streetwise, but so was the ability to stylize your actions – indeed, your whole being – in terms of the most sophisticated extensions and refinements of jazz music and dance.

"Regardless of how good you might be at whatever else you did,"

he has said more than once, "you also had to get with the music. The clothes you wore, the way you talked (and I don't mean just jive talk), the way you stood (we used to say stashed) when you were just hanging out, the way you drove an automobile or even just sat in it, everything you did was, you might say, geared to groove."

By the mid-thirties, Bearden is pursuing his increasing commitment to drawing at the Art Students League with George Grosz, a political satirist from Germany. "It was during my period with Grosz," he wrote, "that I began to regard myself as a painter rather than a cartoonist." But he's also doing cartoons for the *Baltimore Afro-American*, writing essays ("The Negro Artist and Modern Art"), and getting involved with other artists. The Harlem Artists Guild leads into the Harlem Community Art Center, for which Bessye's friend Eleanor Roosevelt attends the opening in 1937, and the WPA

2. Bearden and model in the 125th Street
studio, 1948. *Photograph by Sam Shaw, courtesy
of Romare Bearden Foundation.*

ROMARE BEARDEN
A Life in Art

19

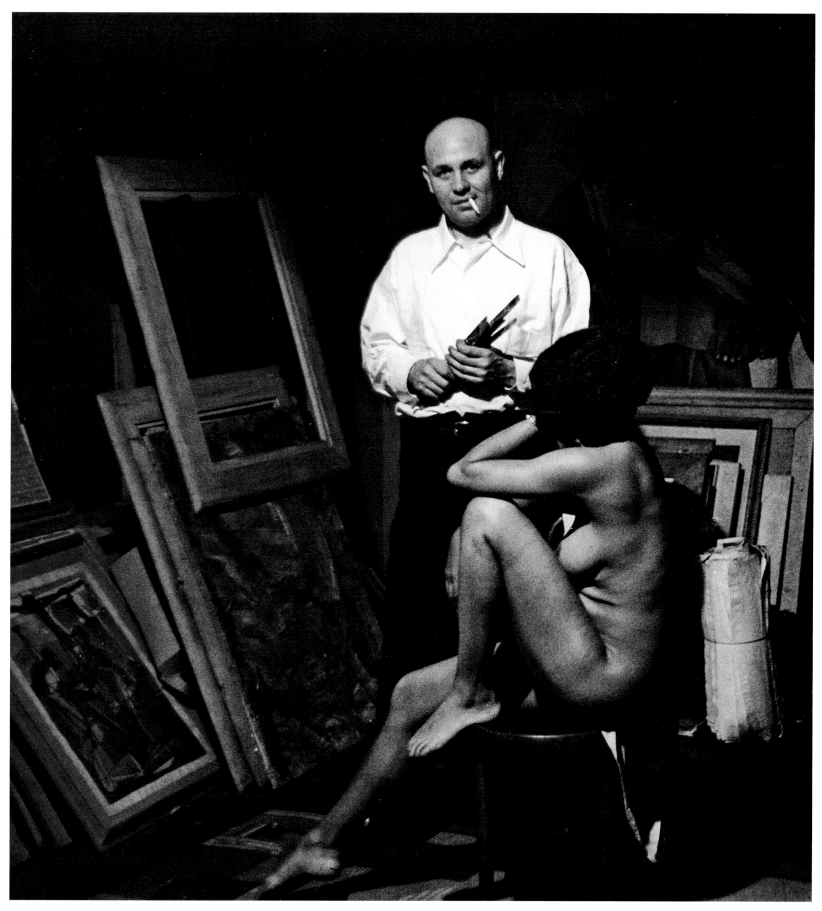

Federal Art Project provides funds for Harlem's "306" – artists, writers, and musicians who meet informally in the studio of Bearden's childhood friend Charles Alston, downstairs from the Harlem Art Workshop on 141st St. Everyone's there – Richard Wright, Langston Hughes, Ralph Ellison, Katherine Dunham, the young Jacob Lawrence and his future wife Gwendolyn Knight. And around the corner is the Savoy Ballroom, where artists get in free to hear Duke Ellington, Cab Calloway, Earl Hines, Benny Goodman. In 1938 Bearden begins a three-decade-long career as case-worker for the New York City Department of Welfare.

1940s. Bearden has taken a studio on 125th St. and has had his first solo show at "306." |▶2| Jamaican novelist and poet Claude McKay is his neighbor and friend. He's also hanging out with artists Stuart Davis and Walter Quirt, photographer/film director Sam Shaw, and writer Harry Henderson, trading notes on art, literature, philosophy, and jazz. A three-year stint in the army during the war hasn't taken him away from New York, and he continues to paint. *The Passion of Christ* is a one-artist exhibition at the Kootz Gallery in 1945, where he meets playwright Barrie Stavis who becomes a close friend. At the Kootz, he also meets artist Carl Holty, some fifteen years his senior, and their correspondence (Bearden in New York, Holty teaching at the University of Georgia) develops into richly detailed reflections on artmaking that provide the substance for a co-authored book on "structure and space in painting" and a second book-length manuscript on color.

In 1950, the GI Bill gives Bearden nine months in Paris, rarely behind the easel but daily in museums, jazz clubs, and cafés. |▶3| There are walks in the Jardin du Luxembourg and evenings on the banks of the Seine, student fares for opera and movies, French cigarettes, a trip to Italy, a visit with Picasso, friendships with Constantin Brancusi and Jean Hélion, cheap wine and rich conversation with James Baldwin, Herbert Gentry, and Myron O'Higgens, and occasional socializing with Richard Wright, Wifredo Lam, Georges Braque, and Sidney Bechet. It's also in Paris that he first meets soulmate Al Murray. At the cafés of Montparnasse, artists like Alberto Giacometti are regulars. Bearden is particularly impressed when a frail, octogenarian Matisse walks by on the arm of a nurse and receives a standing ovation from the waiters; "How you gonna beat this goddam Paris, man?! How y'gonna beat it?" he later remembers exclaiming. "My God, this isn't Brigitte

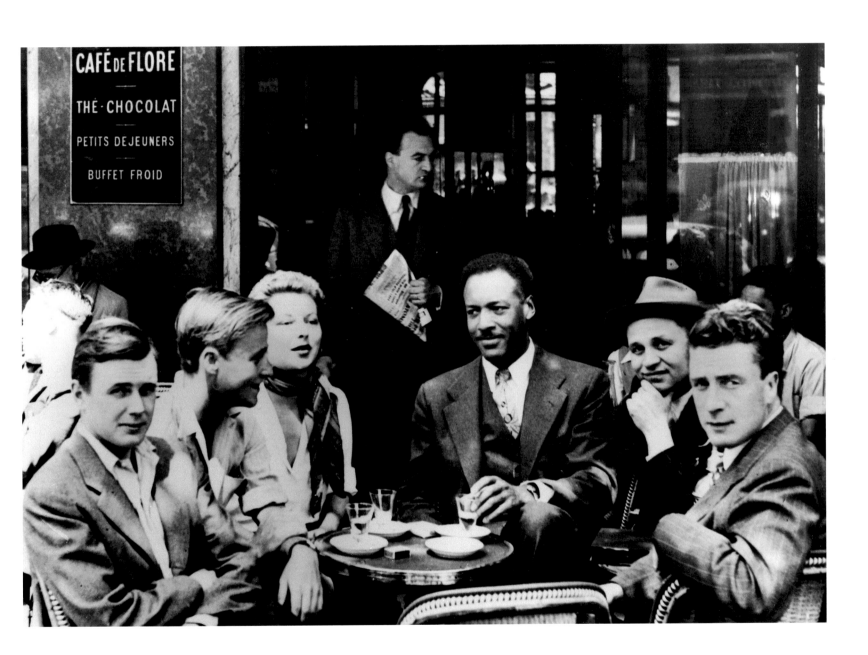

3. Café de Flore, Paris, 1950. Marvin Smith is in the center, next to Bearden.
Photograph by Morgan and Marvin Smith, courtesy of Romare Bearden Foundation.

Bardot or Maurice Chevalier. You have a chance in Paris."

The early 50s continue as a low point in Bearden's artistic productivity. He picks up his job at the New York Department of Social Services, working especially with Gypsies, tries his hand at songwriting (creating one hit tune, "Seabreeze," recorded by Billy Eckstine and later Tito Puente), and spends several years copying, copying, copying photostatic reproductions of great works of art. By the mid-1950s, he's dropped into an emotionally and artistically stagnant period that culminates in a nervous collapse which lands him briefly in the psychiatric ward of Bellevue Hospital. But he's also met Nanette Rohan, daughter of immigrants from the island of St. Martin, at a benefit for victims of a Caribbean hurricane, and they are married in 1954. |▶4| Two years later they move to Canal Street, where a fifth-floor walk-

up on the edge of Chinatown provides both studio and living quarters (and space for Bearden's "thousands of books"). They do some traveling, sometimes inviting Nanette's mother or one of her seven sisters to come along. In 1960 they take their first cruise to the Caribbean, and the next year it's Europe, where they are disappointed in Paris. "This doesn't seem to be the same place in many ways that I left 10 years ago," Bearden writes to Holty. "In going around to the art galleries, I was appalled. Really bad stuff. ... In other words, there ain't nobody trying anything new." The city seems to them to be "sleeping artistically."

The Canal Street studio becomes the initial meeting place for fifteen artists concerned with the role of art in the context of the Civil Rights movement who take on the name "Spiral" to symbolize their goal of moving "outward embracing all direc-

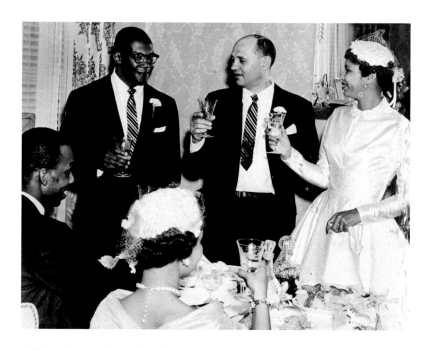

4. Bride and groom, Staten Island, 1954. *Photograph courtesy of Romare Bearden Foundation.*

5. At the Bearden retrospective, Museum of Modern Art, New York, 1971. *Photograph courtesy of Romare Bearden Foundation.*

tions, yet constantly upward." Bearden proposes a collective project using cutouts from magazines to create group collages, which the others greet with something less than enthusiasm but which constitutes a turning point in his own artistic career. In 1964, the Cordier & Ekstrom Gallery exhibits his "Projections," photostatic reproductions that blow up typing-paper-size collages into "montage paintings" as large as four-by-eight feet. By all accounts, it constitutes a radical and exciting departure. Bearden's art begins to make its appearance on newsstands – in 1968, *Fortune* magazine uses a Bearden cityscape on the cover of its January issue devoted to "business and the urban crisis" and *Time* adapts another for its November 1 issue, "New York: The Breakdown of a City." In 1969 the *New York Times* commissions a collage for the cover of its Sunday magazine.

Retiring from the Department of Welfare, Bearden continues to be concerned with the plight of black artists in the United States and, together with two others, convinces the Ford Foundation to underwrite the establishment of the Cinque Gallery, an exhibition place for young African American artists. Rigorous reflection on art continues alongside this commitment to social concerns – the book he has now finished with Holty on structure and space in painting is published in 1969, as is a critical essay on his own recent work, "Rectangular Structure in my Montage Paintings" and, in collaboration with Harry Henderson, he's beginning his important book on the history of African American art. He also co-organizes two exhibitions on African American artists past and present.

By 1970, the Caribbean has become, in addition to Nanette's

ancestral home, a cruise-ship escape from the pressures of life in New York, and plans are made for a house in St. Martin, to be built on Rohan family land. Once it's finished, the Beardens begin spending several months each year on the island, where Bearden turns most of his new-felt energy to watercolor. Back in the United States, he's receiving increasing recognition – a Guggenheim Fellowship in 1970, a one-man retrospective at the Museum of Modern Art in 1971, election to the National Institute of Arts and Letters in 1972, and an honorary degree at the Pratt Institute in 1973. |▶5| Some years before, Al Murray had come up with a theme, "The Prevalence of Ritual," which now tags the MoMA show and later an important Caribbean-based series exhibited at Cordier & Ekstrom.

The late 70s bring more awards, more honorary degrees, commissions from the *New York Times* and the Alvin Ailey Dance Company, and a long profile by Calvin Tomkins in the *New Yorker*. Bearden produces a collage series on the travels of Odysseus that's set in the Caribbean, and continues an artistic output – on a range of themes from New Orleans and jazz to conjur women and southern gardens – that Harry Henderson aptly describes as "a rushing waterfall." The aqueous forms and luminous colors that capture the tropical sunsets and seascapes and market scenes of the Caribbean carry over into his Canal Street (and later, Long Island City) studio, and by the 1980s, childhood memories of the U.S. South and images of Harlem jazz clubs have become saturated with the rich chromatics of the Caribbean.

The 1980s get off to a blockbuster start with the Mint Museum's retrospective, "Romare Bearden, 1970-1980," which shows in five museums on the east coast. Bearden collaborates with poet Derek Walcott (providing both illustrations and overall design for their book) and with alto saxophonist Jackie McLean (in "Sound Collages and Visual Improvisations"). He creates a cityscape for a John Cassavetes film and does murals for Manhattan College, the City University of New York, and the Baltimore subway. He's portrayed on the cover of *Newsday Magazine* and *ARTnews*. There are more honorary degrees, a documentary film, a lifetime achievement award from New York's Mayor Koch, and the National Medal of Arts presented by Ronald Reagan.

In March 1988, a major obituary in the *New York Times*

recognizes him as "the nation's foremost collagist."

Romare Bearden's art was born of a fertile interaction between open-ended improvisation and rigorous study. His creative response to things that "happened" as an artwork unfolded in time constituted an explicit parallel to the kind of improvisation that drives a jazz performance. "One thing leads to another, and you take the options as they come," he has said. "Once you get going, ... all sorts of things begin to open up." At the same time, an analytically demanding turn of mind led him to read voraciously, probe theoretical questions with rigor, and base the choices he made in his own work on a thorough study of the world's great art. Spontaneity never implied casualness. Research never precluded playfulness.

In reviewing his reputation as the painterly (or perhaps, collagerly) chronicler of Harlem and Mecklenburg County, as the artistic ethnographer of the world of jazz, and as a modern-day narrator of Odyssean voyages, we inevitably confront the relative roles – and the delicate interaction – of form and content. His Caribbean artworks, most of which carry titles referring to particular people, places, and specificities of cultural life, raise questions about the same tension. How did his exceptionally insistent focus on structure, spatial relations, and the visual dynamics of a flat surface play into his gift for capturing the heartbeat of urban scenes, the complex fragrances of a southern garden, the mellow tones and percussive heat of a jazz session, or the sultry air of the Louisiana bayous that have so indelibly marked his reputa-tion as an American artist? And on the island of Saint Martin, how did his concerns with the formal properties of a canvas work together with his ability to capture the exuberance of a Carnival dancer, the otherworldliness of an Obeah in trance, the lush moisture of a tropical garden, or the magic of a flame-red Caribbean sunset?

6. A demonstration of "the proto-Cubist
methods in Japanese art."
From Bearden and Holty 1969:116-117.

*"You mustn't make it smell of midnight
oil," Bearden said, "...too much research."
But you see, only a guy who's a scholar
can say to forget the research.*

Derek Walcott

A Painter's Mind

"Romare was genuinely erudite – I mean technically erudite about painting," Walcott told us in a recent interview. "That's not supposed to be the normal attribute of a black painter. In this period, the painter was supposed to be a guy in a T-shirt and dirty jeans, fucking everything, you know? Not to intellectualize, that was a great American virtue."

But intellectualizing was at the heart of Bearden's sense of his identity (and responsibility) as an artist. Parts of *A Painter's Mind* sound almost like a physics text. There are multiple references to slide rules, Euclidian geometry, Copernicus, the invention of calculus, and Sir Isaac Newton's readings in trigonometry, which, we are told, fall into a "discipline more closely related to art than one might believe." As such, they are called on to explain relations of structure and space in the art of Michelangelo, Matisse, and Miró, in Chinese and Japanese art, in Dutch masters and Pop artists, in Impressionism and Abstract Expressionism, and more. The book's pages are peppered with diagrams in which arrows and solid or dotted lines trace forces, intersecting planes, and "the implied movement through shapes." |▶6| And its concluding pages argue for the central importance in art of "percipient deliberation." This is an approach to mainstream art history that presents the art of Mondrian, for example, in terms of theories of movement within a spatial field, arguing for its rootedness in the thematically unrelated but structurally parallel work of seventeenth-century Dutch painters.[1]

In a similar spirit, essential differences between Renaissance art and the principles that dominated in Byzantine or Cubist art are viewed in terms

1. Bearden and Holty write:
With Mondrian, the vertical and horizontal movements terminate in the revolving movement of a kinetic space. If the various planes in his painting cannot be seen as moving horizontally or vertically, such planes would produce a dead spot – a clogging of the movement. In Diagram 1, a tracing from a painting by Mondrian ... was drawn to explain the continuing direction of a line that actually ends at the first vertical bar on the left of the painting. In Diagram 2, the diagonals ... show an implied large, asymmetrical, diamond-shaped movement; apparently tilted to the right, this imparts kinetic movement to the whole picture. (Bearden and Holty 1969:177)

of solid geometry: Renaissance space is concave, while "Cubist space is convex, very much like an umbrella turned inside out," and Cubic space, "not to be confused with twentieth-century Cubism, ... is a transition between flat Byzantine space and the receding space of the Renaissance."[1]

Bearden also took cues from a close study of Chinese painting, to which he was introduced by a calligrapher named Mr. Wu who had a bookstore in Chinatown. He was captivated by the way it used "voids, or negative areas, as sections of pacivity and as a means of projecting the big shapes." And he concluded that "it is not the objects that matter to me but what is in between them; it is this in-between that is the real subject of my pictures. ... I find I am increasingly fascinated by the possibilities of empty space on a canvas." Bearden and Holty wrote:

The use of negative space, or voids, is uniquely handled in Chinese painting. The voids not only emphasize the scale of the painting ... but also provide a resting place where the eyes and the mind can contemplate the painting.

And Bearden elaborated:

In Chinese paintings, probably the greatest of paintings, you'll find – and I sometimes try to do this – an open area, or open space, which allows the onloooker to enter the painting and find his own surprises in it. They always refer to the "open corner" of Chinese painting.

And in a 1985 interview with Lowery Sims, Bearden spoke about "the curious 'inverted space' of traditional Chinese painting."

The lines and planes and spaces in Bearden's concept of structure all existed in a temporal dynamic. As he wrote to his friend Walter Quirt in the 1940s,

I honestly believe the new stuff is better than anything before. I've studied space [in Byzantine paint-ing and the Italian primitives] rather hard, so that the paintings are more unified now – and the fantasy is held together. ... I finally think I'm beginning to understand what makes a picture move – what time sense in a picture means – leading plane by plane – step by step in a series of counterpoints – rather than focusing to give an immediate reaction.

"Time sense" implied rhythm, and meant that the elements structuring a two-dimensional composition could be seen to function like the tones and beats structuring a musical score. "Volume in painting evokes the same sensation as in music," argues *The Painter's Mind*. "It swells and recedes, but it is always there."

If "space" and "time" were two cornerstones of Bearden's vision of art, "color" constituted the third, and the dynamics of their three-way interaction extended well beyond the realm of visual arts, not only energizing paintings but also lending

1. For an interesting analysis of the ways Bearden played with compositional principles that he identified in works of art from other moments in art history, adapting them to his own themes and techniques, see Kennel 2003.

brilliance to music and serving a function as foundational to jazz as to flat painting. This vision implied a significant parallel, even an identity, between the negative spaces of a painting and the silences in a musical performance.

I listened for hours to recordings of Earl Hines at the piano. Finally, I was able to block out the melody and concentrate on the silences between the notes. I found that this was very helpful to me in the transmutation of sound into colors and in the placement of objects in my paintings and collages. ... Jazz has shown me the ways of achieving artistic structures that are personal to me.

Bearden's friend Max Roach seconded the idea from his perspective as a jazz drummer:

My approach to rhythms ... is the use of space, of silence. It's not that there's necessarily *nothing* going on. There's always a pulse there. But there are times when there's nothing *but* the pulse. [With Miles Davis] the rhythm was there even though you didn't have a rhythm section. Some

of the horns, like Lester [Young] and Bird [Charlie Parker], had a built-in rhythm section. They didn't need a drum or a bass player. When they played, you felt the pulse. So that allowed the drummer to do colors. ... With these people, it was always there: the silence, the meter. The pulse was there, in the silence. Bearden's paintings are like that.

Bringing the color/sound tie-in back to his own domain as an artist, Bearden painted a portrait of Roach and called it *A Portrait of Max: In Sounds, Rhythms, Colors and Silences*. More generally, Bearden had an unusual gift for bringing music and art into a single embrace, for relating disparate realms of his life experience. The academic study of art history was in no way out of place next to the "finger-snapping, head-shaking enjoyment" that he got from jazz. It was all of a piece. For Bearden, it was not only a matter of bringing the structure of a Mondrian painting to bear on the rhythms of

jazz, but as Ralph Ellison has pointed out, playing the *rhythms* of Mondrian against the *structure* of jazz. Al Murray talked about how pivotal Stuart Davis, a mainstream white painter, was in Bearden's awareness of the importance of the connection.

During the war Romie was hanging out with that American painter, Stuart Davis. He was a personal friend. *He's the guy who turned Romie on to jazz.* Romie wanted to find out about Raoul Dufy and all these guys, 'cause Davis had been to Paris, but Davis wanted to talk about Earl Hines![1]

Or, as Bearden put it,

The more I just played around with visual notions as if I were improvising like a jazz musician, the more I realized what I wanted to do as a painter, and how I wanted to do it. ...I was not just impressed but also deeply moved by the fact that Stu Davis, who so far as I was concerned was one of the best American painters around, felt that it was so crucially important and worked so long and deliberately to acquire something that, as he pointed out, I had

1. Murray describes the Bearden-Davis relationship in more detail in *The Blue Devils of Nada*, pp. 124-125.

inherited from my Afro-American environment as a matter of course.

And when artist Gwendolyn Wells asked him, in an interview, about his approach to color, his answer was phrased in terms of music:

GW: So when you put down a certain color, do you choose it visually? Is it based on an emotional reaction?
RB: Well, you put down one, and it calls for an answer. You have to look at it like a melody.

In writing *The Painter's Mind*, Bearden and Holty concentrated on spatial relations and structure, placing virtually all analysis of color in a companion volume entitled "Color: The Other Art." Because of production costs, the second book was never published, but we did find portions of it in the cartons of archival material being unpacked and filed at the Romare Bearden Foundation.[1] With more fragmentary materials to work with on color, we are

less richly equipped to analyze this crucial aspect of Bearden's vision than we were in presenting his ideas about spatial relations. But it is clear – from the manuscript pages as well as letters, interviews, and the recollections of those who were close to him – that his approach to color was as firmly backed up by careful study and thoughtful reflection as was his approach to compositional structure.

Just as he conceptualized a painting's structure in terms of movement – whether the "revolving movement of a kinetic space" in Mondrian, the eye's journey into a Chinese painting from its "open corner," or the ever-present volumes that "swell and recede" in Picasso – Bearden saw color as a dimension of art that emerged from motion. He often spoke in terms of a scenario in which colors were the result of light moving across a space. As he wrote to

Holty, contrasting his own ideas with those of the cubists,

I think of some light source that moves across the canvas, pausing to become yellow, blue, pink, or what have you during its passage; and always yellow, blue or pink according to the painter's desire.

As early as 1945, critics were recognizing that Bearden's "uncanny sense of space and what to do with it" was strengthened by "a sensitive yet powerful feeling for color." But after his return from Paris in 1950, he threw himself into a disciplined exercise that led to new ways of thinking about color. For a period of three years, he produced virtually no compositions of his own, but rather copied paintings from oversized black and white photostats, substituting his own colors for those in the originals. "I did that with Giotto, Duccio, Veronese, Rembrandt – right on up to Monet." When he emerged from

1. Some draft pages of the color manuscript are in Bearden's handwriting, others are crudely typed, and still others look as though they were professionally typed; all have been subject to detailed rewriting in terms of word choices, sentence structure, and factual details. The text is explicit that "it is not the purpose of this book to attempt a detailed analysis of scientific color theory ... [or to provide] an historical essay," yet both science and art history enter the discourse in some form on nearly every

page. As in *The Painter's Mind*, technical observations and mathematical diagrams are complemented by artistic passion: references to equilibration and lines of force are interspersed with comments about artworks that "seem to emerge like glittering dreamers." In general, the text is addressed to artists more than viewers, and treats in some detail the physical production process, including such matters as the application of paint through quick-drying washes, brush-stroking, and palette-knife dragging.

"The movement of the artist's hand and body is related to that of the modern ballet dancer and pantomimist. This involvement of the body is the mystique by which the material integration of the work is given the breath of life and the mark of the artist's personality." We are grateful to Harry Henderson, who read and criticized the manuscript at its authors' request, for alerting us to its existence. In a 1985 letter to June Kelly, Bearden alludes to a series of Bearden/Holty discussions which were typed and which

Henderson thought should be a book. Pages of that manuscript are also among the papers at the Bearden Foundation.

this period, he began to "give free rein to color. Tracks, patches and bars of color made their way up, down and across the canvas in a structured action." Critics were quick to note the shift in his art, and began to refer to him as "primarily a colorist," though the feeling for spatial relations that he had developed in the 1940s remained crucial – color and form worked hand in hand. Bearden himself wrote that he considered "color as a place and a position in space. ... You must consider color as coincidental with form & space." Or, as Ralph Ellison put it, Bearden began to control "the magic by which color became space, space became perspective, and color became form."

"I felt that by using these tracks of color up and down and across the canvas I learned a great deal more about the color's action," he reiterated some thirty years later. The colors could now

"walk like free men" because he had found a way of using his friend Stuart Davis's advice that "in a painting color has a position and a place, and it makes space." Around the same time, his turn from temperas to watercolors infused new brilliance into his use of color.

My temperas had been composed in closed forms and the coloring was subdued, mostly earthy browns, blues and green. When I started working with watercolor, however, I found myself using bright color patterns and bold, black lines to delineate semi-abstract shapes.

We will see below how this shift was carried even further two decades later when he returned to watercolor to capture the luminous hues of the Caribbean.

In light of Bearden's analytical focus on structure, it is not surprising that his attitude toward experiments with automatic painting was decid-

edly negative. *The Painter's Mind* expresses skepticism that works created explicitly according to the principle of spontaneity were untouched by "postexcitement rearranging":

A shortcoming of this method is that so many of the automatically controlled paintings lack sequence, cadence, and contrast, and that the natural rhythms of the painters, born of gesture and calisthenics, cancel each other out. In the best examples of this manner, the painters must have done a certain amount of postexcitement rearranging. ... There is no denying that a growth of the spirit is involved in all creativity, but thought is at least an equal partner in this activity, if not the governor.

Bearden voiced related sentiments with regard to amateur and "naive" artists:

So many people ... will say: "I took the most beautiful ride today through up-state New York. I wish I was a painter. Boy, I could invent my own beautiful painting." But, of course, they couldn't have, because they have to learn how other people did that. You learn from other paint-

ers how to integrate things. And then you try apples and trees. ... But if you just go and start painting you'll create a mess; you'll create confusion. You might say, "How about the naive painters?" They all paint pretty much alike. They have their own way of seeing from Grandma Moses on. Most of them all look pretty much alike.

Bearden was insistent, in correspondence, journal notations, interviews, and authored texts, that his own primary focus was more on spatial relationships than on themes or representational content, more on a rigorous attention to structure than on a disposition of form and color toward illustrative ends.

I first put down several rectangles of color, some of which, as in a Rembrandt drawing, are of the same proportion as the canvas. I next might paste a photograph (or a piece of paper), perhaps of a head, in the general area where I expect a head to be. The type of photograph does not matter, as it will be greatly altered. At this stage I try only to establish the general layout of the composition. ... I try to move up and across

the surface ... avoiding deep diagonal thrusts and the kind of arabesque shapes favored by the great Baroque painters. Slanting directions I regard as tilted rectangles, and I try to find some compensating balance for these relative to the horizontal and vertical axes of the canvas. ... What I'm trying to do is establish a vertical and a horizontal control of the canvas.

Bearden's analysis of spatial relations applied to representational works of art as much as it did to the art of, say, Mondrian or Jackson Pollock. Abstracting back from the content of a painting to arrive at the underlying structure was sometimes facilitated by viewing a representational image upside down, as he often described doing with Vermeer, or by encouraging younger artists to paint their pictures upside down, as participants in his Caribbean workshops have reported.

Take Vermeer's drawings – you turn them upside down, and there's real, great abstraction. The wrinkles in

the clothes, for instance; you turn the drawing upside down, and you see something else, the great relationships. This is the abstracting of things. People think abstraction means that you don't have figurative objects in a work. So a more accurate word is "non-representational" rather than "abstract," because Poussin, Ingres are great abstractionists.

"So this canvas [*The Piano Lesson*] is not, per se, about a music lesson, it's just as much about the relationships of rectangles and the composition of the whole," concludes Myron Schwartzman with perfect logic, when Bearden describes this upside-down technique. "Yes..." replies Bearden, "but it's the music lesson."

Al Murray has elaborated insightfully on Bearden's "Yes... but," explaining that his approach to painting is predicated on the idea that

the painter should dominate his subject matter rather than be dominated by it. His talent is not at the service

of description. The essential process is one of stylization. What counts is *how* what is said is said. ... All the same, Bearden ... sees no reason why his pictures should not tell a story so long as the narration and depiction do not get in the way of the painting as such. In his view, a painting does not *have* to say anything ethereal, literal or symbolic, but it may if it wishes. ...Description is always subordinate to design.

Referring to a series with the explicit theme of childhood recollections, Murray elaborates on the relationship between abstract form and descriptive representation:

The specific reminiscences that now seem so integral to each picture actually came only after each composition began to click into focus as an aesthetic statement. It was, he reports, more a matter of saying this looks like a garden, so why not Miss Maudell Sleet's garden, rather than saying now I'm going to recreate Miss Maudell's garden.

Of course, once such a painting is completed an artist can say any number of interesting and essentially literary things about it (as Bearden has done on request on not a few occasions). But although sometimes he may talk as if about an illustration, what he is referring to is a painting, *a system of organized forms*; and in the process of pulling it together he was far more concerned with such aesthetic elements as decorative and ornamental effect than with narrative or dramatic impact. Indeed, as charming as such remarks can be, the picture as a painting would not be changed one bit if he called Maudell Sleet Miss Emily Ellison and reminisced about how after her husband died she used to bury her savings in an Alaga syrup bucket. ... The exact imitation of nature is irrelevant to the aesthetic statement Bearden wishes the picture to make. That statement, however, is altogether dependent upon the ornamental and decorative quality achieved.

Or, as Bearden put it in commenting on a montage painting of 1967, "the thumb of the woman on the far left has as much to do with integrating the painting as a whole, as with representing the 'handedness' of hands."

Bearden's serious flirtation with Abstract Expressionism, and his ultimate rejection of it, played an important role in working out his position about the interaction of form and content in his art. In the late 1940s, after his stint in the army, he felt as though the art world of Europe was migrating to the United States, and by the 1950s, the "energy" seemed to have shifted even more decisively in favor of New York. Bearden's interest in this environment of artistic "questing" – whether by his friend Piet Mondrian, Surrealists such as Salvador Dali, André Masson, and Yves Tanguy, or abstractionists such as Motherwell, Baziotes, and Rothko – was sparked to an important extent by the idea that many of them were immigrants or first-generation Americans, "searching for something in the Modern tradition, but that would have some-

thing to do with their American experience." Bearden, too, was searching. His voluminous correspondence with Walter Quirt, Carl Holty, and others struggled unrelentingly, and often in excruciating detail, with questions about the nature of art and the role of the artist. He had run the gamut from political cartoons decrying the injustices of American life to the most formally conceived compositions, often in a Cubist mode. And all around him, artists were moving in a direction that would place Abstract Expressionism at center stage. Al Murray singles out the "Cedar Tavern guys."

Cedar Tavern was where the abstract expressionists and that generation used to hang out. He knew all these guys. We'd be walking down the street, you know, and he'd say hello to Jasper Johns, de Kooning, Jackson Pollock. They were all the same age.

And Harry Henderson reminisced how

the development of Abstract Expressionism ... was a problem for Romie. He was excited and influenced by the fact that the development of that movement shifted the focus of world art from Paris to New York. This excited him and he wanted to be part of it. But the very basis of Abstract Expressionism was this kind of inner freedom, inner liberty to do what you damn please. And Romie couldn't do that. Cause if he did that, he would be opening up all kinds of things. So he turned to zen.

The art of Mondrian (who was Bearden's friend in New York during the forties) was particularly important to Bearden's ultimate conclusions about the nature of art, for its non-representational character and structural formality in no way implied, as he interpreted it, an absence of content. "The subject is important," he wrote. "Painting, art, is about something. Because he relates to something more than the solution of a design problem in hori-

zontals and verticals, Mondrian means more than all the hard-edge or neo-plastic painters that he influenced." Bearden's admiration of Mondrian's art, in combination with his dismissal of painters who reinterpreted Mondrian's non-representational art as a championing of contentlessness ("What you see is what you see"), was based on a conviction that abstraction and content could work together to strengthen a painting.

Ralph Ellison picked up on this, insisting that a strong narrative element distinguishes Bearden's art "even at its most abstract," giving it the power to transcend the canvas. Murray has argued in a similar vein, stressing that the primacy of design over description in no way contradicts the importance of subject matter: "It is precisely by working primarily in terms of ornamentation and decoration that Bearden

generates the strong ceremonial and ritualistic associations which some reviewers refer to as 'mythic overtones.'" And Derek Walcott interprets the greatness of Bearden's accomplishment in terms of his mastery of narrative, and the astonishing feat of pulling it off with the tools of a woman.

You don't tell the story with a pen and a pencil, you tell it with that phenomenal thing of using the scissors. Now, the scissors is the weapon and the tool of a matriarchal society. Scissors cut cloth. So what the paintings represent is the same as if a mother or an aunt or a grandmother had cut fabric to make a utilitarian object. I mean, this is staggering! Because what Romare did is that he made himself like a woman, ... he made a matriarchal thing of a painting. If you draw it, then you're doing some kind of assertion. But if you make it utilitarian, then you have a phenomenal humility. ... So that all these designs look like a mother making dresses for her children. ... And if you think of the children as being not only children in terms of being children having dresses, but of being male and female of whatever age who are being *transformed* into children, you see that they're transformed into children in the exact way that a "Negro spiritual" transforms black people into children. Exact fucking thing! There's no artist in the twentieth century who has done that. About any people. Nobody.

When Romare is cutting out a figure of a black face, and putting it on a fabric that he has also cut out, you're telling a story. You are a novelist. That's what you're doing. And you are doing something that has the stillness of a Piero della Francesca. It does! I *hate* collage, can't stand collage. But when I look at Romare Bearden's painting, I say: "Well, you gotta like fucking collage!" Because that's what this is. But it's also more than that, you know? I think it's painting with a scissors.

Bearden himself has occasionally talked about the transcendent power of his paintings.

In my work, if anything I seek connections so that my paintings can't be only what they appear to represent. People in a baptism in a Virginia stream, are linked to John the Baptist, to ancient purification rites, and to their African heritage. I feel this continuation of ritual gives a dimension to the works so that the works are something other than mere designs.

This idea that a baptism in Virginia is not just a baptism in Virginia is relevant for an understanding of the words that become attached to his images. Much of his art bears titles that evoke particular people, places, and events: *Miss Bertha and Mr. Seth*, *Odysseus and Penelope Reunited*, *Mill Hand's Lunch Bucket*, *Farewell Eugene*. And many of these are expandable into larger narratives of memory. But despite his reputation as a captivating and irrepressible storyteller, Bearden leaned on others to help out with the titles for his images. As he remarked on more than one occasion, "Visual art is not a verbal thing." At times, Nanette suggested titles, but more often it was the men he hung out with. There was a

definite element of serendipity in the process. Cultural critic Fabian Badejo laughed as he told us during an interview in St. Martin how Bearden offered him a painting after he'd done a review for the local press. "There was a line in the review that used the words 'purple' and 'edenic,' so he read that and he said, 'Ah!'" and the title of the painting became *Purple Eden* (see |▶14|). But the most frequent adviser on titles was Al Murray, Bearden's main man ever since 1950, when they had met in Paris. |▶7|

Romie was at the Coupole with a friend named Myron O'Higgens, who's a poet – he was a very close friend. I saw them together, and Romie was sitting there, and the guy was talking, and then Romie broke out into a laugh. And I realized that it was neither Khruschev nor Jean Genet! [laughs] I said, "This is a colored guy! 'Cause he had this laugh, he stuck his tongue out, *heeheehee-hee*!" That was an idiomatic laugh!

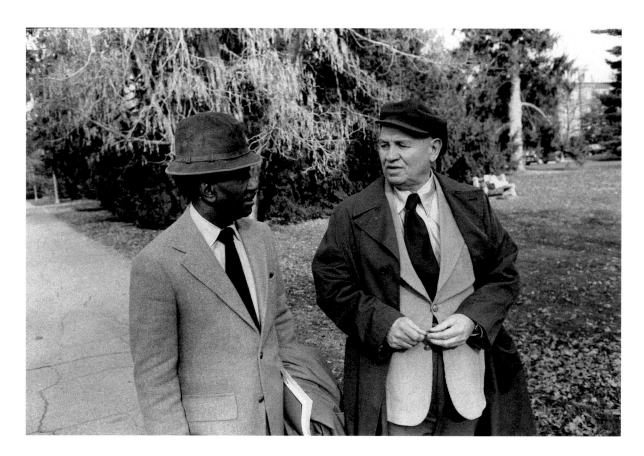

7. Murray and Bearden. *Photographer Frank Stewart.*

Murray took on a multi-faceted role in Bearden's life: "I was Romie's intellectual guru, his literary guru, and his social guru with the ladies."[1] Some of this involved titling the paintings. Henry Louis Gates, Jr. recounts an example of the process:

The literary scholar Robert O'Meally remembers being with Bearden and Murray in Books & Company when the two were trying to decide on a name for whatever picture Bearden had brought along that day. O'Meally recalls, "It might be that Al Murray's eye was caught by the figure of a woman in one corner of the image. And he'd say, 'Who's that?' And Bearden would be looking embarrassed, because the woman in question had been an old girlfriend of his. Maybe Bearden would say, 'Oh, she's just a woman I once knew from North Carolina.' And then Murray would say, 'I've got it. Let's call it "Red-Headed Woman from North Carolina."' Or, 'I know, call it "Red-Headed Woman from North Carolina with Rooster."' And Bearden would go and write that on the back of his painting."

For the 1978 collage series based on childhood memories of Mecklenburg County and Pittsburgh, Murray extended his titling to longer texts, which Bearden then wrote on the wall of the Cordier & Ekstrom gallery, next to each collage. Bearden described to Schwartzman how "Murray asked [him for his] recollections of specific people and scenes, found a narrative style for them, and orchestrated them to form a series." For the two collages devoted to Maudell Sleet, for example,

Al Murray would ask me what she did, and I would tell him about her: that she had a green thumb, that she kept a small farm going by herself after her husband died. When I passed as a boy, she would say, "Well, here's some blackberries or blueberries; take it to your grandmother"; or "Here's some flowers." Then Al would condense these recollections for me.

With Murray's collaboration, one collage became *Maudell*

Sleet's Magic Garden and the wall narrative declared, "I can still smell the flowers she used to give us and still taste the blackberries."

Murray also stepped in quietly when Bearden received an invitation from Gates to present a lecture series on Afro-American art at Yale. The impressively clear lectures, each neatly double-spaced and lasting exactly fifty minutes, seemed puzzling, given Bearden's original protestations that he felt "pedagogically incompetent." But "comprehension soon dawned," reports Gates. "Bearden, taking matters into his own hands, had found a way to bring Murray along to New Haven; the critic had ghostwritten Professor Bearden's erudite lectures."[2] Murray's coaching role occasionally spread into Bearden's actual artmaking. He described to us how Bearden once phoned him in 1969 as he was finishing

1. In a 1996 interview, Murray told Gail Gelburd:
"My three most sophisticated friends were [Ralph] Ellison, Bearden, and Duke [Ellington] — but Duke was older. Romy, Ralph, and I were all about the same age, within two years of each other, whereas Duke was the age of my father. ... Romy was capable of a lot of explanation and mathematical logic. We spent so much time together going to galleries and museums and bookstores. So that's why we were so close over a long period of time.

I had ongoing conversations with him about the conceptions that he was going to stylize." (Murray in Gelburd 1997:58)

2. We would put on record here that June Kelly finds all such accounts of Murray's ghostwriting for Bearden exaggerated, saying that she has, for example, seen detailed notes for the Yale lectures in Bearden's own hand.

a photomontage and asked for some feedback. "What've you got down there?" says Al. "Well, I got a guitar player, and I got a schoolboy and some buildings, and I got the flag on it..." So Al says, "OK, put an African mask in there someplace." And there it is, just under the American flag, peering down at the guitar player on the cover of the Sunday *New York Times Magazine* – an African mask, courtesy of artistic counseling over the phone.[1]

Murray's involvement in Bearden's paintings and collages, the titles they carry, and the stories attached to them makes it hard to question his reading of Bearden's artistic intent. And what he has to say goes far toward correcting the facile assessment by many critics of Bearden's art as bald social commentary. A brochure announcing the 1997-1998 exhibit, "Bearden in Black-and-White," for example, summed up his art

as a depiction of the culture of African Americans in the 1960s with resonance for "the indignities of segregation and the political turmoil of the times." And the massive *Grove Dictionary of Art*, regularly updated on-line, still makes no substantive mention of Bearden other than citing the power of his art to confront social realities and build racial pride, tucking its assessment of his life's work into an entry on 20th-century propaganda art.

Romare Bearden's collages interpret the realities of an American life, and the emergence of Black Expressionism in the 1960s led to a body of highly publicized works of art aimed at building racial pride. In such works the observer is forced to confront the inherent ugliness of certain situations in order to arrive at a reaffirmation of life's possibilities.

This sound-bite treatment of Bearden's art quickly withers on the vine when challenged by Murray's insights on his friend's artistic priorities.

When black functions as a symbolic reference to so-called black people of Africa and the United States, it is not the reference that is of paramount importance but the design: how the black shape works with other shapes and colors. Moreover, black may or may not say Afro but inevitably says silhouette, and almost always has the effect of a cut-out in a collage. ... Bearden has made it clear that his actual use of African art is based on aesthetic, not political and certainly not racial, considerations.

Bearden's friend Barrie Stavis was particularly impressed, in the late 1940s, by his ability to dissociate his life as an artist from the suffering he saw on a daily basis working for the New York City Department of Welfare. And Myron Schwartzman, quoting Bearden's 1946 article, "The Negro Artist's Dilemma," concludes: "Of all the problems facing the Negro artist, Bearden found the 'pressure to use his art as an instrument to mirror the social injustices inflicted upon his people' the

1. In speaking with us, Murray, showed no excessive reverence for Mother Africa. In a characteristic riff, he went off in his own direction, entertaining us with his vision of *American* aesthetic beginnings and creativity. "For me, it was the train stuff. The whole theory based on locomotive onomatopoeia. That's the basis, and if you're dealing with that, then you're dealing with, you know, the basis of jazz! You've got all this African stuff – what *they* brought was a disposition to play dance music, which meant they featured percussion. But culture is such

that you respond to what you're around. And what they were responding to was not the chief sending a message across the Zulu River, you're responding to a locomotive. To the locomotive onomatopoeia, which is a guitar. ...That's completely American! It wasn't just the fact that they had drums. Indians already had drums – but they weren't swingin'! [laughs] You know, the Africans, they came down to the other part of the thing, *they* had drums. But they weren't swingin' either! Only the guys *here* were swingin' – right?"

most perplexing. 'It is not necessary that the Negro artist mirror the misery of his people.'"

Ralph Ellison, like Murray on an inside track with Bearden, wrote that his art

is not only an evaluation of his own freedom and responsibility as an individual and artist, it is an affirmation of the irrelevance of the notion of race as a limiting force in the arts. ... It was as though Bearden had decided that in order to possess his world *artistically* he had to confront it *not* through propaganda or sentimentality, but through the finest techniques and traditions of painting. He sought to recreate his Harlem in the light of his painter's vision, and thus he avoided the defeats suffered by many of the aspiring painters of that period who seemed to have felt that they had only to reproduce out of a mood of protest and despair the scenes and surfaces of Harlem, in order to win artistic mastery and accomplish social transfiguration.

Harry Henderson, a friend and collaborator over four decades, linked Bearden's dis-

approval of social protest art to the detrimental effect of depicting dated realities.

Romie was never a part of the propagandistic aspects of art. Like, say, Norman Lewis, who was a so-called social realist. Lewis painted tenements and hunger strikes, WPA protests, and things like that. ... The issues that might arouse you, like bad housing, or job protests, ... hunger, a steel barrel with flames coming out, people trying to stay warm and huddle in the snow, poorly clothed. ... Romie felt like those things may change, and if that changes, your art's gone since it was related to an issue which was going to disappear. Now, when it did, well, where was your art? It lost its meaning! And so Romie differentiated himself from that sort of thing. And he would tell stories about that. I remember one story about a young painter who came in with a painting about people on the street, homeless people. And then others said: "Not just homeless, you've got to have police brutality in there. You oughtta put some police in there beating him up." "They put in the police," Romie said, "and they destroyed the painting."

Through the years, Bearden frequently reaffirmed his position that art was not the proper medium for protest. In 1964, at a time when his concern with the civil rights movement was at its height, he explained it this way:

I create social images within the work so far as the human condition is social, I create racial identities so far as the subjects are Negro, but I have not created protest images because the world within the collage, if it is authentic, retains the right to speak for itself.

Calvin Tomkins, who conducted in-depth interviews in 1977 for his profile of Bearden in the *New Yorker*, picked up on Bearden's feelings about the interpretation of his art as social protest:

Inevitably, perhaps, in the emotional climate of the sixties, critics read social content into these powerful and evocative paintings. They saw "tormented faces," "vision of beauty and horror" and the travail

and anguish of the Negro's existence; the work, as the *Times* noted, was "propagandist in the best sense." Bearden has made it plain that this was not part of his intention. "A lot of people see pain and anguish and tragedy in my work," he conceded a while ago. "It's not that I want to back away from this, or to say that those things are not there. Naturally, I had strong feelings about the civil-rights movement, and about what was happening in the sixties. But you saw that on television every night, you saw the actuality of it, and something was needed, I thought, other than to keep repeating it in art. I thought there were other means that would convey it better than painting." Bearden was concerned with art, not propaganda.

And speaking with Charles Rowell just months before his death, he said it again:

There is nothing wrong with protest. But as I said before there are other things that do it better than art. Other ways. ... People can protest much better now through other forms than through art.

"Other ways," in Bearden's case, included writing, which he

generally did in a collaborative role. Arguably the most monumental contribution he made in this mode was the history of African-American artists that he wrote with Harry Henderson. The project began in the mid-1960s when Bearden was asked by the Museum of Modern Art to give a talk about the history of black artists. After putting together a paragraph on each of about twenty artists, he asked Henderson to help. He had read a lot, he told Henderson, and he knew things about Duncanson, Tanner, and others that no one else knew, but he often couldn't put his finger on his sources and didn't have time to do the necessary research. Before long, they had expanded the project into a decision to write a book together, and over the subsequent two decades their collaboration weathered a series of battles with a string of publishers that eventually culminated,

five years after Bearden's death, in the publication of *A History of African-American Artists from 1792 to the Present*.[1]

The bulk of the book is devoted to chapters on several dozen individual artists, complemented by essays that flesh out the social and historical context of their lives and art. It is here that Bearden's reading of social injustice finds voice, and a recurrent theme is the racially-based prejudice that blocked African-American artists from enjoying the recognition they deserved. Bearden is not among the artists chosen for inclusion ("That was a conflict of interests," Henderson told us. "What are you going to do? Give him two pages? ten pages? no pages?"), but a stinging article he wrote while still in college does make a cameo appearance in the text: "A concrete example of the accepted attitude towards the Negro artist recently occurred

1. Doubleday originally made a deal with them to publish the book if they would first produce a children's book on African American artists in a government-subsidized series designed for mass distribution to inner-city schools. In 1972, the children's book, *Six Black Masters of American Art*, was published – "poorly produced and an absolute fraud in a sense," said Henderson during an interview at his home. Seven years later he and Bearden completed the big book and delivered it to Doubleday,

but after a year passed they had still heard nothing from the publisher. "Finally we began to complain: 'What's happening. What's going on? When are we going to see proofs?' And the young woman who, because she was black, got assigned to everything that was black, told me she was trying to work on two chapters – she carried them in her handbag and read them on the subway. When we complained, they farmed it out to a freelance editor and I worked with her until she got a call saying, 'Stop everything,' so

she stopped. It seemed that Doubleday was losing a lot of money. When I found that out, I went to Sam Vaughn who was president, who I knew quite well, and I said, 'What's going on here? This is irresponsible! You have a contract!' So he took the thing away from them, and got another editor, who worked on it very diligently and very well. But by this time about five more years had passed." There were heated arguments about production costs and then Sam Vaughn resigned. The authors took back their

manuscript, much of which then had to be rewritten on the basis of further research they had conducted while the book was in limbo. Random House (Pantheon) eventually took the book on, but fights over the book's length, design, and marketing strategies continued right up until its publication in 1993.

in California where an exhibition coupled the work of Negro artists with that of the blind. It is obvious that in this case there is definitely a dual standard of appraisal."

Personal intimidation, exhibition policies, and coverage in the press and in art historical publications are all brought into the picture. Discussion of the achievements of Henry Ossawa Tanner (who in 1996 became the first African American artist to be represented in the permanent collection of the White House) and Edward M. Bannister (winner of the 1876 Centennial Exposition award for oil painting and host of the discussion group which eventually led to the establishment of the Rhode Island School of Design) is joined by observations that they remain largely unrepresented in American art histories. "According to some art histories, the first African-American

has yet to pick up a brush. ... There is a great blind spot in American art history, one that is color-sensitive, not color-blind." This theme carries through the entire book, bolstered by example after example.

Writing of Edmonia Lewis, they note that her fellow sculptors shared a "subtle, unconscious unwillingness to accept a black person as an artist." One dubbed her successes "color indulgence" and another "sneered that color was 'the pleading agent of her fame."[1] Henry Tanner was subjected to persistent racial abuse by his classmates, one of whom penned an essay entitled "The Advent of the Nigger." And "one night his easel was carried out into the middle of Broad Street and, though not painfully crucified, he was firmly tied to it and left there." Later in Tanner's career, he was awarded a medal for *The Bagpipe Lesson*, but instead of displaying his paint-

ing with those of the other three winners, the exhibition organizers placed it in a specially designated "Negro Building." When he won a prestigious international award in Paris for *The Raising of Lazarus*, a Baltimore newspaper illustrated their coverage of this honor with a photo of a black dockworker, figuring that "any black face would do" for the purpose. "And ... despite prizes in Paris and in America, Tanner could not enter most restaurants in New York with any certainty that he would be served."

Bearden and Henderson's useful essay on the social and economic struggles of artists during the 1930s singles out the responsibility of two particularly destructive misreadings of the work of African Americans. "One view took a somewhat demeaning, however sympathetic, sociological perspective. ... The second

1. In 2003, several months before his death, Harry Henderson told us that he was putting the finishing touches on a book that he and Bearden had written together about Edmonia Lewis.

view was fundamentally derived from stereotyped expectations about 'primitive' people. Both perspectives neglected aesthetic consideration, a pattern that has continued to this day."

They illustrate the first of these views by citing a 1941 review which asserted that "If [the black artist's] art is homogeneous, then it is because he has been forced to live in a black ghetto, walled about by the poverty, disease, and lack of opportunities." And they argue that this is the kind of attitude that stood behind the exhibition policies of state fairs in the 1930s and 1940s, where work by black artists was often displayed in a special section alongside the needlework of the handicapped.

The second view had already come up in their discussion of the problems confronting black artists of the more upbeat decade of the 1920s.

The more talented the artists were, the more they were subjected to pressure to paint in ways that the majority perceived as "primitive." That perception required – indeed, demanded – a degree of awkwardness or crudity, violent color, and sensuality. Catering to that idea became the easiest way for an African-American artist or writer to gain attention from ... the gatekeepers of recognition and acceptance. ... Langston Hughes refused the demand of a patron who "wanted me to be primitive and know and feel the intuitions of the primitive. But, unfortunately, I did not feel the primitive surging within me, and so I could not live and write as though I did. I was only an American Negro – who had loved the surface of Africa and the rhythms of Africa – but I was not Africa. I was Chicago and Kansas City and Broadway and Harlem." ... The demand for the African-American artist to be "primitive" has persisted to this day.

One can, in fact, see remnants of this race-based demand in the phrasing that critics have used to characterize Bearden's own work. In 1948, American art historian Oliver Larkin dubbed his paintings "will-

fully primitive." In 1980, Avis Berman, critiquing Bearden's work for *ARTnews*, saw a "tribal need to salvage his childhood." And even Dore Ashton, a long-time champion and sensitive critic of Bearden's art, falls victim to a cliché'd vision of "primitive art" in tracing his debt to Picasso in terms of an appreciation of African masks for "their power to invoke fear, awe, magic, ritual, ceremony" – a classic bundle (mis-)attributed to objects of non-Western art, whatever their actual place in the society where they were created. His art, she argues, tells of "the abiding African mores that seethe beneath the surface of black life in the United States."

Details of interpretation aside, Bearden's stature as an American artist was well established by the late 1960s. The rewards ranged from higher prices for his work and favorable

reviews in the major media to solo gallery shows and a retrospective, "Romare Bearden: 1940-1970," at the Museum of Modern Art. But they also included significantly increased stress in his daily life. He was having difficulty working in the Canal Street studio because of the constant stream of visitors, and finally moved his working quarters to a former classmate's sign shop in Long Island City, which helped because few people knew about it. "Romie had trouble working down on Canal Street. He couldn't get anything done. There were people coming there all the time. ... There used to be school busses of kids coming with their teachers. ... Romie could never say no to these people, he could never set up hours. He just had to disappear."

But the demands were still there. The Museum of Modern Art was asking him to talk to artists about the history of African American art. The challenge of securing a space and financial support for the Cinque Gallery, dedicated to the promotion of young minority artists, was taking time and energy. The pace of work in his studio was frenetic, and when he got home "the phone would be ringing ev'ry 5 minutes." He needed a place to relax.

Paris doesn't have the old enchantment for me. I suppose I need another kind of reality. ... Art will go where energy is. I find a great deal of energy in the Caribbean. ... It's like a volcano there; there's something underneath that still smolders.

Watercolor Country

Five years before his death, Bearden wrote a sketch of his life in the Caribbean for the *New York Times Sunday Magazine*.

Three summers ago, I was standing with the painter Herbert Gentry in the lobby of the Chelsea Hotel in New York City when Virgil Thomson, the composer and critic, left an elevator carrying a suitcase. When Gentry asked him if he was going on vacation, Thomson replied: "An artist never goes on vacation. He just takes his work someplace else."

My "someplace else" is St. Martin. Every winter and summer for more than 16 years, my wife, Nanette, and I come down to our second home, spending at least 15 weeks altogether in the land of her parents. The Caribbean island's air and ambiance, at least for the first week following my arrival, always lull me into a deep eight or nine hours of sleep a night. Only then do I realize how tiring the pace and pressure of my life in New York are – and how in need of rest and revival I am. |▶8|

My day in St. Martin begins about a half hour before dawn with the bravura cock-a-doodle-doo of a rooster down the road. If I get out of bed immediately, I see the lanterns of the fishing boats staining the sea with their yellow lights. Out since 4 in the morning, the fishermen have dropped nets and traps over Oyster Pond and Pompey Gut, two rich fishing grounds.

Imagine one of those Japanese fans on which a landscape has been painted. This is the view from our hillside home, which overlooks the lower slopes and ponds of the French side of St. Martin (the other side was settled by the Dutch) as well as le Galion beach. To the left, a row of hills descends gracefully to large l'Embouchure pond, and in the center, flat sandy ground overgrown with reeds enclose the pond. On the right, the deep blue Atlantic with white threads of surf breaks over coral reefs, with Anguilla and Flat Island visible in the distance. |▶9|

In front of my porch, in the fading darkness, hundreds of egrets rest in the reeds along the pond's edges. They look like a great patch of sea-island cotton. The continuing boasting of the rooster stirs them, and in a few minutes they take flight, not as a flock going in one direction, but in twos, threes and fours, off in all directions except out to sea. Later, if I drive to Marigot, the French capital, I shall see the egrets again, perched on the backs of cows, picking ticks off with their sharp yellow

beaks. Before Hurricane Donna blew the egrets onto the island 23 years ago, the islanders had to burn the ticks off with a kerosene torch. This procedure was painful for the cows and difficult for the men who had to tether the animals firmly before carrying out the procedure.

As the egrets fly away, the pelicans start diving for fish. Then, just as it becomes light, a large black bird soars into view. Sometimes called the "hurricane" or "weather" bird by the people on the island, this frigate bird, with its wingspan of about six feet, glides effortlessly, a master of rising and falling air currents. The coming of the weather bird heralds the dawn. There comes a charging wind that this fine bird uses in his swift climbing spirals, and the dark purple, now graying clouds of night begin to take on new colors as the sun mounts. The clouds become saffron, then vermillion and many shades of red, especially a deep cardinal. Undoubtedly, the sun is the emperor. Observing this vast elemental change, I can readily understand how people worshiped the sun in ancient times.

And now the whole island begins to wake up. I can hear the bawling of goats and sheep, the mournful echo of cows and bouncing of the work trucks along Oyster Pond Road followed by the crisp barking of dogs. I enjoy these sounds, but I still watch what the sun is doing to the colors. The island is now predominantly white, blue and green. I always think of Turner's watercolors, how some of them are so like the dawn in St. Martin. I have tried to make watercolors outdoors, working directly before this great display, but I find I do much better painting in my studio.

Now that the morning is sure of itself, we have some beautiful little gray-white mountain doves in the garden, darting about in pairs so close that they constantly bump into one another. A bird called a chinchary hops along our roof, trying to outwhistle a thrush down in the bush. About 6:30 A.M., I water some of the plants, usually with the help of my wife's cousin Alfonso. In front of the house, we have many varied flowers and plants, so that colors of all shades and tints sway to the choreography of the morning breeze.

The morning is usually cool and pleasant, and after breakfast I may read a little, delving into a pile of Times of London Literary Supplements, some of which are 10 years old. Then I go to my studio, working on a large table where I can lay out my pad and colors without

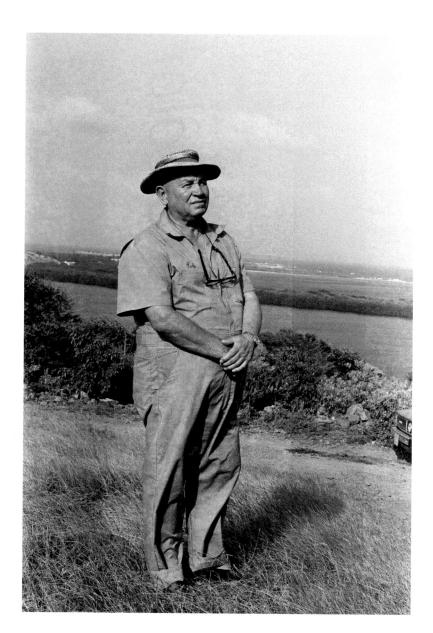

8. In St. Martin, 1983. *Photograph by Manu Sassoonian.*

being disturbed by passing visitors. The sketches I do are not very large, but I find them useful. Sometimes they are quite finished. At other times, they are just notes on the color of a tree or a cloud or the water off the beach.

After lunch, I start for le Galion beach, a mile away as the frigate bird flies, but three miles by our winding roads. The sand there is white, with the water changing from blue to turquoise, to slate blue, to blue green, according to whatever magic the clouds work on the water, which no matter the color, is always clear and calm. If I prefer a pounding surf, I can walk about a half mile around to Orient Bay. After two hours of swimming, resting on the beach and watching the clouds float over from St. Barthelemy, about 17 miles away, I'm ready to leave.

For Bearden, the Caribbean was a kaleidoscope of colors dancing to the sounds of island life. The day begins in "the fading darkness" before dawn, "with the bravura cock-a-doodle-do of a rooster." The view from his window is a landscape painting on a Japanese fan, the sea "a

9. At home in St. Martin, 1983. *Photograph by Manu Sassoonian.*

deep blue ... with white threads of surf," and the egrets "a great patch of sea-island cotton." Fishermen's lanterns "stain the sea with their yellow lights," but soon "the dark purple, now graying clouds of night begin to take on new colors as the sun mounts. The clouds become saffron, then vermillion and many shades of red, especially a deep cardinal."

As the day gets underway, this visual collage is joined by more sounds – the bawling of goats, the mournful echo of cows, the bouncing of work trucks, and the crisp barking of dogs. But colors continue to hold center-stage – the white, blue, and green that evoke Turner's watercolors, the gray-white of the mountain doves, and flowers in "colors of all shades and tints [that] sway to the choreography of the morning breeze." Later, walking on the beach, "the sand ... is white, with the water changing from blue to turquoise, to slate blue, to blue green, according to whatever magic the clouds work on the water."

Myron Schwartzman, who visited St. Martin in January 1985 in connection with the book he was writing about Bearden, reflected on the contrast between this Caribbean setting and the New York area studios where the two had begun their conversations some three years earlier.

Game cocks strutted outside the glass-enclosed dining room, the cats eyeing them warily. But just beyond there was another world suffused with Caribbean light, the bay, islands in the distance, birds seemingly suspended between sky and sea. ... Romare and I would ascend the long set of stone steps (there were at least a hundred) up to the studio. If I arrived late, Romare was there waiting for me. Unlike the Long Island City studio, which he did not reach until 10:30 A.M., this studio was only a five-minute climb away, and he began painting *early* here in St. Martin. The water-

colors were already drying in pools on the paper by the time I arrived. We talked for hours, about Harlem, the Apollo, the Kootz gallery. ... His collages that January were set in Mecklenburg, but a Mecklenburg suffused by a constantly changing Caribbean light.

Other visitors picked up on Bearden's sense of "rest and revival" in St. Martin. June Kelly, who managed his affairs in New York for the period of his life that involved the Caribbean, hesitated not a moment before summing up the importance of the island in a single word: "rejuvenation." And Frank Stewart – professional photographer, volunteer chauffeur, fellow baseball fan, and general soul-mate – recounts the spirit of his first trip to St. Martin in the mid-70s:

We were like two small boys together, one describing a playground yet to be experienced by the other. The days leading up to our departure were met with mounting enthusiasm by

10. Ma Chance in her kitchen. *Photographer Frank Stewart.*

Wherever Bearden went on the island, his painterly eye was active. His sketch for the *New York Times* continued:

On some days, after going to le Galion, I drive around the northern section of the island, past the French village of Cul de Sac and the small airport, into Grande Case, a little village. I usually visit Ma Chance, famous locally for its French-Creole cuisine. |▶10| Across the road from Ma Chance is the great beach of Grande Case, which touches the Caribbean Sea.[1] This long scimitar-curved beach is one of the best on the island, and on it are nets drying in odd loops, boat bottoms being scraped and painted and fishing-gear pulleys being repaired.

Once on the beach at Grande Case, when it was almost deserted, I saw a young couple in the water. They had a radio playing on the beach. Aided by the undulate waves and the steady beat of the music, the girl swept up and embraced her lover. The young lady waved to me, but I turned and walked down the beach, leaving them to their own ecstasies and with the sun on their shoulders.

Sometimes I visit Colombier, a luxuriant valley on the underside of

Paradise Peak, the highest point on the island. This deep valley, draining the mountainside, causes everything to grow profusely and large. Some royal palms in Colombier are 50 feet high, and the great nuts are allowed simply to fall when they ripen. A long row of oleander banks the entrance to the Louis Richardson estate, one of the largest and most cultivated on the entire island. These hedges are decorative but toxic, and cows and other animals will neither eat nor walk through them. On these grounds, I have seen the bird of paradise flower, chenille plants, poinsettia, anthurium, a cannon-ball tree and many other plants, flowers and trees I do not recognize.

St. Martin is not considered to be farm land, although once a great deal of its produce was exported. Today, the island depends on imported foodstuffs. There is an open market every Saturday on the pier at Marigot, and the schooners from Anguilla and other islands, some as far off as Dominica, come with avocados, bananas, cabbages, christophines, eggplants, limes, potatoes, sweet potatoes, hot peppers, tannia seeds; coconut and mango trees ready for planting; live goats and sheep, and fish, mostly varieties of angelfish, doctorfish, jacks, yellowtails and groupers. Fish are abundant in the

Bearden, who spoke of the island as a mystical place where the mythology that makes life bearable could still be found. ... New York City takes its toll, and he would travel to St. Martin to be rejuvenated, to refresh his creative spirit. He was drawn to the people of the island who, along with the sun, the water, and the food, were a tonic to him.

1. Bearden consistently misspelled the name of Grand Case as "Grande Case."

11. With a neighbor, Justin Haliger, 1983.
Photograph by Manu Sassoonian.

waters off St. Martin, which are frequented by a large Japanese fishing fleet, and there is a processing plant at Point Blanche, on the Dutch side. However, most of the catch goes to Japan. |▶ 11|

When I get home, Nanette will have started dinner. Afterward, we usually walk out to watch the sunset, which creates another range of colors and presents a softer drama than the dawn. With the mountains hiding the view, we are unable to watch the sun drop into the sea, but the undersides of the low, rolling clouds take its last orange darts and glide into Paradise Peak. With the sun diminished, there is a short afterglow, and the night eases in along with the stars. Once I bought a star chart to study the constellations, but I finally discarded it. Down here, at least, I feel very much as Walt Whitman did when, after listening to the lecture of a learned astronomer, he left the hall and looked up at the distant stars in "perfect silence."

Again and again, when Bearden spoke of the Caribbean, he evoked its special energy.

Art will go where energy is. I expect a convincing outpouring of creative energy from lands touched by the Caribbean Sea. An Obeah woman once told me she took in the moon before dawn and held it as a locket on her breast and then threw a rooster out in the sky who spun himself in the rising sun. That is energy.

Or, as he said to an interviewer in the Caribbean shortly before his death, characteristically invoking the names of great writers whose work he had read,

Right now there should be art – and there is – coming from this region, where the Caribbean Sea touches – Gabriel García Márquez, Derek Walcott, Carlos Fuentes, Octavio Paz, C.L.R. James, George Lamming

and others. All of these are here. That energy is not grounded out by tourism. ... This is the last great unspoiled region.

Bearden's vision of himself as an outsider-insider, an engaged visitor to the region, influenced the way he thought about the art he produced there. While his Caribbean paintings do not – could not – have the historical groundings of his Mecklenburg or Harlem works, they remain far from being a casual visitor's impressions. He cared about the people he encountered in the Caribbean and he saw there aspects of himself, and his history, that he valued. Listen to him describing a neighbor:

Until his death in 1981, Reginald lived in a small house on the pond side of l'Embouchure, directly below us, with his wife, Germaine, and his dog, Montaine, who followed him everywhere in the slow pace of his master. Reginald, his face lost in a huge straw hat, would often come up in the mornings when Alfonso

and I were in the garden. After a few strokes with his cutlass, he and the dog would stand watching. Reginald was tired.

After a while, the three of us would come into the porch. Reginald would point to where he wanted Montaine to stay. Alfonso and Reginald preferred the strong rum from Guadeloupe to the light green Sellé Bridé du Cap from Haiti, which I liked. Although Reginald said he most enjoyed a meal of salted pigs' tails, tannia seed and sweet potatoes, I never saw him eat, and he was so thin that his friends worried about his drinking. Across the table, his hat off, Reginald's face blended all the crossing winds and peoples of the Caribbean. The foliage of his face was withering but sensitive, and time and all Reginald endured had erased the false color of guile and left the old intelligence of people who live close to the sea and the sun. Gauguin would have liked Reginald, finding in his face not just the lights and darks that brought it alive, but also those firm metallic elements that made it enduring.

Reginald, born near the sea in Grande Case, knew everything that went on in the island. His thoughts were full blooded, and he was devoted to what he thought was right. To him, young people and politicians were "too reckless." His leak-

ing roof, the cars passing his house at night, the hungry cows that ate the vegetables in his small garden, the lack of rain or too much of it, the high cost of food, the lies told that men had actually landed on the moon, all these things, he said, "harassed him."

Alfred de Musset once wrote "Je suis venu trop tard dans un monde trop vieux" (I have come too late into a world too old). Reginald indeed belonged to another time, a time of old dirt roads over older hills, of three-masted Guadeloupe schooners with their horn salute as they turned into Marigot Bay, a time of John Wesley hymns, kerosene lamps, lisping accordions and merengue nights and old values worn smooth as stones in the sea.

When I return to my other home, in an ancient building in lower Manhattan (artists are like rats and mice; they get along best in old houses where no one sets traps for them), I often think of Alfonso and Reginald and of those chance impressions that nature offers, and I wonder in what way I can find a form for these facets of life that are also a tangible part of myself.

Changing Your Anchor

Bearden's imbrication in the Caribbean was gradual. An urbane Harlemite possessed of what Al Murray calls "a jazz and blues sensibility," he initially looked at the region – in addition to its being the ancestral home of his in-laws, and largely Nanette's thing – with an external, American gaze. True, he had played semi-pro ball with Negro leaguers who included Puerto Ricans and Cubans, he had hung out with Jamaican writer Claude McKay and his friends,[1] and he had lived through Garvey's rise and fall in a Harlem that included many Caribbean immigrants.[2] In the mid-twenties, he had lived near a cricket field where West Indians played, and he'd even met his future wife at a benefit for Caribbean hurricane victims. Curious about the region, he viewed it, says Murray, in a "romantic" light: "He saw it ini-

tially as a vacation-type place, an escape-type place." And his first direct encounters were Caribbean cruises that he and Nanette took during the 1960s. Nanette's sister Evelyn told us how, on a 13-day cruise with Romie, Nanette, another sister Annette, and her mother (plus Gypo, the cat) on the German ship the Bremen in 1971, they stopped in Martinique, traveling to the base of the Mont Pelée volcano, visiting the statue of Empress Josephine in the center of Fort-de-France, and dining in a restaurant near the palm-lined Savane. "Romie ordered everything in French – he really loved that place and went back on another cruise." The sisters also remember Romie spending hours at the porthole, watching the islands pass in and out of view. But though Romie and Nanette were vacationing on their Caribbean cruises, he didn't lack a critical, if good-humored,

perspective on their activities. Harry Henderson: "Romie came back from one of those cruises. They went down to Aruba and other places, and he came back and he said, 'You know, Harry, there are people on those boats, you know, they don't have any idea of where they are. They just keep going around the world on them. And they're all drunk.'"

Bearden's more personal involvement in the Caribbean came with the decision, around 1970, to build a house on Nanette's family's land. Her parents, who had raised their family in Staten Island, were so young when they left St. Martin they didn't even know where their mother's house had been, but her father's father, Joseph Rohan, whose own house had stood at the foot of the road in the district called French Quarter, left property for them all. For two years, beginning in 1971, they oversaw the frustrating project of house

12. Keeping fit. *Photographer Frank Stewart.*

1. In fact, Bearden claimed that it was McKay who urged him to get back to his roots and paint his childhood memories of Mecklenburg County. "[I] still didn't know what to paint till one day Claude McKay came to the studio and said, 'Why don't you paint your life in North Carolina?' – That gave me a start."

2. "By 1930, almost a quarter of Black Harlem was of Caribbean origin" (James 1998:12).

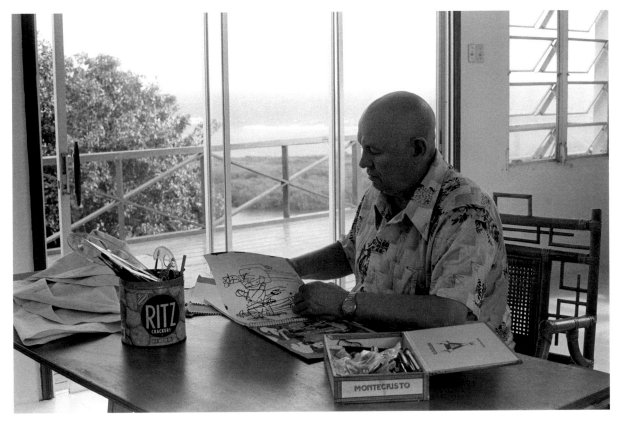

13. In the St. Martin studio, 1983.
Photograph by Manu Sassoonian.

construction – in large part via letters to and from New York. By early 1973, it was nearly finished. Louis Brooks ("Brooksie"), a friend of the Beardens and their habitual driver, had not had the benefit of much schooling, but took pen in hand to keep them up to date on its progress:

Dear Nanette by this you will lone that I have reciev your welcome letter and I was very glade to hear frome you & also glade to here you all was fine ... I reciev 6 more coconut & the all is planted plust evry thing that was plant is plant, but this I whant to be shoer of did you tell just that you whant any mango tree in fronth ... what abouth my good romie ... you just lette him no that yhou all have a good friend here in st martin which is me & a very faith fold one...

By summer of that year, the Beardens and their cat were still staying in a St. Martin hotel, waiting for the arrival of a home generator for their electricity. Bearden wrote dealer Arne Ekstrom that

The house is finished and looks quite handsome – and the view Mr. E. across the open sea with the plunging breakers – is worth our selection of the site, alone. ... I can't say I've been your most energetic artist, either in thoughts or actions: but I've read about 6 books, and having accompanied Commander James Bond half way around the world, I'd really like to do just a small watercolor, and if I can get some down here, I'll get started. |▶12|

When all was finally ready with the house, Bearden realized that he'd need a separate place to work. "If you have your studio right where you live, you're always jumping up at night: you want to paint, and you start wrecking things. ...I would do a small collage, or a watercolor, because the space I had to work in there, until I got the studio finished, would not be conducive to working in oils – on my wife's tile floor!" The "studio," at the top of one hundred-plus steps, became Bearden's workplace for part of each year during the final, and most productive, fifteen years of his life. |▶13| As Walcott said of the move,

"You change your anchor from putting it down in that base, to putting it over here."

The St. Martin where Nanette and Romie built in the early 1970s still resembled the place that Nanette's parents had left in the early 1900s to make a new life in New York. But a decade of "development" was fast transforming the once-sleepy island into the fourth largest tourist destination in the Caribbean. And continuing development during the next decade and a half, when the Beardens were spending a few months each year there, far outstripped what anyone might have imagined when they arrived.

St. Martin was settled in the seventeenth century by the Dutch, who gathered salt from the ponds using the labor of African slaves. At the end of the eighteenth century, it was producing 23 million kilos of salt per year for the North Sea fisheries. At the same time, the island's modest plantation economy was at its peak – some one hundred sugar, tobacco, and cotton plantations – with 1000 mainly Protestant Dutch and French masters, 7000 African slaves, and 1000 "colored" freedmen. The nineteenth century and the end of slavery saw a gradual economic and demographic decline, and the early twentieth century a large out-migration to the Dominican Republic (the cane fields), Curaçao (the oil refineries), and the varied opportunities of the United States. By 1960, only some 2000 people – largely women, children, and the elderly – remained on moribund St. Martin.

But during the early 1960s capital, largely from the United States, began streaming into the island, much of it from investors (including mob/gambling interests) who had recently been chased from Revolutionary Cuba. Sudden tourist development brought a land rush, drug trafficking, money laundering, and large-scale immigration from neighboring islands to staff the burgeoning construction and hotel industries. "It is a goldrush, just like in the Klondike," wrote a worried Dutch civil servant in 1971, noting that there were suddenly five major casinos in operation. The next year, *Fortune* magazine featured an article about "La Belle Créole," a still-unfinished hotel-casino characterized by the ultimate in excess – Italian-marble bathrooms, Spanish terra-cotta floors, a broad Mediterranean-style plaza paved with hand-chiseled limestone, and rooms with gilded mirrors, furnished in styles ranging from Louis XIII to Louis XVI.

When Romie and Nanette moved to St. Martin, these developments were gaining steam.

There were already some 10,000 residents, most of them recent immigrants, on the half-Dutch, half-French island. English was the most-widely spoken language, the U.S. dollar was the standard currency, and the whole island – with no border controls between the Dutch and French sides – was a free port. By the time Bearden died, the island population numbered some 80,000, of which more than two-thirds worked in the tourist industry – and one million tourists were visiting the island each year. As one knowledgeable observer put it, "Visitors to St. Maarten since 1970 have seen it transformed from a quiet islet of small hotels to a mammoth beach resort where New York accents, traffic jams, and sanitation problems prevail."

Romie and Nanette, high on their hillside, could to some extent look past these problems. But Bearden was concerned about the ecological degradation he saw around them. In the days before development, a visitor described one of Bearden's favorite places, Oyster Pond (which people in St. Martin claim was the inspiration for *Purple Eden*). |▶14|

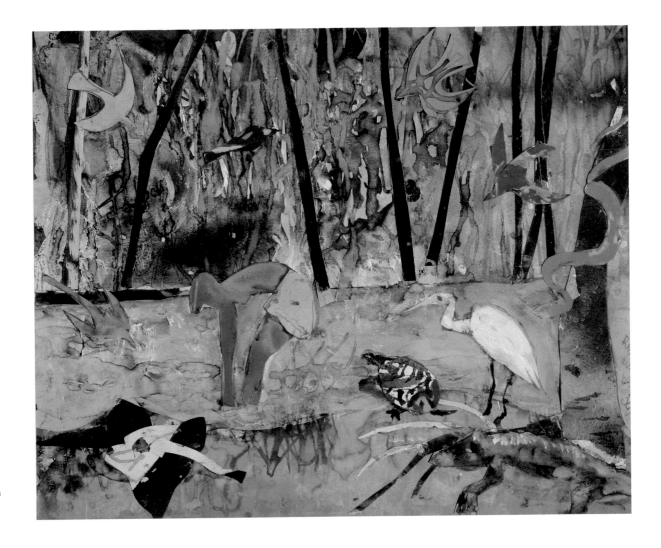

14. *Purple Eden* (1987). Watercolor and collage, 10 ½ × 13". Collection of Fabian Badejo, St. Martin. *Photograph by Carlos Lippai.*

"I remember walking over to Oyster Pond, a little idyllic bay connected with St. Barthelemy Channel via a narrow inlet. It was situated in the middle of steep, rocky country with exuberant vegetation. The waters of such bays were so limpid as to make the bottom visible. We saw small fish and crustacea in fantastic colours at great depths."

But by the 1980s, we hear instead that the island's several ponds have become subject to "dumping and piping in of sewage, waste material and oil; the cleaning of cement, dump, and septic trucks; and the clearing of the shore vegetation." And when the two of us visited Oyster Pond in 1999, we were approached by a young French tout who tried to interest us in one of the multistorey time-shares that had come to surround the place and cut off the view of the sea; he pointed to adjoining Dawn Beach, recently acquired, he said, by Bill Gates,

and high above, to a massive villa topped by a heliopad, which he said was a vacation house owned by Sylvester Stallone. Bearden apparently had his own ideas about the neighboring L'Etang des Poissons (Fish Pond), which he could see down below his studio, once telling his friend Fabian Badejo, "You know you can farm fish in that Pond that can feed the whole island and still leave a lot more for export to the other islands."

On several occasions, Bearden expressed himself, with a blend of resignation and humor, about St. Martin's runaway development. In a 1984 letter to Arne Ekstrom, he noted that "The island is still nice, but the French (European & Algerian) have discovered it and the building of more hotels and ninth-rate French (Nouvelle Cuisine) restaurants continues. Well as the old spiritual goes – 'Lord, there aint no hidin' place.'"

Around the same time, he complained to June Kelly that the "French restaurants with that foolish translation of the 'nouvelle cuisine' will turn anyone off – All decoration and you need a microscope to find the food." And a letter of the following year explained that

St. Martin was sparsely populated when I first came here, but now it is going through a steady pilgrimage of tourists. Of course, there is the constant clearing of land and of building to accommodate the visitors. But

15. Rusty and the lizard. Fragment of a 1980 letter to June Kelly. *Courtesy of June Kelly, New York.*

unlike Chaucer's pilgrims, I'm afraid most of our modern day voyagers head for the beaches by day and the roulette tables by night.

Art too, Bearden felt, would suffer from such development. "Most great art comes from where there's flowing water that's not polluted. ... The energies of flowing water have to do with the energies of art. You can't work in a polluted situation."

By the mid-1970s, the Beardens were spending four or five months each year, divided between a couple of visits, in their new island home, leading relatively quiet and private lives there. (They usually came down from January to mid-March and then again from mid-July to the end of August.)

Their cats – first Gypo, then Rusty (short for "Rustropo-

vitch," according to Nanette's sisters, or Rustum, the mighty Persian hunter, according to Schwartzman), then Mikey (Michelangelo) – always came along. They regularly accompanied the couple on their Caribbean cruises and Bearden once booked a separate stateroom for their two cats (and hired someone to look after their needs) on a transatlantic voyage on the *France*. "Nanette, come feed your cats," he would say playfully. But clearly, he doted on them himself. In a letter to June Kelly, he reported that "Rusty just caught a little lizard in the plants. Cats are so patient, he's been waiting 2 weeks for the lizard to get careless." |▶15|

16. *Mt. Celine* (n.d.). Watercolor. *Photograph courtesy of Romare Bearden Foundation.*

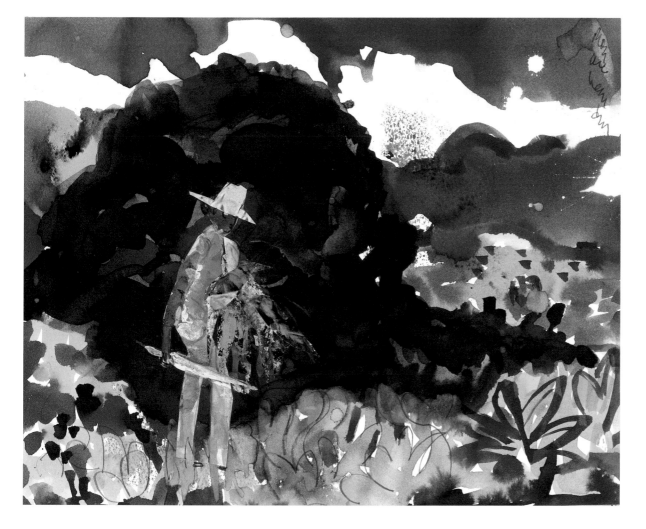

17. *Sailing St. Martin* (n.d.). Watercolor with collage, 10 × 15½". Collection of Marty and Gloria Lynn, St. Martin. *Photograph by Marty Lynn.*

During this period, the great bulk of Bearden's Caribbean work was landscape-inspired – beaches, mountains, sunsets, sailboats, flowers |▶ 16, 17|. But by the early 1980s, he began to engage social realities – from Obeah to Carnival – as if he were gradually coming to grips in his work with the human element in the island. A story he told in 1983, ending with his "energy" mantra, captures some of these concerns.

Several years ago I was on a boat about four miles off shore when two young girls came out in a kind of canoe that might have been made out of a log. The younger child, five or six years old, constantly baled out the ocean water. The older child, nine or ten, swam over to our boat in waters of the shark and barracuda. What energy and vitality! I constantly see this in the island dances, the way men put together a stone wall, in the stride of the island people, in the imaginative use of language. The elements in the islands are so over-whelming that even the most ordinary response is an acknowledgment of it all. If a person simply stands on a rock that person's relationship immediately coincides with the elemental forces of sky and sea. And from this fusion of forces will come creation. Art will always go where energy is.

By the early 1980s, the Beardens seem to have stepped out into St. Martin society, begun participating in local cultural affairs, and significantly enlarged their circle of local friends and acquaintances. It is from this period that many of the St. Martiners who remained close to them date the beginning of their friendship. And they were a varied lot.

Josianne Fleming was a cultural organizer and wife of the mayor. Nanette's father's cousin, R. Motius Rohan ("Moti") played the concertina. |►18| Poet Lasana Sekou was a politically impassioned undergraduate at Howard. |►19| Uncle Oswald raised goats. |►20| Artists Gloria and Marty Lynn had left a fast-lane life in Manhattan to recapture the idealism they'd known in the 1960s. |►21| Louis Richardson owned a magnificent estate in St. Martin's rich central valley. "Ma" Chance had a creole restaurant in a north-coast fishing village. |►22| Ruby Bute, from Aruba, was a divorced mother of two who dreamed of opening an art school. Roland Richardson nurtured political ambitions and made etchings of historic buildings. |►23| Fabian Badejo, a Hausa from Nigeria, directed the Council of the Arts. |►24| Cynric Griffith, the island's

first professional artist, was from St. Kitts. Painter Lucia Trifan was from Romania. And Mosera, from the island of St. Lucia, was a dreadlocked Rasta who painted for a living.

Bearden's friends, in the United States as well as St. Martin, stress that he was a gregarious man, always happier when he had people around to talk with. And he often brought American friends down to the island. |►25| He sometimes described "driving" to this or that part of St. Martin, but neglected to mention that he didn't do the driving himself, preferring observation and conversation. As Frank Stewart recounts, "He was an artist, I was aspiring to be one. He was a willing teacher, I an eager student. But most important of all, I was a driver, and he loved to ride. He claimed he could never drive a car because he would always be running people over

– architecture, nature, and people would distract him from the task at hand."

Otherwise it was Louis Brooks, |►26| a gregarious friend of the family and the proud father of several dozen island children, who did the honors, abandoning his local taxi service during the Beardens' stays in St. Martin to become their full-time driver. As Frank and Brooksie point out (and no one else who knew Bearden fails to mention), he was an irrepressible raconteur, bursting with stories that could go on as long as there was someone listening. Derek Walcott remembers:

Romare telling a story was *fantastic.* I know the great one he told about being on a schooner sailing the islands. He told of how the boat went adrift, and then he described the cargo, the pigs, the sailors, the people on board. ... Oh God, if that had been taken down verbatim – I mean the sentence structure of the narration! Romare's genius had as

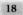

18

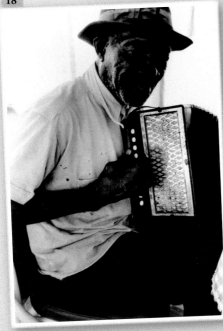

20

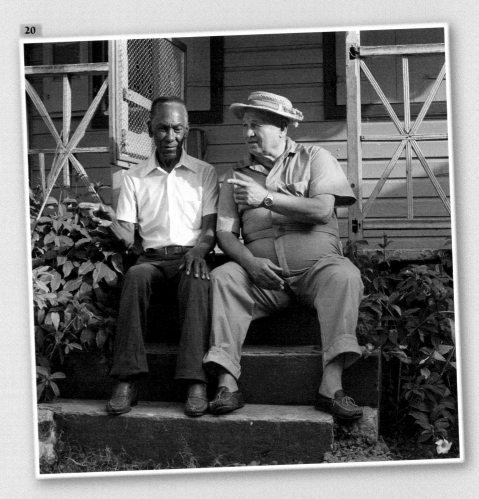

21

26

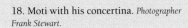
18. Moti with his concertina. *Photographer Frank Stewart.*

19. Lasana reciting, Clara Reyes dancing at CARIFESTA VI, 1995. From *St Martin Massive!*, p. 87.

20. With Uncle Oswald, 1983. *Photograph by Manu Sassoonian.*

21. Marty and Gloria Lynn, 1993. *Photograph courtesy of the Lynns.*

22. With Ma Chance, 1983. *Photograph by Manu Sassoonian, courtesy of Romare Bearden Foundation.*

23. With Roland Richardson, 1983. *Photograph by Manu Sassoonian.*

24. Fabian Badejo. *Photographer Frank Stewart.*

25. With Richard Long. *Photographer Frank Stewart.*

26. Brooksie. *Photographer Frank Stewart.*

24

25

22

23

19

much to do with his verbal ability to tell a story as his "scissors" ability to tell a story. ... A sentence by Romare telling a story would be like reading a terrific short story.

Gossip, too, says Frank, "but it had to be good gossip. After all, he did come from the South, where they say, 'You carry a bone and you take a bone,' but in his case it had to be a bone with some meat to it."

While in St. Martin, Bearden enjoyed living life to the fullest, whether working, swimming, cooking, or reading. Nanette's sister Dorothe confided, "He loved food! They *both* loved food. Always cooking. Both of them. And Romie would bake pies." But they also ate out often, and as Bearden liked to say, his favorite spot was Ma Chance's on Grand Case Beach. In the early eighties, on the suggestion of June Kelly, Bearden collaborated on a book – *Ma Chance's French Caribbean Creole Cooking*

– for which June gathered and arranged the recipes and he made the sketches that open each section. In a description of the restaurant, which he wrote as a warm-up for the book, Bearden evoked the ambiance:

The finest creole cooking on the French side of the island of St. Martin is found in the home of Mrs. Leon Chance – Ma Chance as the sign over her gate indicates. This vigorous lady lives in the gentle little village of Grande Case, whose one street follows the meandering northwest shoreline of St. Martin, on this green and mountainous Caribbean island. ... |▶27|

In order to eat at the Chances you must call in advance and she will discuss with you what you would like to eat, so that the conversation is something more than just making a reservation. Ma Chance's home is efflorescent with splendid tropical plants. One can rest in lounge chairs on the verandah and look out at the blue Caribbean and the neighboring island of Anguilla, resting like a green snake on the horizon. Once inside, the long, spacious living room is furnished in a manner that can only be described as "le

27. *Ma Chance* (1983). Watercolor, 10 × 6". Collection of June Kelly, New York. *Photograph by Becket Logan, courtesy of June Kelly Gallery.*

style Mere Chance." In the front of the room, large antique chairs and several long couches are decorated with pillows and doilies crocheted by Mrs. Chance. Dolls half life-size, in island costumes, turtle shells, figurines, lace curtains, old cut glass, a mirrored wall, make a most individual though comfortable island setting. Mrs. Chance usually seats her guests, on their arrival, in this area, serving them her home made rum punch in delicate ruby red glasses.

At one end of the room, there is a long table, with a complete formal service for a sumptuous Ma Chance meal. During the course of a meal, which is served by young ladies trained by Ma Chance, the hostess will herself explain the nature and origin of her various dishes, especially the particular French Creole variations that she has prepared. Since Mrs. Chance has been cooking actively for some fifty years and has trained a number of cooks in her kitchen, she enjoys telling about the nuances of her dishes and how they came into being. Mrs. Chance recalls as a young girl how most of the native families cooked out of doors using fire bricks and charcoal, made from certain island twigs that give a hot almost smokeless flame. Mrs. Chance helped her mother with the meals, some of the methods of which were carryovers from an African heritage. It was the interfusion of native cooking with traditional French cuisine in St. Martin, Guadeloupe, Martinique and New Orleans, in particular, that lead to what is called French Creole cooking. |▶28|

28. Drawings made for *Ma Chance's French Caribbean Creole Cooking* (Chance 1985). *Courtesy of Romare Bearden Foundation.*

29. Fragment of letter to June Kelly, 1986.
Courtesy of June Kelly, New York.

Bearden's letters from St. Martin show that he was also a voracious reader and used books as a springboard for reflections of every kind. Rare is the letter to friends in the States that fails to offer his thoughts on a recently devoured book or two, whether English mysteries ("where the detective Sir Somebody or other has to apologize to Lord What/his/name for aresting him for the poisoning murder of Lady You/name/her"), Joseph Conrad's *Nostromo* ("a hard going, absorbing novel, once you get into it – greed, avarice, bribery, violence in a South American country (maybe Columbia) in the late 19th century – the nature of evil, I suppose"), or a novel given to him by a local French artist depicting "the eventual triumph of Woman's Liberation, in a kind of Lady Amazonian world, in which men are false no gooders, all of whom are to be kept in line by ... the French converts (naturally) of the American group for Men's annihilation."[1] Frustration at his less-than-perfect command of the French language, a remnant of his time in Paris, never prevented him from making the effort. On this particular novel, for example, he notes

a lot of very detailed descriptions of the sexaul preferences of the converts, if that's the rite word. Unfortunately again, my french is not able to draw all the needed substance of of these sections that might have made the day for the ole voyeur. Then there is a whole lot about linguistics and Marxism, which the French seem to have rediscovered.

And he continues, reaching past the Lady Amazonian world for larger reflections on cultural difference:

The French intelectual can take a theme an improvise so brillantly on it. We are amused, but there is a lack of structure and revelation. They should study some of the great jazz viruosos like Charlie Parker, and Earl Hines and learn how to do this. But then there are so many, many sytems of thought that's now leveled on our shoulders that it makes original thought very difficult indeed.[2]

Or again, he displayed his catholic tastes, and his critical eye, in a 1986 letter to

30. The Beardens at home in St. Martin, 1984. *Photographer Frank Stewart.*

1. What Bearden refers to in this letter as "lite mysteries – dignified English ones" is a genre known as the "country-house mystery" or just "the cosy"; see W.H. Auden's classic essay, "The Guilty Vicarage" (1948) about these detective novels set in upper-middle-class country houses between the wars. Bearden doesn't mention titles, but he could have been referring to such works as *Trent's Last Case* by E.C. Bentley, *The Red House Mystery* by A.A. Milne, some of the novels by Dorothy Sayers and Josephine Tey, many Agatha Christie novels, or anything by Patricia Wentworth. He does specify the French novel – Philippe Sollers' *Femmes* (1983), a misogynistic roman-à-clef about the author's cavortings with feminist thinkers, including his wife Julia Kristeva. Some of these letters were written in pen, others on a manual typewriter. (We are grateful to Leah Price for providing the literary background.)

2. After pecking out this letter to Arne Ekstrom on a manual typewriter, Bearden added in handwriting: "All misspellings & rotten grammar is yours for free."

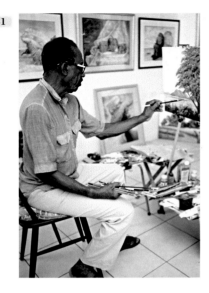

June Kelly. "Have read a lot of wonderful mysteries by Simenon – he's more than just a mystery story writer – an incite ful, & brilliant writer – who wastes not one word. 'The Street of the Crocodiles' by [Bruno] Schultz (late Polish writer) is beautiful & lyrical." |▶29, 30|

By the early 1980s, according to his friends, Bearden was becoming a magnet for cultural energy on the island. He encouraged and helped pull together the small group of people who painted professionally. Pioneer Cynric Griffith ("Griff"), had arrived from St. Kitts in 1956 and was still active in 1999 when we visited him in his small kitchen that doubled as a studio. Roland Richardson, a political and cultural activist (and son of Louis Richardson, whose Colombier estate Bearden often visited), had begun his artistic career with etchings, but gradu-

ally shifted into colorful oils during his years of friendship with Romie, and now maintains galleries in St. Martin and Florida. Two younger artists arrived from other Caribbean islands – Ruby Bute (whose parents were from St. Martin) arrived from Aruba in 1976, and Ras Mosera came from St. Lucia in 1984. Both are still painting professionally today. And there were several expatriate European and American artists, including Marty and Gloria Lynn, who received the gift of Bearden's art supplies just before he left the island for the last time. |▶31, 32, 33, 34|

In 1982, Fabian Badejo organized SMAFESTAC, a St. Martin cultural festival modeled on one he had seen in near-by Nevis, and Bearden made several public appearances. Three years later, Nanette moved the small gallery she had established at René Florijn's restaurant-arcade to Front Street, the main shopping

31-34. The "big four" of St. Martin painting (as a recent book described them): Cynric Griffith, Roland Richardson, Ruby Bute, and Ras Mosera. The recently refurbished Arrivals Hall of St. Martin's Princess Juliana International Airport now features works by the first three artists. *Photographs by Manuel Diego van der Landen.*

street of the island, and Bearden began helping her put on a show or two a year, selling a number of watercolors, with the idea of benefitting the dance company she directed.[1] In the summer of 1987, despite failing health, Bearden was actively involved in St. Martin's Festival of Culture Under the Sun (FOCUS), for which he designed the official poster. |▶35, 36| During the ten days surrounding that festival, the Beardens hosted Derek Walcott and his wife Sigrid, who had come for a performance of Walcott's *Pantomime*. |▶37|

Thinking back to those days, Josianne Fleming remembers Bearden as "very unassuming, always in his overalls, even in the biggest receptions." But he pulled together people in the arts as no one has since. Badejo recalled:

Each one, whether you were in the arts, in drama, in whatever it was

that you did, you saw in him a father figure, and somebody who had very interesting points of view to bring to your work. He could critique a play as if he was a playwright himself. And he had almost a fatherly manner, you know. ... So when he was here, he brought us all together. ... at that time, you knew what everybody else was doing. ... You knew you were going to meet again with Romie and that he was going to ask what've you been up to. ... He took a lot of interest in each one's development. ... He had that kind of magnetic pull. Since he's no longer there, everybody's a satellite on your own now, just doing whatever, without any kind of interconnectedness.

Bearden actively encouraged these younger artists. Badejo reminisced with a chuckle about how Bearden pinned Roland Richardson at a time when he was running ragged from juggling his work in the tourism office, management of a local magazine called *Discover*, a budding political career, and his painting ambitions. "Roland was getting ready to enter political life. Everyone

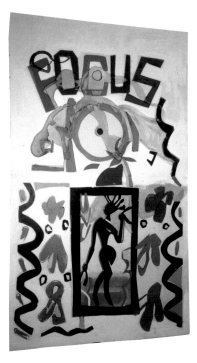

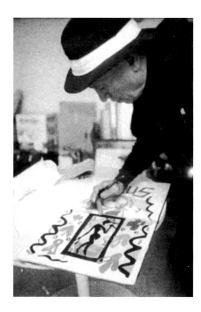

35. Bearden's design for the FOCUS poster, 1987. *Photograph courtesy of Romare Bearden Foundation.*

36. Working on the FOCUS poster, 1987. *Photographer Frank Stewart.*

was thinking he's going to run for mayor or something. Bearden would ask Roland: 'Do you want to paint or do you want to do something else?' And Roland would say, 'Yeah, I wanna paint.' Bearden would tell him, 'Well, then: PAINT!!'"

And Ruby Bute described how he'd encourage her own painting:

Romare, when he come down, he would visit the shows with us. And we used to chat. Sometimes I would sit down with him and ask him questions. And he'd show me how to have courage. ... Romie, he was the father. To me he was the father figure of us. And he started to show us how to work upside down. How to

37. Derek and Sigrid with the Beardens in St. Martin, 1987. *Photographer Frank Stewart.*

put a work upside-down, which was new for me. I never know that. There was this big famous man with us, in a big yard in front of the cultural center, and everybody was trying to grasp what he was teaching. ... I was very shy at those times, shy about coming out, and showing my work. But he used to tell me, "Do it! Show your work!" [Then her voice turned dreamy:] But what I had liked about the man is his appearance! Romare Bearden was a man that you could a see a saintly look. He was big. He had a kinda roun' look – his head roun', shaved clean, a cute big round ol' face, his body roun', and he used to wear these kinda overalls, big overalls, so everything about him is roun'. And everything about him is

light. His skin complexion was light, had a big overall, it was soft, light blue. So he was something special for me, you know. He had a purity about him.[1]

Ras Mosera, whose work was also influenced by Bearden, spoke repeatedly of his personal style:

What impressed me about him was his nonchalance. He had this carefree way about him. He's got this obsession about the Caribbean, as being the place of new energy in the Americas. He said, "You know the artist Gauguin?" I said, yes I know the artist Gauguin. "Well, I think

you should do like Gauguin and own the Caribbean." I said, How? He said, "No, I mean, you got a chance, you're younger than me, and I think you should try to own the Caribbean as Gauguin did in Tahiti." He made you feel relaxed. ... He was 74 years when I met him. But there was not this generation gap. ... He had an identity, he was comfortable, you know. He was relaxed.

And René Florijn, who owned the Poisson d'Or restaurant and was the first to exhibit Bearden's paintings locally: "He was a simple guy, always walking around in his overalls. Down to earth in every way. He was not a young man when I knew him. He was already in his seventies at the time. But he had a vitality when he talked, like he was a young guy. And he was joyful. Like life had no end."

Bearden's generosity became as legendary in St. Martin as in Harlem. (As Al Murray told us, "He'd see a guy he hadn't seen in fifteen years, and he don't

1. Walcott spoke to us about Bearden with similar love.
"Romare, he was like a Buddha. He sent out a kind of Buddhist vibrations. He was very centered, very pivoted. And he spoke with great humor. The love that you felt for him was astounding. ... There was something central in what he had seen and what he knew. I was sometimes eager to ask him questions that weren't important, like 'Did you know Matisse?' 'What was Picasso like?' – the kind of shit you might ask a very famous person. And

then you felt before you asked it, 'This is of absolutely no consequence!' So you didn't ask it! (I have some very famous friends. ... I might ask Arthur Miller, 'What's Gable like?' and he'd tell me, y'know. But you didn't need that with Romare.) That's what he had – this astounding centrality. Some quiet that was there. And when anybody mentions his name, young or old, when they talk about him, 'Romie' or 'Romare' ... It was not a saintly thing. It was like a human thing, the humaneness that he had." (interview 8/17/00)

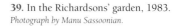

even like the guy, and the guy'll come up and he'd say, 'Good to see you, man,' and he'd hand him fifty dollars.") Lasana Sekou describes returning to the island in 1984, at the end of his graduate studies at Howard University and reciting (as a guest artist at a Paul Keens-Douglas performance) what he says "might have been considered radical or revolutionary poetry at that time in St. Martin." A week or so later, Bearden appeared at the newspaper office of Lasana's brother, Joseph, with a watercolor for the young poet – a fluid work incorporating fragments of the poetry that Lasana had read that evening. Bearden wrote on the painting:

Romare Bearden / for the young
/ Poet / Lasana / Sekou!
Hail he
who took you back
took you home...
on rooted thought

Seated you in the village of
Juffere
Bid you sit with Kinte Clan
revitalize your spirit
and move onward.[1]

Louis Richardson showed us a gift in response to the afternoon Bearden had spent on the Richardsons' patio, surrounded by a profusion of plants – *Flowers Around the World*, a watercolor-and-collage map with tiny, labeled images of the flowers native to different regions. |▶38, 39| Josianne Fleming told a similar story about *Josie's Sunset* hanging in her front hall – a spontaneous gift made days after Bearden had sat enraptured on the Flemings' verandah watching the sun go down. |▶40| And in 1986, while visiting an exhibit in Nanette's Front Street Gallery, she was surprised to find a study of her fourteen-year-old daughter, who looked much younger to her in the painting – Bearden hadn't

mentioned it to her, though he later told her simply, "This is my vision of this child." |▶41, p. 72| Fabian Badejo, who had a background in Caribbean literature when he arrived in St. Martin in 1980, laughed as he recounted how he'd never heard of Bearden when first introduced a year or so later. "But from that moment on, it's like I've known him all my life." The two spent countless evenings together, arguing philosophy, politics, art, and the state of the world, and listening to jazz in a club on the French side.

Oh yeah, he thought [local saxophonist] Bobo Claxton was another, you know, John Coltrane, hiding

38. *Flowers Around the World* (n.d.). Watercolor and collage, 15 × 20". Collection of Louis and Cynthia Richardson, St. Martin. *Photograph by Alexandre Julien.*

39. In the Richardsons' garden, 1983. *Photograph by Manu Sassoonian.*

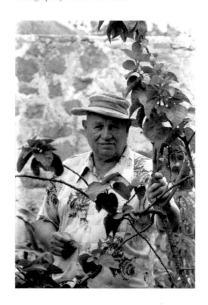

1. The verse is from "Poem To Alex Haley" in *For The Mighty Gods... An Offering*, by Lasana M. Sekou (New York, House of Nehesi, 1982).

40. *Josie's Sunset* (early 1980s).
Watercolor, 8 ¼ × 10 ¼". Collection of
Josianne Fleming, St. Martin. *Photograph by
Carlos Lippai.*

42. Bobo Claxton. *Photographer Frank Stewart.*

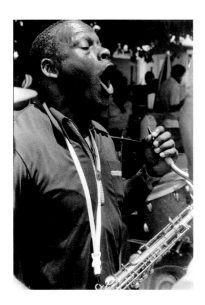

somewhere here. |▶ 42| He was a
member of the group called "Superfly
Brothers." There were about four of
them, played all kinds of music,
played jazz too. And there was Bobo
Claxton on the sax. And oh, boy.
Bearden used to like to sit down there,
all evening and have some drinks and
just listen to those guys play. And
those guys would come over to the
table and just talk and talk. As a mat-
ter of fact those guys used to go over
by him, up at his studio. I met them
up by him a couple of times. Bearden
was that kind of person who every-
one took to very easily.

Fabian became a regular
reviewer of Bearden's local exhib-
its for *Newsday*, an island news-
paper. One exhibit included
some portraits.

I found them very very very intrigu-
ing. The moods – very very special,
different. And so in reviewing it, I
zeroed in on the approach that he
was using in those portraits. And
then the next thing I see, I get this!:
"Santo Domingo Woman." He had
had it framed; it was wrapped. And
Nanette called me aside and said,
"Romie has something for you." So
I saw this huge big wrapping, and I
said: Wow! "Just take it, take it. Go!,"
she said. I was speechless. ... That's
an original watercolor. I should have
written more reviews, right?

Fabian was touched both by
the subject and the approach:
"At that time, being a Santo
Domingo woman meant that
you were a prostitute. You can
see Bearden's humanity in the
painting. He *understood*." |▶ 43|
At the time Bearden painted his
Dominicana, the several brothels
of St. Martin, grouped on a hill-
side above one of the island's
prettiest marinas, were *the* place
where prominent men gathered
to wheel and deal – about poli-
tics, real estate, tax-free invest-
ments, money laundering,
and drug trafficking. Since the

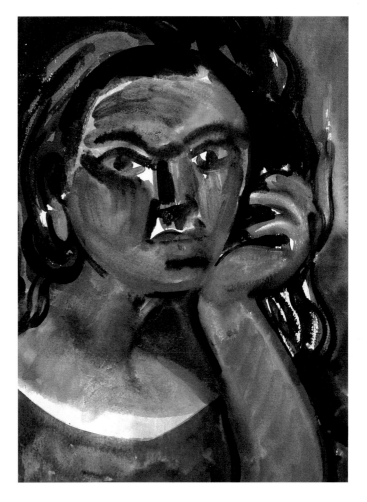

43. *Santo Domingo Woman* (early 1980s).
Watercolor, 13 ½ × 9 ½". Collection of
Fabian Badejo, St. Martin. *Photograph by
Carlos Lippai.*

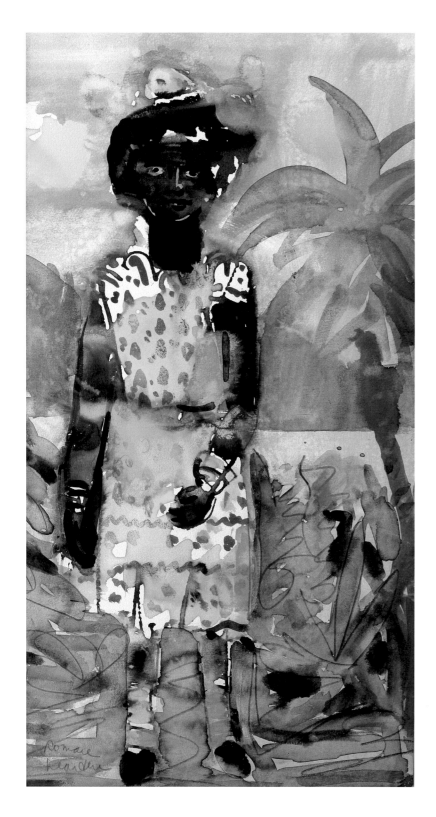

41. *Claudelita* (ca. 1986). Watercolor, 21¼ × 11½". Collection of Josianne Fleming, St. Martin. *Photograph by Carlos Lippai.*

1970s, when they replaced the Haitian women who had staffed the brothels, Dominican women were appreciated both for their light skin and their attitude – "They make you feel like you are a god," said one habitué. Bearden's painting, in which one can read both the suffering and the humanity of the Dominicana, speaks to a brutal Caribbean reality. In 1985, not long after it was painted, a container from the island of St. Thomas bound for St. Martin was opened in Puerto Rico. In it were found the bodies of twenty-eight suffocated Dominican women.

The Walcott Collaboration

In the late 1970s, Bearden embarked on a collaboration with Derek Walcott. Published in 1983 by the Limited Editions Club in New York, *The Caribbean Poetry of Derek Walcott & the Art of Romare Bearden* is a sumptuous quarto volume, composed of Bearden's personal selections from six books (and twenty years) of Walcott poetry, accompanied by eight monoprints, of which two are full-page and six are two-page spreads. |▶ 44, 45, 46| The cloth covers – which required fifteen hand-cut separate silkscreens to produce – were designed and signed by Bearden, |▶ 47| and each copy of the book includes one of eight different, detached, lithographs, pulled in an edition of 250.[1] |▶ 48| Each copy of the book is numbered and signed by Bearden and Walcott. The introduction, about Walcott – later published as a separate essay in the *New York Review of Books* – is by Nobel Laureate Joseph Brodsky.

Al Murray maintains that Walcott was not Bearden's (or, at least, Murray's) first choice for the project.[2]

1. Our personal copy has 95/275 pencilled on it, suggesting that the 250 claimed by the Limited Editions Club was slightly raised by the Blackburn Studio, which printed them by hand. For an illustration of another of the eight lithographs, see R. Fine 2003:123.

2. In telling us about it, Murray puts himself front and center – where he may well have been, at least at the very beginning.

44. Untitled frontispiece, *The Caribbean Poetry of Derek Walcott & the Art of Romare Bearden* (Walcott and Bearden 1983). 12 × 9 ½". Collection of Richard and Sally Price, Martinique.

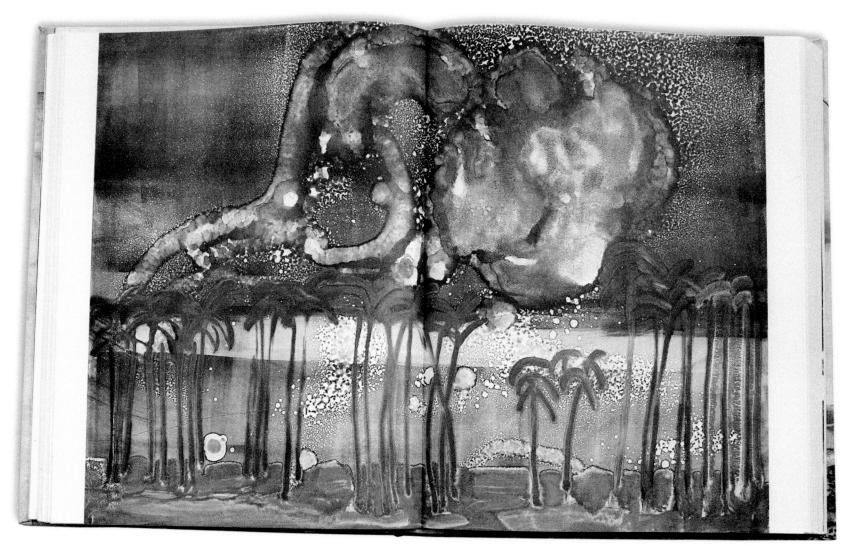

45. Illustration for excerpts from
Walcott's «Another Life,» *The Caribbean
Poetry of Derek Walcott & the Art of Romare
Bearden* (Walcott and Bearden 1983).
12 × 17 ¼". Collection of Richard and
Sally Price, Martinique.

2000 copies of *Poems of the Caribbean* by Derek Walcott—selected and illustrated by Romare Bearden—have been printed for the members of The Limited Editions Club. The book was designed at the offices of The Limited Editions Club. The text was set in Monotype Bembo by Michael and Winifred Bixler of Boston and printed by The Anthoensen Press, Portland, Maine. The artwork was reproduced by the Seaboard Lithograph Corporation, New York. Romare Bearden created eight original lithographs which were hand-printed on Rives paper at the Blackburn Studio, New York. Each book contains one lithograph; the edition size of each lithograph is 250. The binding material was designed specially for this edition by Romare Bearden and was executed at Ratti d, Lake Como, Italy. The book was bound by Robert Burlen & Son, Hingham, Massachusetts.

Copy number

1879

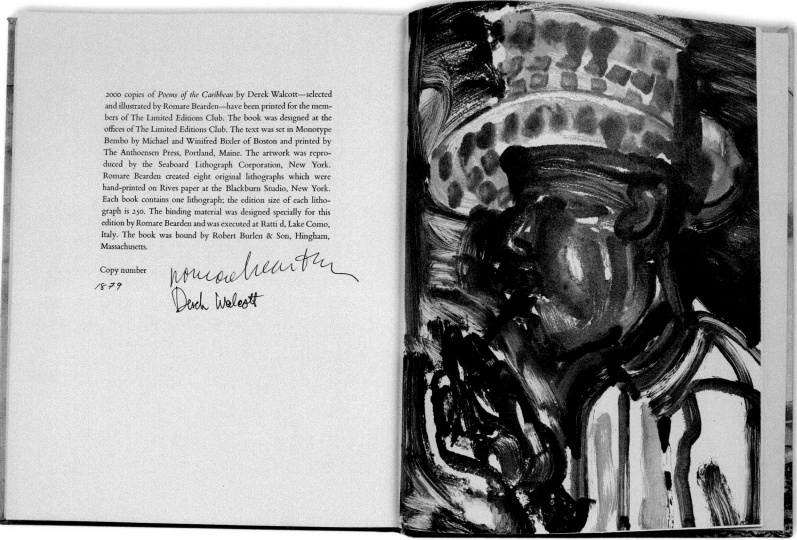

46. Untitled finis page, *The Caribbean Poetry of Derek Walcott & the Art of Romare Bearden* (Walcott and Bearden 1983). 12 × 9 ½". Collection of Richard and Sally Price, Martinique.

47. Front cover of *The Caribbean Poetry of Derek Walcott & the Art of Romare Bearden* (Walcott and Bearden 1983). 12 ½ × 9 ½". Collection of Richard and Sally Price, Martinique.

48. Papaya tree, untitled lithograph from *The Caribbean Poetry of Derek Walcott & the Art of Romare Bearden* (Walcott and Bearden 1983). 12 × 9¼". Collection of Richard and Sally Price, Martinique.

Romie was always playing around with literary stuff, which is why we had such a pleasant time together. There was always something that we shared an interest in, and I was his guide, 'cause I was more accessible than Ralph [Ellison]. I spent more time going to bookstores with him than with any of my writer friends. And he spent more time looking at pictures with me than with any of his painter friends. He was breaking down that stuff for me. And I would break down the literary stuff. We would talk about Kafka. We would talk about existentialism.

When the Caribbean book came up, I was into Perse, and then you know Braque did that thing. [He shows us an English-language edition of Saint-John Perse's *Oiseaux*, with four prints by Braque.] There were two chic bookstores on Madison Ave – one was Books & Company, next door to the Whitney, a kind of British book store. And Romie and I used to go there – we were there just about every Saturday, discussing literary problems. We'd go see whatever shows, whatever galleries, and look at the Braques and look at the Cézannes at the Modern, and he'd want me to explain what Hemingway meant when Hemingway said...

Somebody – I think it was that girl who was working with him, June Kelly, decided it was worth doing

something about the Caribbean watercolors and notebooks and so forth. I was a sort of literary consultant. So: "What are we going to do about this Caribbean stuff?" I said: "Well, you got to frame it, you know," Through Paz and Eliot we got to Saint-John Perse. I wasn't in on the negotiation. I just had the concept – that he should do some responses to the poetry. Like the *Éloges* – that's great stuff! I didn't have to introduce him to that. He was just that sophisticated and he had that degree of catholicity in spades! He'd go out and buy two copies of everything and give me one. ... But they ran into difficulties with the Saint-John Perse thing because of copyrights.

So we thought maybe Conrad. We thought of H.M. Tomlinson. And what's that other name? William McFee who did the Conrad Argosy. I think he edited that. You know, they were post-Conrad people. Sea stuff. Island stuff. You see? It's all aesthetically connected.

But by the time Bearden had decided to do Walcott poetry, Murray was out of the picture, the two friends having had a personal falling-out that was to keep them apart for a good five years.[1] Walcott told us that

1. The incident that sparked the separation occurred sometime around 1980. Murray told us that they had planned to spend the summer in St. Martin working together on the final layout of a book called "Paris Blues Sweet" (text by Murray, pictures by Bearden, and photos by their friend Sam Shaw), but that the invitation for the Murrays to come to the island was suddenly withdrawn because Nanette had made alternative plans involving her dance company. Others who were close to Bearden have told

us different versions of the reasons for this estrangement, citing both problems over Murray's role in supplying titles for Bearden's paintings in the Cordier-Ekstrom Gallery and conflicts regarding the text of the Paris book, which in the end was never published. It was because of this painful break, during which Murray was deeply engaged in writing the autobiography of Count Basie, that the two were completely out of touch during Bearden's most productive Caribbean period. The day after the Basie book was published, Murray

said, he saw Bearden touting the book to his friends and giving them copies. Their friendship was back on track for the final three years of Bearden's life.

he himself played no role in the choice of poems, saying of Bearden that "In terms of intelligence, in terms of reading, it was wide and deep. Good, solid." Harry Henderson recalled that

Bearden was very happy to do that book of Walcott's poems. Unlike most painters, he had a tremendous background in literature. And even in 19th-century British poetry. He had really the background of a writer in many ways. And that was an important aspect of him – very unlike most artists. Most artists are artists or painters because they can't deal with words. They're blocked somewhere. But that wasn't true of Bearden. His knowledge of literature was deep, it wasn't cornball stuff.

Walcott and Bearden had first met sometime in the 1970s, at the Chelsea Hotel in New York, where "Charles," who manned the desk, thought they should get to know each other.[1] In 1979, Walcott used a Bearden collage – *The Sea Nymph* – for the dust-jacket of *The Star-Apple Kingdom*. In the following years, they bumped into each other at

cultural events a couple of times – once at a festival in St. Thomas, where Walcott claims Bearden's presence may have sparked the beginnings of his great poem *Omeros* (see "Reflections" pp. 229, 244) – and Bearden, who was deepening his intellectual ties with the Caribbean, had become a serious fan of Walcott's poetry. At the end of the collaborative volume, Bearden wrote an "Artist's Note," expressing appreciation of (and admiration for) Walcott's rootedness in the archipelago.

Much of Walcott's sense of being derives from the Caribbean locale that is crucial to his own language. He centralizes his art with this sense of place and history. The islands are a palimpsest with traceries of pirate and merchant vessels, of old houses and harbours, of fishermen in small boats, of British magistrates, of mango and papaya trees, and of ancient Caribbean faces almost obscured. He etches these things in his poems with clarity of form in a line that is firm, sometimes restrained, balanced, then again of sharp contours. The technique never intrudes on his pas-

sion, his anger, or his sentiment. The rhythms of the poetry in this selection, like the rhythms of this art, are inspired by the Caribbean.

Bearden was careful to point out that he was not "illustrating" the poems. Walcott agreed: "I think he was trying to do a feeling that was inside him." The publisher wrote that "the pictures are allusive, nostalgic, freely related to Walcott's verse yet truly independent works of art." Nonetheless, Bearden chose the poems in terms of what they meant to him. As Walcott reminded us, "it was Bearden who made the selection of poems to suit the painting that he was going to do." And he chose poems that were quintessentially Caribbean: from the magical opening pages of "The Schooner *Flight*" and the elegiac "The Sea is History" to the Homeric echoes of "Homecoming: Anse La Raye" and "A Map of the Antilles."

1. Walcott tells the story of their meeting in "Reflections on *Omeros*," p. 231.

Enchanted Places

During the final weeks of his life, Bearden worked on a collage he was calling *Enchanted Places* (which was eventually re-titled *Eden Midnight*). |▶49| This work, and its companion piece, *Eden Noon* (originally called *The Hundred-Animal Piece*), |▶50| drew on a thematic bundle he had been playing with for over two decades – scenes centered on a nude, a forest pool or stream, and a variety of fish, birds, and other animals. But his arrival in the Caribbean, and his continuing experiences in the islands, strongly influenced the development of both imagery and color in these works.

Bearden's Caribbean Aesthetic

Early examples of the "enchanted places" theme date from the 1960s. The figure in *Conjur Woman* (1964) is set against a background of collaged forest and birds, both distinctly non-tropical, and *Girl Bathing* (1965) includes a woman who is standing in a pool with fish, a wading bird and others flying, and a collage of vegetation – again without tropical allusions. Several works from 1970 reflect further exploration of this theme, but remain explicitly North American, by the inclusion of locomotives and rural southern houses, and the absence of tropical imagery (for example, *Memories*, |▶51| *Green Times Remembered [The Wishing Pond]*, |▶52| and *Cypress Moon*).

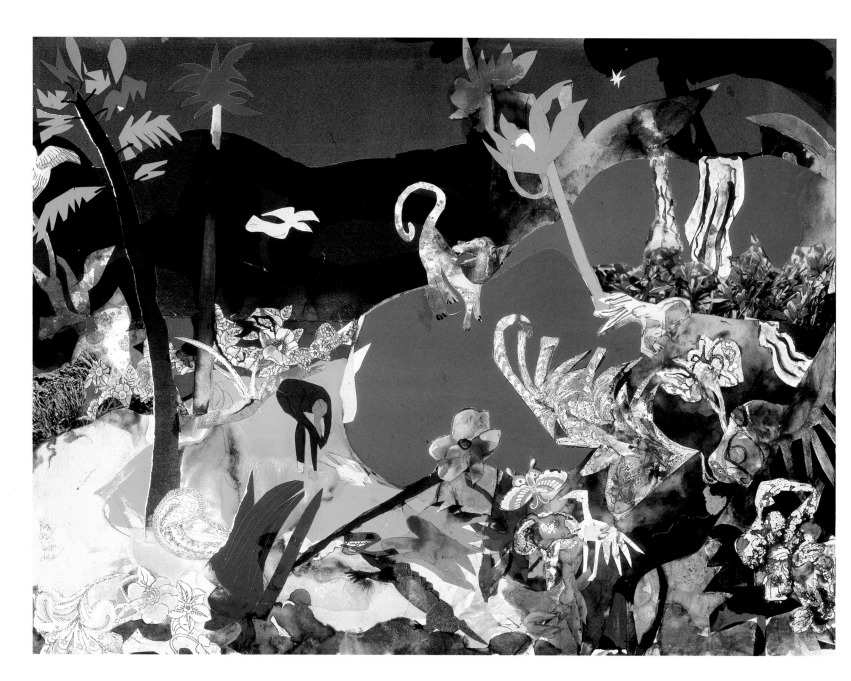

49. *Eden Midnight* (1988). Watercolor
and collage, 30 × 40". *Photograph courtesy of
Romare Bearden Foundation.*

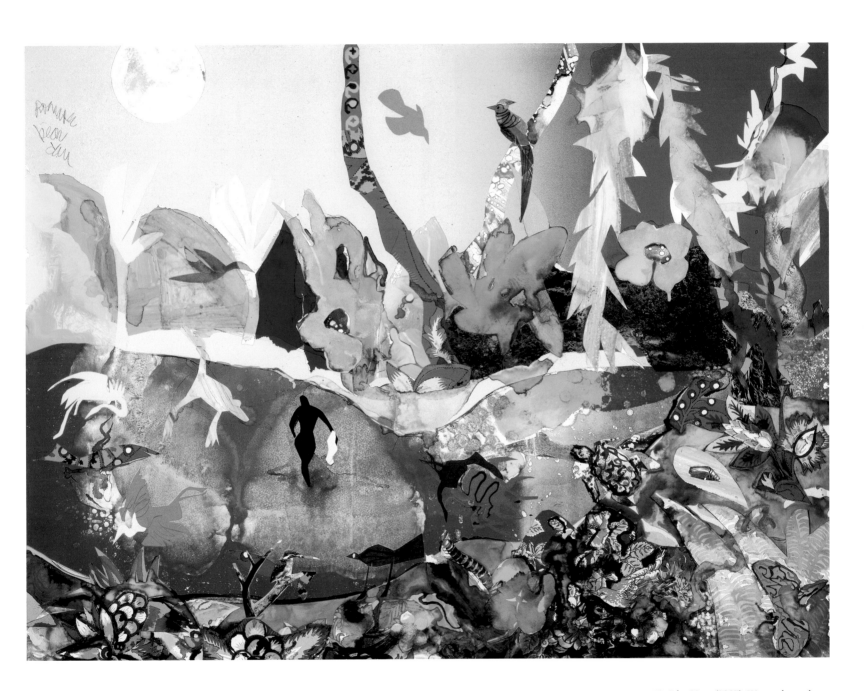

50. *Eden Noon* (1987). Watercolor and collage, 30 × 40". *Photograph courtesy of Romare Bearden Foundation.*

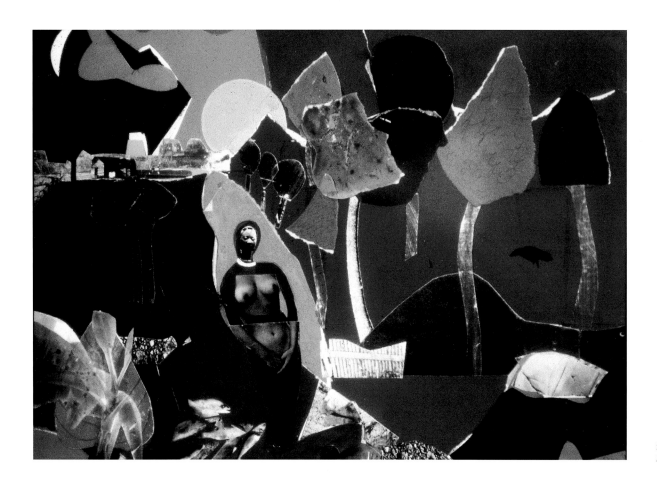

51. *Memories* (1970). Collage, 14 × 19¾".
Photograph courtesy of Romare Bearden Foundation.

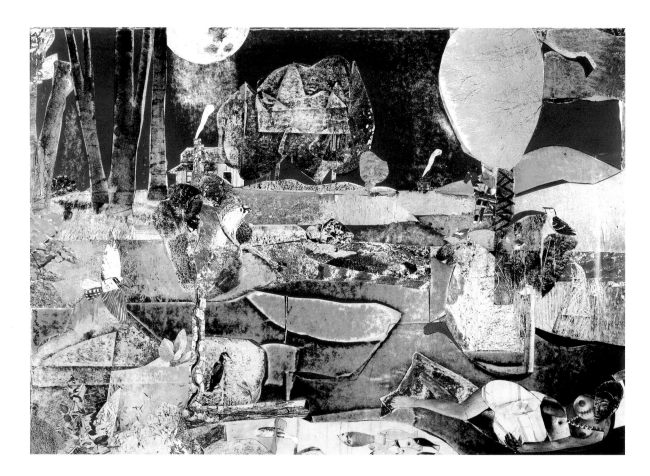

52. *Green Times Remembered* (*The Wishing Pond*) (1970). Collage and mixed media on board, 21¾ × 32". *Photograph courtesy of Romare Bearden Foundation.*

In 1971, soon after a brief visit to Martinique on a Caribbean cruise (and while the house was being built in St. Martin), Bearden produced his first Caribbean work on this theme – *Byzantine Dimension* |▶ 53| – which he told his dealer Arne Ekstrom was inspired by the rainforest of northern Martinique. It depicts, in the words of Mary Schmidt Campbell,

the jet black silhouette of a nude standing in ... a body of water ... in a thicket of birds, trees, flora and fauna. ... Hanging from her hand, like a mosaic of precious jewels, is a serpent... [We have here] the Conjur Woman in the form of the seductress, the woman as the agent of the loss of innocence... the theme of the female destroyer ... the magic woman in nature.

That same year, he produced *Blue Snake* and the significantly titled *Dreams of Exile (Green Snake)*, two similar scenes with tropical fish, lizards, and a pelican that radiate Caribbean

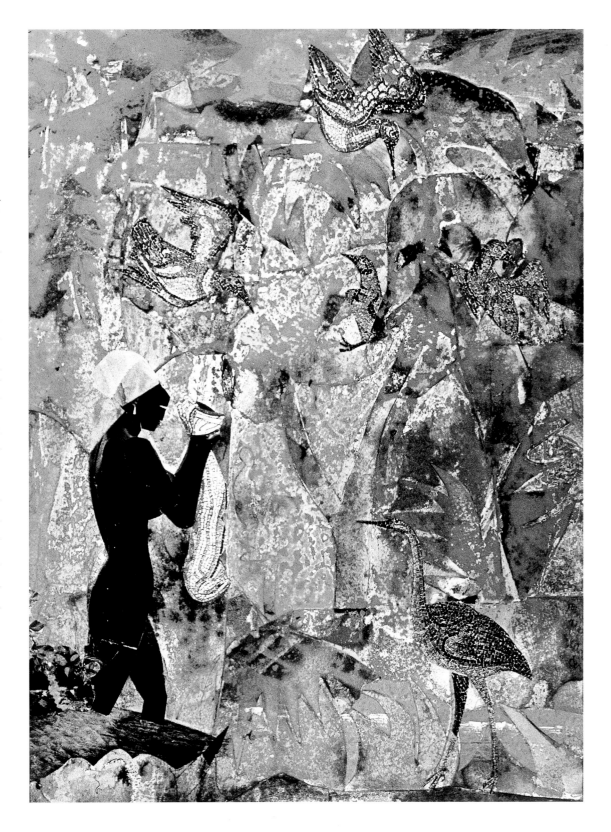

53. *Byzantine Dimension* (1971). Collage, 24 × 18". Collection of Nicholas Ekstrom.
Photograph courtesy of Romare Bearden Foundation.

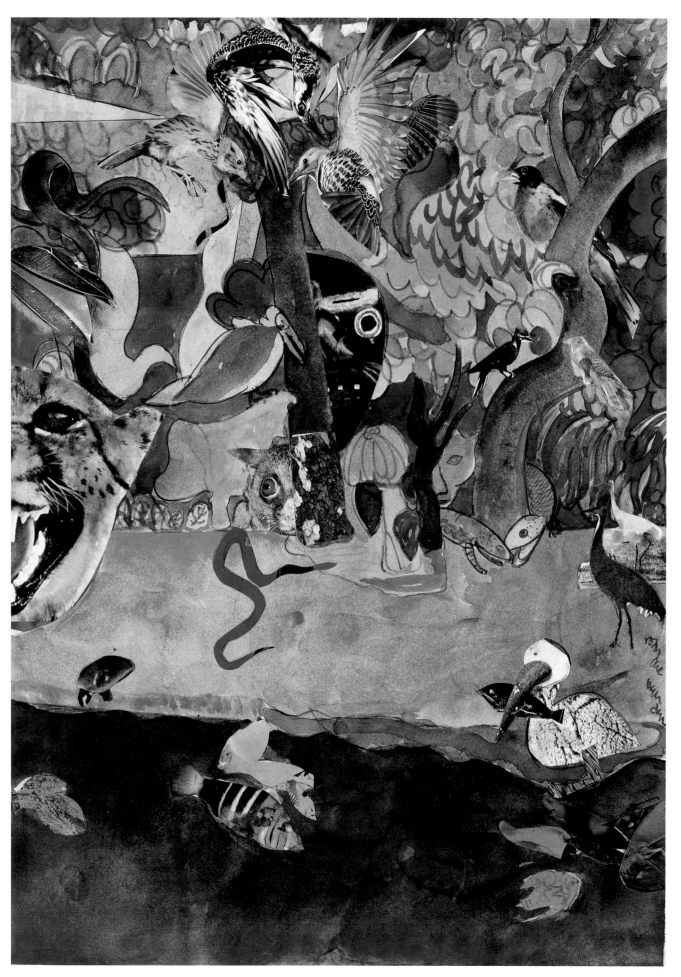

54. *Indigo Snake* (1975). Collage and watercolor on paper, 23 × 16". The Freedom Place Collection, Washington DC. *Photograph courtesy of Keny Galleries, Columbus OH.*

blues, greens, and yellows. Later he replayed the scene in *Indigo Snake*, but the cat of the 1971 works now appears as a jaguar. |▶54| Subsequent treatments of this theme, such as *Forest Pool Bathing,* |▶55| *The Blue Nude,* |▶56| and *Birds in Paradise,* |▶57| bring back the female figure of *Byzantine Dimension,*

depicting her as a black or blue-black silhouette standing in limpid water surrounded by a lush forest scene alive with birds, snakes, fish, and other animals, and holding (or rinsing out?) what appears to be a piece of clothing she has just removed (which plays the same compositional role as the "serpent" of

Byzantine Dimension). In *Untitled (Eden Series),* |▶58| the nude appears to be struggling with the turbulent Caribbean sea. The oversized mask-like faces in *Birds in Paradise* and *Indigo Snake* recall Bearden's U.S.-based collages of the 1960s, and the triangular forms and the bamboo-like stalks that fill much

55. *Forest Pool Bathing* (1981). Collage, 9 × 14 ½". *Photograph courtesy of Romare Bearden Foundation.*

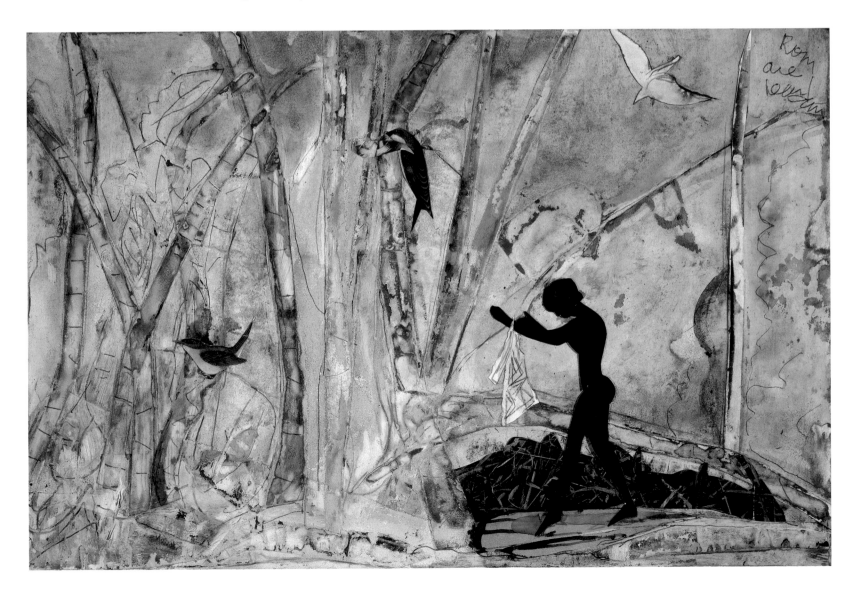

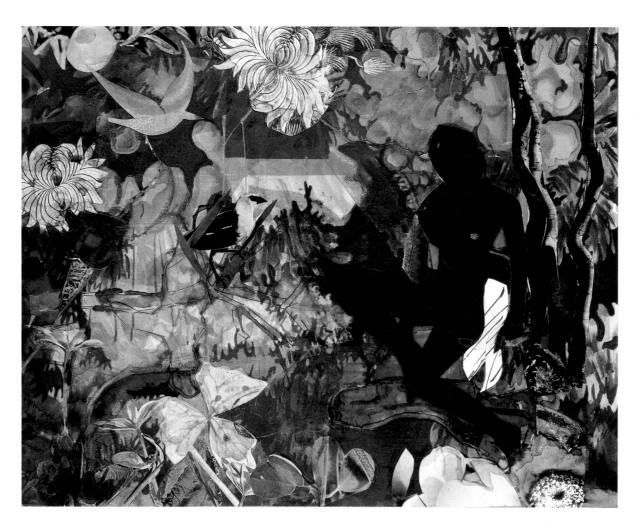

56. *The Blue Nude* (1981). Collage and mixed media on board, 14 × 18". *Photograph courtesy of Franklin Riehlman and Megan Moynihan Fine Art, New York.*

57. *Birds in Paradise* (1982). Collage and watercolor on paper, 29¼ × 20¾". Collection of Annemarie and Mark Couture, Charlotte NC. *Photograph courtesy of Jerald Melberg Gallery, Charlotte NC.*

58. *Untitled (Eden Series)* (1982). Collage on board, 30 × 40". *Photograph courtesy of Romare Bearden Foundation.*

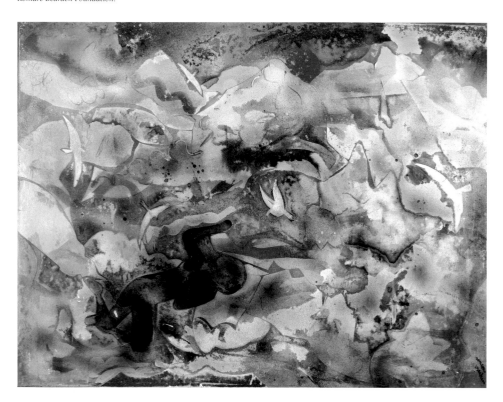

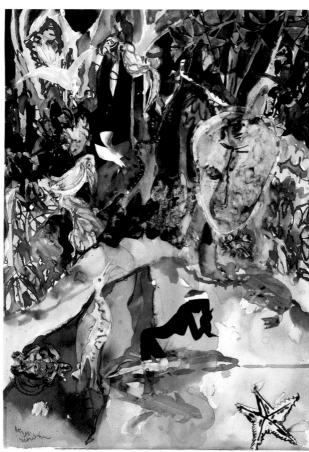

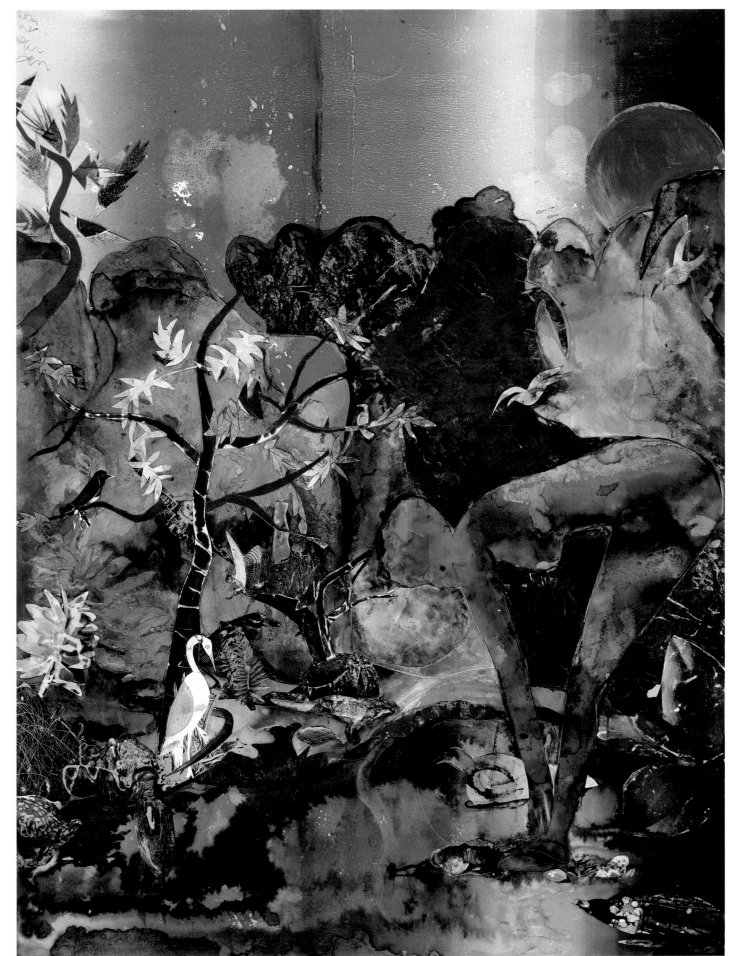

59. *In a Green Shade* (1984). Collage, 40 × 31". Collection of Yvonne and Richard McCracken, Charlotte NC.

Photograph courtesy of Jerald Melberg Gallery, Charlotte NC.

of the composition of *Forest Pool Bathing* have more recently become recurrent elements in Bearden's art. *In a Green Shade,* with its allusion to an Andrew Marvell poem and its fully Caribbean colors, again depicts a woman bathing in a pool as an egret looks on. |▶59| The wash of greens used for the triangular form of the bathing woman recedes into the background foliage in a manner reminiscent of the 1973 Martinique/The Rain Forest series (see below). In *Egret-Wading Pool,* the woman and egret appear almost in conversation and the surroundings disappear into a green wash. |▶60| By this time, the balance has shifted away from collage in favor of watercolor.

The influence of the Caribbean is clear in Bearden's

60. *Egret-Wading Pool* (1987). Watercolor and collage, 10 × 15". *Photograph courtesy of Romare Bearden Foundation.*

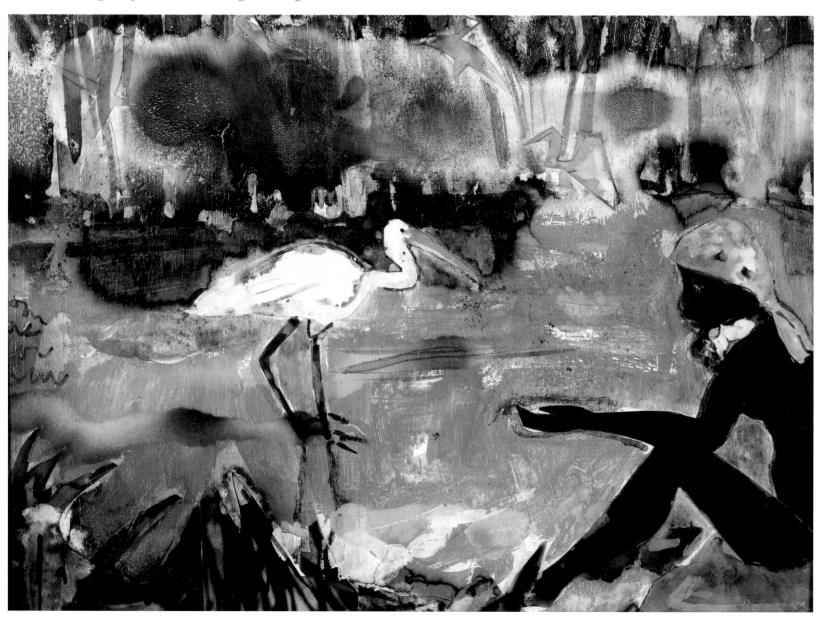

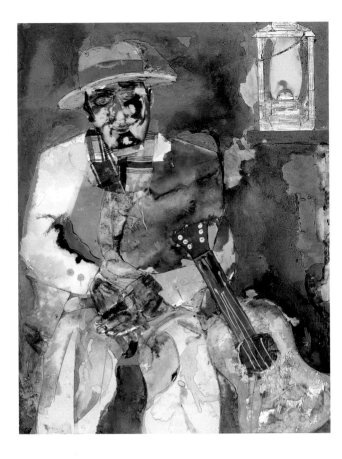

61. *Autumn Lamp*
(Guitar Player)
(1983). Oil with
collage, 40 × 31".
From Schwartzman
1990:31.

62. *Autumn Interior* (1983). Oil with
collage, 32 × 44". *Photograph courtesy of
Romare Bearden Foundation.*

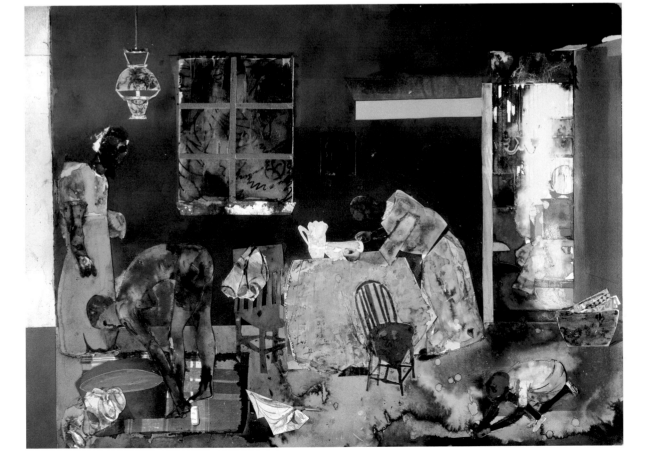

"Mecklenburg Autumn" series of 1983, where oil paintings with collage take on the luminosity and cloudy textures of many of his watercolors. See, for example, *Autumn Lamp*, *Autumn Interior*, and *Morning Ritual*. |▶ 61, ▶ 62, 63| One painting from that series, *September: Sky and Meadow*, is particularly reminiscent of the dense forest scenes with nude figures in the 1973 "The Rain Forest" series. |▶ 64|

Two works included in Bearden's 1986 Mecklenburg series ("Mecklenburg: Morning and Evening") are also strongly Caribbean. In *Evening of the Blue Snake*, |▶ 65| the snake threatens a sleeping nude as a long-legged bird wading in the pond looks on.[1] And *Evening: Small Creek, Back Country*, like the virtually identical *Ocean Inlet*, |▶ 66| (which is not in the series), centers on a woman and egret standing in a pond, with a dense forest background. A very similar work, also not part of that series, entitled *Purple Eden* (see |▶ 14|), adds an alligator, turtle, and snake – showing the flexibility of Bearden's titling and referentiality, as a small creek can as easily be an ocean, or St. Martin's Oyster Pond a Mecklenburg memory. In another late collage, *Blues on the Bayou*, despite the American allusion in the title and a man playing a guitar, the rest of

1. It is clear from the dimensions in the catalogue, as well as evidence presented in Schwartzman 1990:298, that three of the captions in the *Mecklenberg: Morning and Evening* catalogue (1986) have been printed with the wrong images. The image labeled "Evening: Small Creek, Back Country" should be "Evening of the Blue Snake"; the image labeled "Sunrise" should be "Evening: Small Creek, Back Country"; and the image labeled "Evening of the Blue Snake" should be "Sunrise."

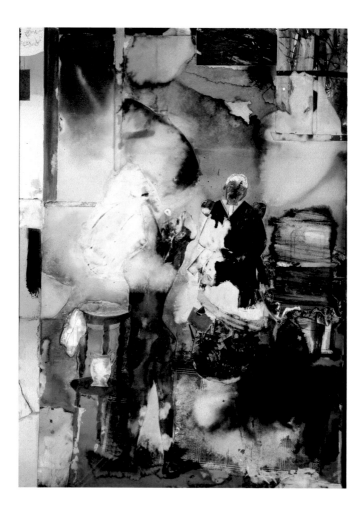

63. *Morning Ritual* (1983). Oil with collage, 40 × 30". *Photograph courtesy of Romare Bearden Foundation.*

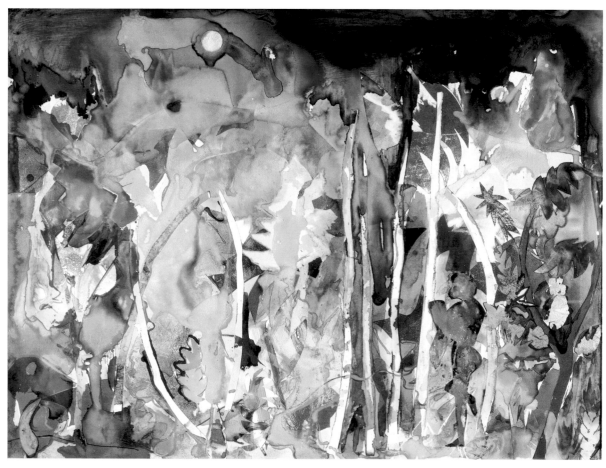

64. *September: Sky and Meadow* (1983). Oil with collage, 32 × 44". *Photograph courtesy of Romare Bearden Foundation.*

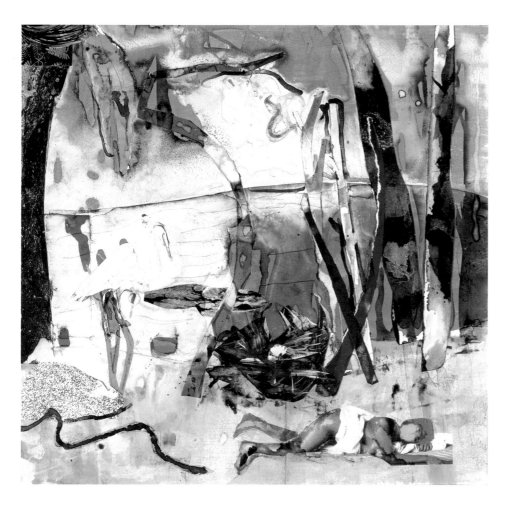

65. *Evening of the Blue Snake* (1986). Collage with acrylic, 11 × 11 ½".
Photograph courtesy of Romare Bearden Foundation.

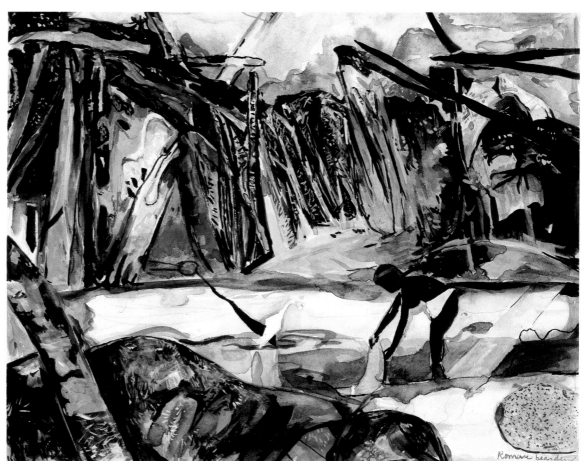

66. *Ocean Inlet* (n.d.). Watercolor and collage on paper, 9 × 12". Collection of Jancy and Gilbert Patrick, Kings Mountain NC. *Photo courtesy of Jerald Melberg Gallery, Charlotte NC.*

the iconography and the color belong to this same Caribbean set. |▶ 67| Or again, in *Mme. Celestine Comes to New Orleans to Sing the Blues*, |▶ 68| the framing of the figure, the upraised hand, and the aqueous splashes of color closely resemble any number of paintings in the Obeah or Carnival series (see below).

From the early 1970s to the end of his life, then, Bearden's "non-Caribbean" work became increasingly influenced by his Caribbean experience, until, by the end, there was considerable overlap, in terms of technique and subjects and color. Moreover, where he was producing what became increasingly blurred. Although Bearden saw the Caribbean primarily as "watercolor country" and claimed he was not comfortable doing collage there, by the mid-1980s he was in fact creating Mecklenburg collages, some of which looked very Caribbean,

while in St. Martin. And many of his Caribbean-style works were being produced in his studio in Long Island City. Moreover, the watercolors he was doing in St. Martin increasingly incorporated elements of collage.

Color was the first obvious change in Bearden's work more generally, once he moved to the Caribbean. "In the mid-1970s," Lowery Sims argues,

Bearden's works began to take on a particularly lush quality. He used sumptuous shades of blue and green to present the dense vegetation of the Caribbean. Now Bearden's work was literally and visually awash with the turquoise blues and lapis tones of the Caribbean... [And he had] expanded his technical approach to include more painting [using] cut sheets of paper that had been washed in watercolor or ... commercially produced colored paper that had been stained with water or benzine.

Hilton Kramer wrote, in a 1973 review, that "the increased power in these new pictures

seems to derive from a more effective synthesis of painting and collage, for it is the painterly impulse that now dominates." Calvin Tomkins observed, in his 1977 profile of Bearden for the *New Yorker*, that Bearden's paintings of recent years were marked by new, much more luminous, glowing colors. Avis Berman remarked, in his 1980 *ARTnews* feature, that "Vibrant, opulent color is [now] a constant, which Bearden attributes to sojourns in the West Indies." And Myron Schwartzman, commenting on the 1977 Odysseus collages, wrote that "One or two of these pieces, set on African shores and shot through with the light of the Caribbean, will stand among Bearden's best work of the decade." Sharon Patton has discussed more explicitly the influence of Bearden's Caribbean paintings on the work he was doing in New York.

67. *Blues on the Bayou* (1987). Collage on masonite, 20 × 18". *Photograph courtesy of Romare Bearden Foundation.*

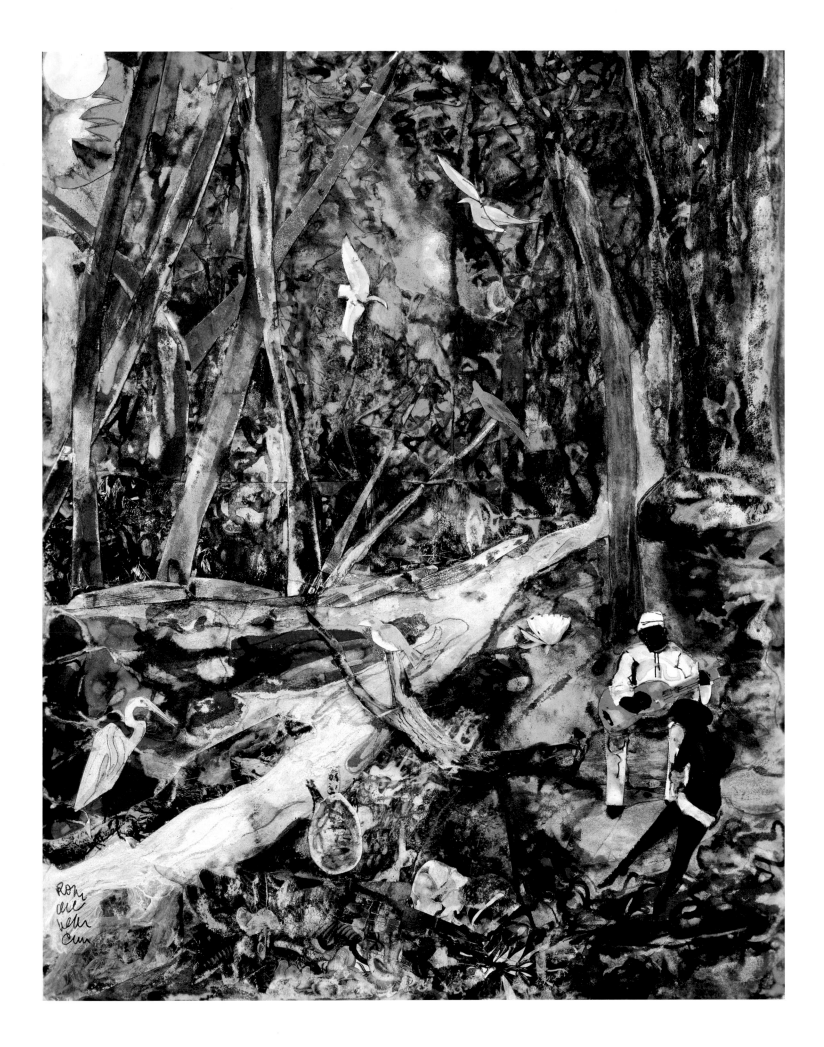

Bearden's monoprint technique and increasing interest in music made for some luxuriously rich, explosively colored paintings. ... Around the early 1980s, pigments increasingly swell, flow uncontrollably, and seem to explode upon the surface. ... During the late 1970s and the 1980s, Bearden used more vibrant, intense almost luminous colors, both hot and cold: pinks, oranges, acid greens, yellows, reds, purples, and midnight blues.

More generally, she argues, after he began visiting the Caribbean "many of his works acquired a tropical feeling." She cites such jazz works as *At Connie's Inn,* |▶ 69| whose iridescent greens strongly recall the 1973 Martinique/The Rain Forest series, as well as *Morning of the Red Bird* (1975) and *Sunset Limited* (1978), which bring characteristic Caribbean colors and a voyeuristic perspective on the female body into rural southern scenes. As late as the mid-1980s, reviewers of the latest Mecklenburg collages were

noting increasing Caribbean influence: "the most remarkable difference [from earlier collages] is that these works are more painterly" and commenting on "the highly saturated color evident in the increasing application of watercolor."

But it is Derek Walcott who, in our view, best captures the inner meaning of the Caribbean for Bearden, and its influence on his oeuvre more generally. Characteristically, he does it with reference to the Aegean.

I think you can't live in the archipelago – and Bearden *lived* in the Caribbean – without that great poem [*The Odyssey*] in the back of your head all the time. And it's not sort of *adapting* it to the Caribbean – it's direct. ... If you're living in the archipelago, the light is there, the rituals – the primal Greek rituals, the pantheism of Greek culture, it's still there in the Caribbean. You know, sacrifice and ritual and celebration. Plus the figures. ... very Homeric.

On another occasion, at sea's edge in St. Lucia, Walcott tried

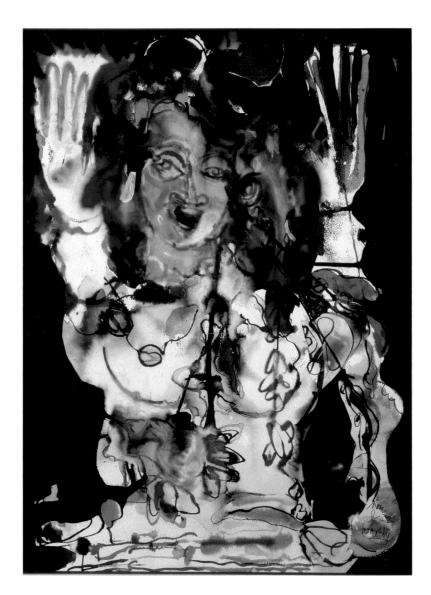

68. *Mme. Celestine Comes to New Orleans to Sing the Blues* (n.d.). Watercolor, 30 × 22". *Photograph courtesy of Romare Bearden Foundation.*

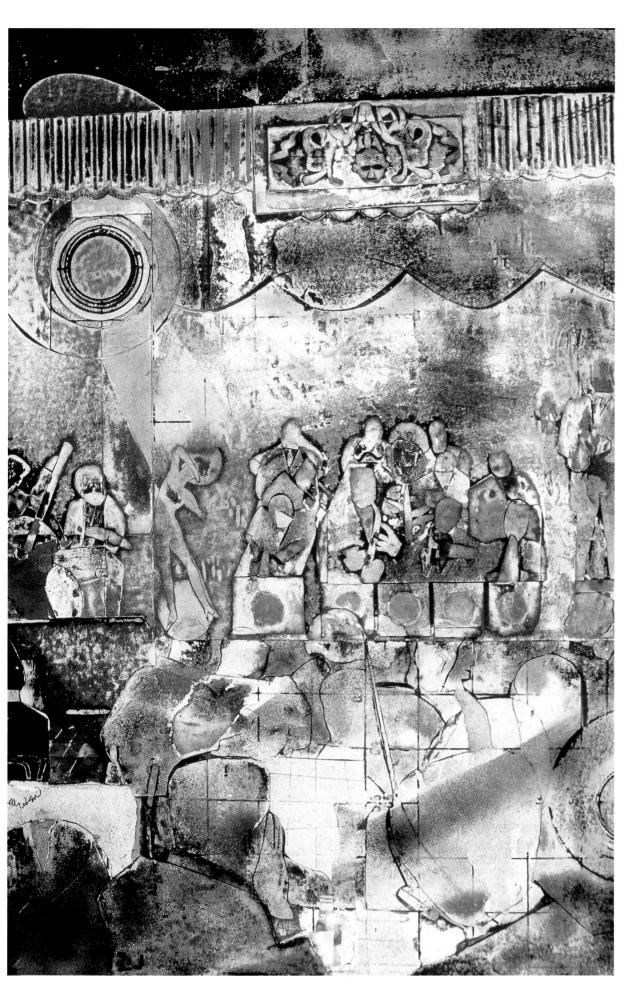

to impress on us the genius of some of Bearden's Odysseus/ Caribbean images, stressing that they're not about "black Greeks."

If you take very dramatized ritual – which is what Romare saw in Obeah... the sacrifices and the magic. ... It's not like saying: "Oh, basically, if you take Obeah, it's blacks trying to imitate Greeks...." You know, they're not! They are what they are. They're Africans, not Greeks doing X or Y – about surviving. And then the grandeur of some of those "Iliad" and "Odyssey" cutouts! Because the *brilliance* of making black silhouettes, right? which come out of Greek vase silhouettes, but are black ... and to make that silhouette alive in terms of the Caribbean. ... Because that Odysseus figure going down ... that's a *Caribbean* guy diving, you know? ... The breadth of it is staggering, because the color of that green is *exactly* what you get when you go down. I was there [diving in the sea] this morning.

69. Detail of *At Connie's Inn* (1974). Collage with acrylic and lacquer on board, 49 7/8 × 39 15/16". Brooklyn Museum, John B. Woodward Memorial Fund. *Photograph courtesy of Romare Bearden Foundation.*

Or as he said once of Bearden's *The Sea Nymph*,[1] in a lecture about *Omeros*,

Besides its veracity, there is the color, like the green surrounding that black figure going down through the water, which is absolutely, perfectly the color of coral water, while the figure could simply be a coral diver or a shell diver going down to pick up shells from the bottom of the sea. So this combination of images – the black diving figure and the green water – immediately strikes me not as Aegean but as completely Caribbean. And as it is for Romare, it is perfectly valid for me to think of an archipelago in which there are boats and pigs and men, scared people and a succession of islands – home to me – to think of the *Odyssey* in terms of the Caribbean.

Between the aqueous *Odysseus Rescued by a Sea Nymph* |▶70| and the final *Sea Nymph* collage, |▶71| Bearden makes a simple but magnificent gesture that transforms beautiful image into moving narrative – the addition, on high, of Odysseus' ship, "the moving sail, alone on the ocean, trying to get somewhere." It is much like a visual figure evoked, in another context, by Walcott (who does not relate it to Bearden): "One of the greatest images in the history of literature is Dante's image of Neptune lying on the bottom of the sea, with the shadow of the *Argo* passing over him – that is just astonishing! ... You gasp at this image of time."[2]

When Walcott spoke of what the Caribbean means to him artistically – the particulars of the relationship between the local and the universal (what Al Murray in an interview with us referred to as "processing the idiomatic particulars of Afro-American experience into universal aesthetic statements" – he could as well have been speaking for Bearden.

In terms of *Omeros*, I felt totally natural, without making it an academic exercise or a justification or an elevation of St. Lucians into Greeks, or

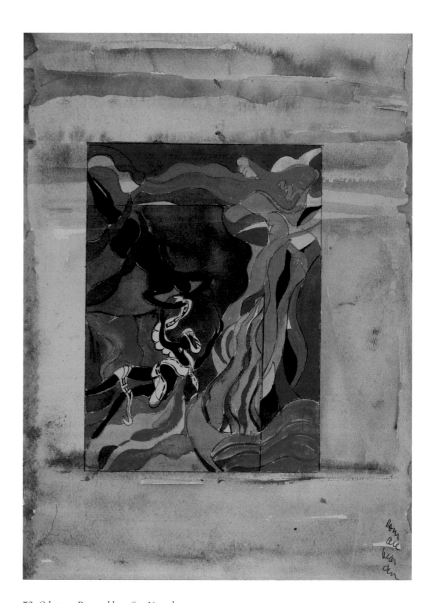

70. *Odysseus Rescued by a Sea Nymph* (1977). Watercolor, 14¾ × 10⅜".
Collection of Evelyn N. Boulware.
Photograph courtesy of Romare Bearden Foundation.

1. In a note to Walcott's published lecture, classicist Gregson Davis suggests that *The Sea Nymph* alludes to a scene from the episode in which the sea-nymph Ino rescues Odysseus with her enchanted veil.

2. We are not persuaded by Ruth Fine's suggestion that, in contrast to earlier chronologies of these works, the smaller, watercolor versions of the Odysseus series are "unlikely" to have predated the final collages, that they "most likely" were not "studies" (2003:89, 261 n. 177).

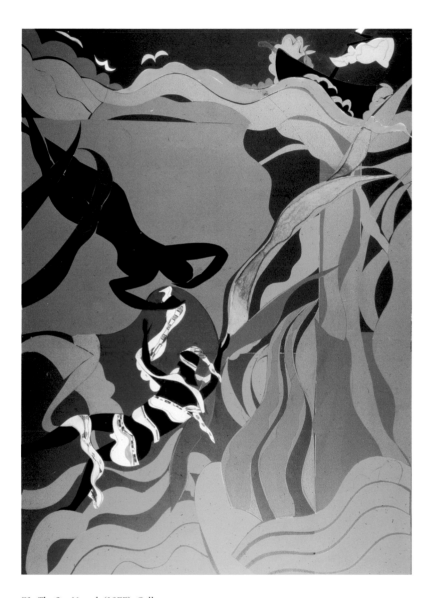

71. *The Sea Nymph* (1977). Collage
with mixed media on board, 44 × 32".
Collection of Glen and Lynn Tobias.
Photograph courtesy of Romare Bearden Foundation.

some such nonsense – because of the harbors of the Caribbean, the work of the people in the Caribbean, the light in the Caribbean. That sense of elation you get in the morning, of a possibility that is always there, and of the width of the ocean – that, to me, is Caribbean first of all.

That "sense of elation you get in the morning ... the width of the ocean" echoes powerfully with the "renewed energy" Bearden felt whenever he was in the Caribbean – an energy that spilled over into all of his work, whatever its subject.

The Prevalence of Martinique

On Bearden's brief visits to islands other than St. Martin (during the late 1960s and early 1970s on Caribbean cruises, during the late 1970s and the 1980s on trips specifically focused on Haiti and Martinique

plus a couple of brief trips to Guadeloupe, St. Thomas, and Saba, and to an art festival in Barbados), he sketched prolifically and stored memories. Of the approximately 400 Caribbean works we have seen (or seen reference to), there are only two or three images each that specifically evoke Anguilla, the Bahamas, Barbados, Dominica, Grenada, Guadeloupe, Saba, St. Barths, St. Lucia, St. Thomas, or St. Vincent.

There are none at all of Haiti, despite Bearden's fascination with the island – perhaps because he felt unequipped to deal with what he understood to be its unique historical and cultural depth, as the first Black Republic.[1] Bearden seems to have felt that despite his growing appreciation of Caribbean realities, his true, personal space remained black America. As an appreciative visitor to the Caribbean, mightn't he have

1. Almost every great Caribbean writer has accepted the challenge of grappling with Haiti: Walcott in his first play, *Henri Christophe*, C. L. R. James in *The Black Jacobins*, Aimé Césaire in *La tragédie du roi Christophe*, Alejo Carpentier in *El reino de este mundo*, Édouard Glissant in *Monsieur Toussaint*, George Lamming, if more obliquely, in *Season of Adventure*, to name a few.

felt a reticence about investing himself in the kind of depth that the artistic encounter with Haiti deserved? An outsider, married into the Caribbean in more ways than one, he seems to have carefully chosen his level of engagement, sometimes delving beneath the surface but always maintaining a respectful distance.

In this balance, the island of Martinique held a special position. Bearden produced at least thirty works that specifically evoke Martinique in their titles (as well as another dozen or so "rainforest" works that were directly inspired – or that recalled for Bearden – aspects of the lush north of that island). His first visit seems to have been on the *Bremen* cruise in early 1971, when he took a day trip up the coast to the ruins of the former capital of Saint-Pierre (destroyed by the great eruption of Mont Pelée in 1902), return-

ing to the ship on the Route de la Trace that runs through the heart of the Martinique rainforest – the only Caribbean rainforest (other than the surroundings of Paradise Peak) that Bearden ever evoked in his work. (Bearden's sister-in-law Annette, who accompanied them on the cruise, told us that "Seeing the rainforest was one of the great treats of my life.") It was soon after this visit to Martinique that he painted *Byzantine Dimension* (see |▶ 53|).

The next year, shortly before the Beardens finally set up house in St. Martin, they took another cruise, this time on the Italian liner the *Raphael*, making a two-day stop in Martinique. By the summer of 1973, still living in a hotel in St. Martin and without art supplies at hand, Bearden began thinking actively about painting the Caribbean.[1] And when he returned to New York that fall, he produced his first

large body of Caribbean-inspired work – the collages (titled in both English and French) that comprise the "Martinique" and "The Rain Forest" series, twelve of which were shown in 1974 at Cordier & Ekstrom, in the "Prevalence of Ritual – Martinique – The Rain Forest" exhibit. |▶ 72, 73, 74, 75, 76| (At the time, Bearden wrote that he and Nanette "love Martinique – and a lot of my last ideas germinated from sketches, and thoughts, originating there.") Continuing techniques he had developed in his "American" collages, Bearden infused these distinctive new works with the island's palette of vibrant blues and luminous greens. Like his edenic "enchanted places," these were scenes rich in shady foliage, quiet pools, mysteriously seductive nudes, birds, and snakes – but all within the carefully conceived geometry of a grid-like structure. |▶ 77| Mary

1. See the "summer 1983" letter to Ekstrom, quoted above.

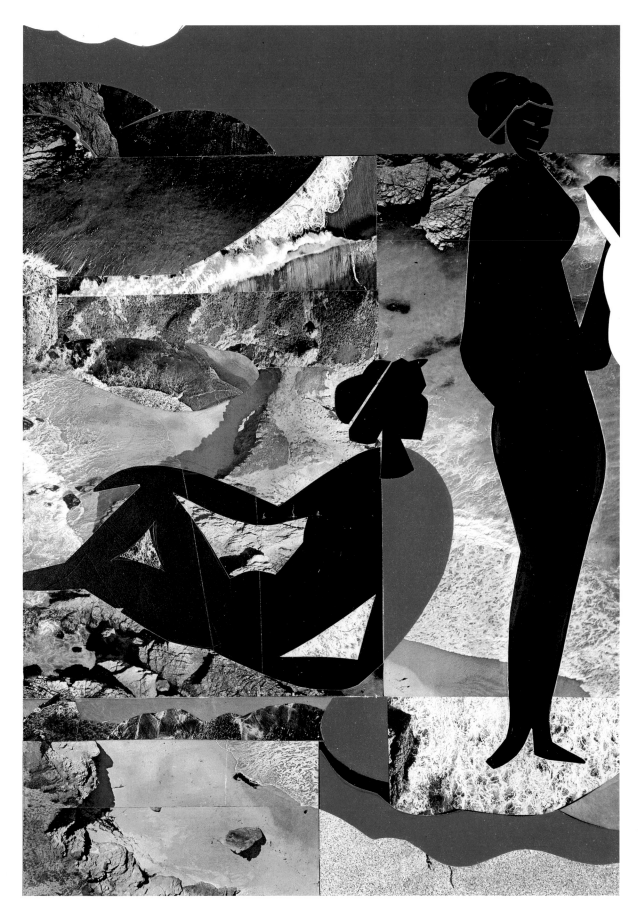

Schmidt Campbell describes *The Source*, |▶78| writing that "the painterly surface unifies birds, serpent, water and woman, rendering them ineluctably bound, inseparable. These are woods – rain forests Bearden calls them – one can get lost in."

In 1979 Bearden made a point of once again visiting Martinique, this time with Frank Stewart. They stayed for several days, touring both the north, with its rainforest and rivers and waterfalls, and the south, with its dramatic sunlight, fishing villages, and beaches. At Bearden's request, a meeting was also set up with Aimé Césaire, the great poet of *négritude* and long-time mayor of Fort-de-France. |▶79| He made a final brief visit to the island in 1987.

Martinique held a special place in Bearden's *imaginaire* until the end of his life, and while he continued doing some collages more or less in the mode of his 1973

72. *The Intimacy of Water* (*L'intimité de l'eau*) (1973). Acrylic and photographic collage on chipboard, 21 ¾ × 15 ⅜".
The Saint Louis Art Museum. Eliza McMillan Trust and Museum Purchase.

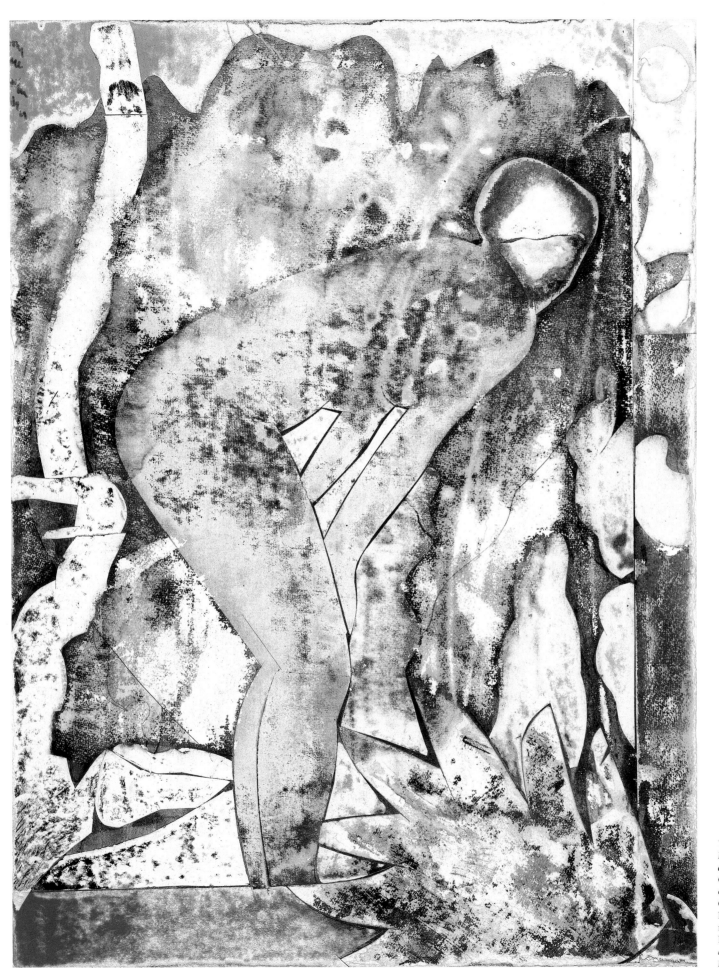

73. *The Lady with Blue Face (La dame au visage bleu)* (1973). Collage with acrylic on board, 24 × 18". Collection of Elizabeth Rindskopf Parker, in memory of Peter Eric Rindskopf. *Photograph courtesy of Elizabeth Rindskopf Parker.*

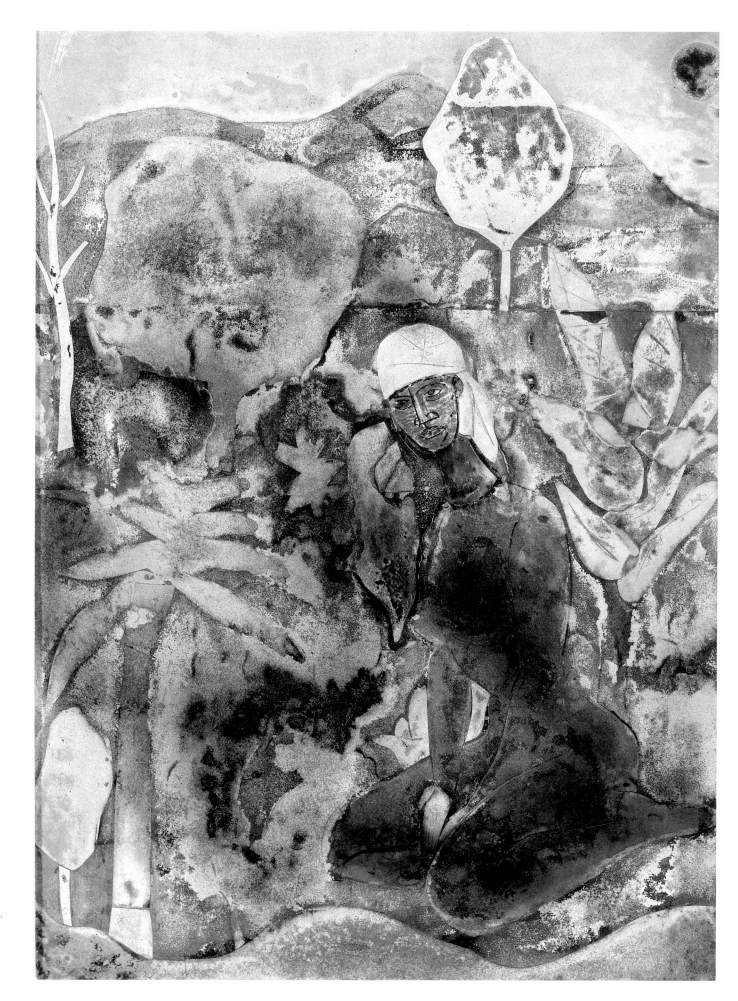

74. *The Blue Girl*
(*La fille bleue*) (1973).
Collage with acrylic
on board, 24 × 18".
*Photograph courtesy
of Romare Bearden
Foundation.*

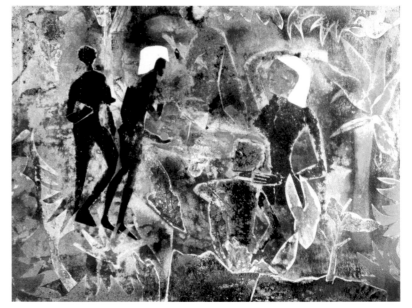

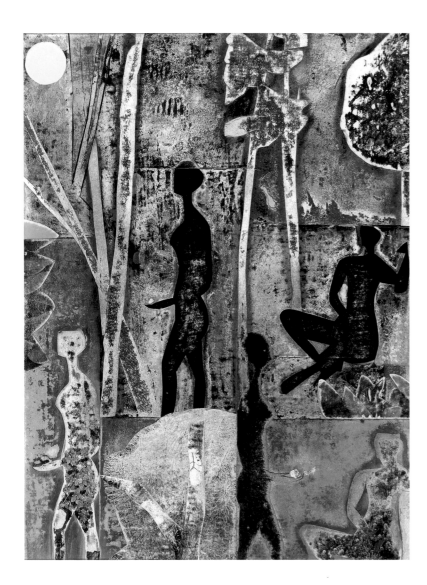

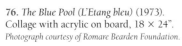

75. *To See, Go Into the Shade (Pour voir, entrer dans l'ombre)* (1973). Collage with acrylic on board, 24 × 18". *Photograph courtesy of Jerald Melberg Gallery, Charlotte NC.*

76. *The Blue Pool (L'Etang bleu)* (1973). Collage with acrylic on board, 18 × 24". *Photograph courtesy of Romare Bearden Foundation.*

77. *Martinique Rainforest* (ca. 1975). Collage and mixed media on board, 10 × 14". Collection of Brandon Cohen. *Photograph courtesy of Franklin Riehlman and Megan Moynihan Fine Art, New York.*

78. *The Source (La Source)* (1973). Collage with acrylic on board, 16 × 20". *Photograph courtesy of Romare Bearden Foundation.*

79. With Aimé Césaire in Fort-de-France, 1979. *Photographer Frank Stewart.*

Martinique work (for example, *Forest Pool* |▶80| and *Caribbean Forest* |▶81|), he also produced a number of Martinique watercolors marked by luminous colors, that brought him back time and again to the island's rainforest and waterfalls, its fishermen, and its sensuous women, such as *Blue River Martinique* |▶82| and *Martinique Morning* (see |▶147|). What Sharon Patton says more generally of Bearden's work during the 1970s and 1980s seems particularly apt for his images of Martinique: "Secrecy and mystery veil faceless women ... who walk or lie nude in tropical landscapes. They remind us of the mythological nudes of Titian, Rubens, and Delacroix or of Renoir and Manet" – see, for example, *Caribbean Idyll.* |▶83| In a number of the paintings or collages whose titles include "Martinique," the imagery seems geographically unspecific, simply evocative of the spirit of the place |▶84|. Others, however, incorporate visual reference to identifiable features – for example, anyone familiar with the island would pick out the peaks of Martinique's Pitons du Carbet mountains within the fluid washes of color in *Sunset Martinique.* |▶85|

The St. Martin Paintings

Bearden's best-known U.S. work is marked by elegiac narrative, much of it set (on the Dutch-master model) within intimate interiors. His St. Martin/Caribbean work, in contrast, is remarkable for its absence of any interior views at all. We would attribute this difference to Bearden's implicit insistence that he did not bring the same identitarian toolkit to the Caribbean, where – how-

80. *Forest Pool* (1975). Collage with mixed media, 19 ½ × 13 ½".

Photograph courtesy of Romare Bearden Foundation

81. *Caribbean Forest* (1977). Collage
on board, 13 ½ × 15 ½". The Walter O.
Evans Collection of African American
Art & Literature, Savannah GA. *Photograph
courtesy of Romare Bearden Foundation.*

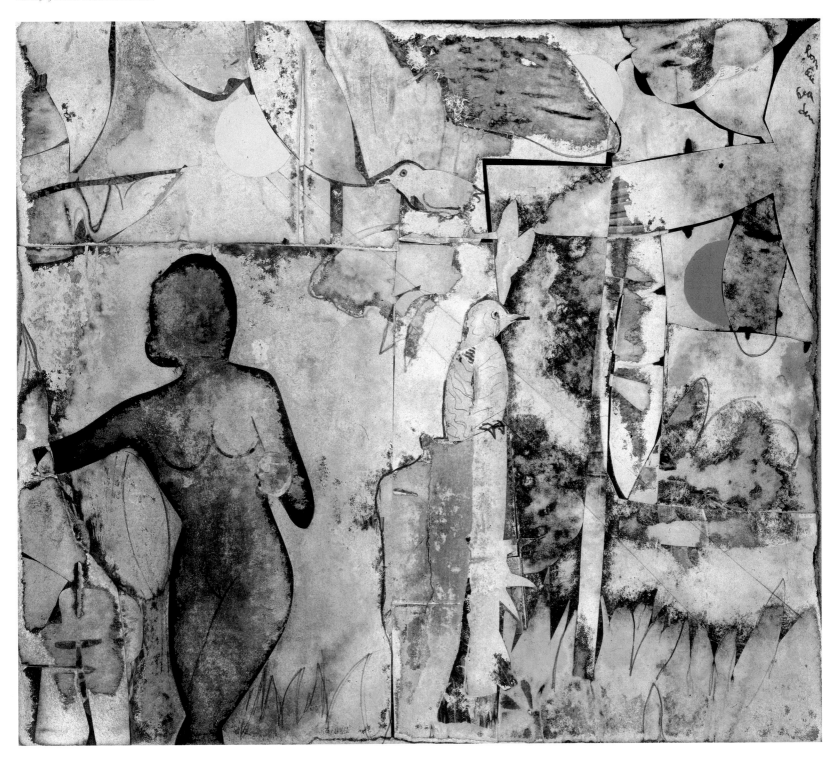

82. *Blue River Martinique* (1986).
Watercolor with collage, 11 × 15".
Photograph courtesy of Romare Bearden Foundation.

85. *Sunset Martinique* (1981).
Watercolor, 11 ¾ × 8 ¼". *Photograph
courtesy of Romare Bearden Foundation.*

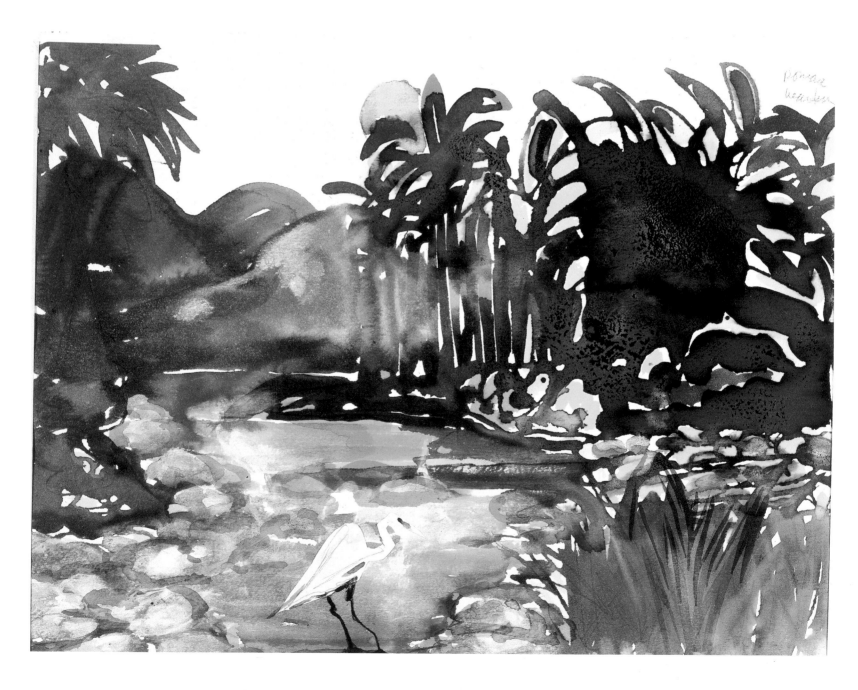

84. *Martinique* (1984). Collage and oil on masonite, 12 × 10 ½". *Photograph courtesy of Martha Henry Inc. Fine Art, New York.*

83. *Caribbean Idyll* (1982). Watercolor with collage, 10 × 12". *Photograph courtesy of Romare Bearden Foundation.*

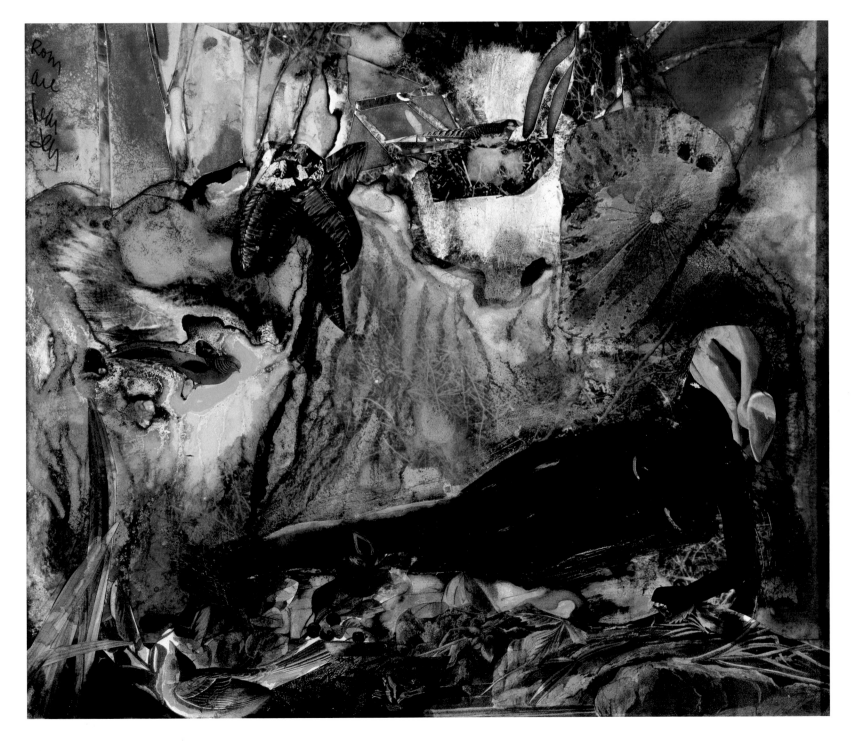

ever much he came to appreci- ate the rhythms of local life – he always considered himself a vis- itor, there to learn. In Walcott's words, "You know, he went there humbly, which is a great thing!" Nevertheless, Bearden's engage- ment with the region increased through time, and by the mid- 1980s he began adding ritual activities to his Caribbean rep- ertoire, reacting to the sorts of Caribbean events and practices that had long fascinated him in the United States – the ritu- als of the Obeah, for one, the annual bacchanal of Carnival, for another.

While in St. Martin, Bearden worked largely in watercolor, tak- ing an almost complete vacation from collage-on-board. When Charles Rowell asked him why he did watercolors in St. Martin, he replied,

When you look outside here, you take out the brush and palette. As Derek Walcott once said to me, "All a man needs to do here is stand on a rock, and you're at one with the sea and the sky." And it's watercolor country. It would be very different in painting down here for me than if I were in New York, where it would be more – I can't use the word solid. It would be a different kind of painting.

Walcott, himself an ama- teur painter, enthused about Bearden's Caribbean water- colors: "The loading of the color, the weight and the brightness and the richness of the color and how he moved the paint around in watercolors, is fan- tastic … how he could make the brightest colors blend, getting the exuberance and simplicity of Caribbean color."

Myron Schwartzman recalled that "When I went down to St. Martin, there would always be watercolors drying – they'd stay wet for hours – and he'd say to me that although he brought down the materials to do col- lage, he couldn't do collage in the Caribbean. It just didn't lend itself." To which Walcott adds matter-of- factly, "The col- lages are embedded in American history – urban, rural. When he came to the Caribbean, he wasn't interested in doing Caribbean history. He was more taken by the immediacy of the light."

Bearden felt special relation- ships with a number of places on St. Martin, coming back to them again and again in paint- ings and in prose – among them, Pic Paradis (which he credited with "showing off for me how green green can be, how blue is blue until, absorbing yellow, it too is green") and Orient Bay. Rather than illustrating them, he painted what these places suggested to him, his feelings about them. He once explained his modus operandi, developing the relationship between struc- ture and representation in his work, using Pic Paradis as an example: |▶ 86|

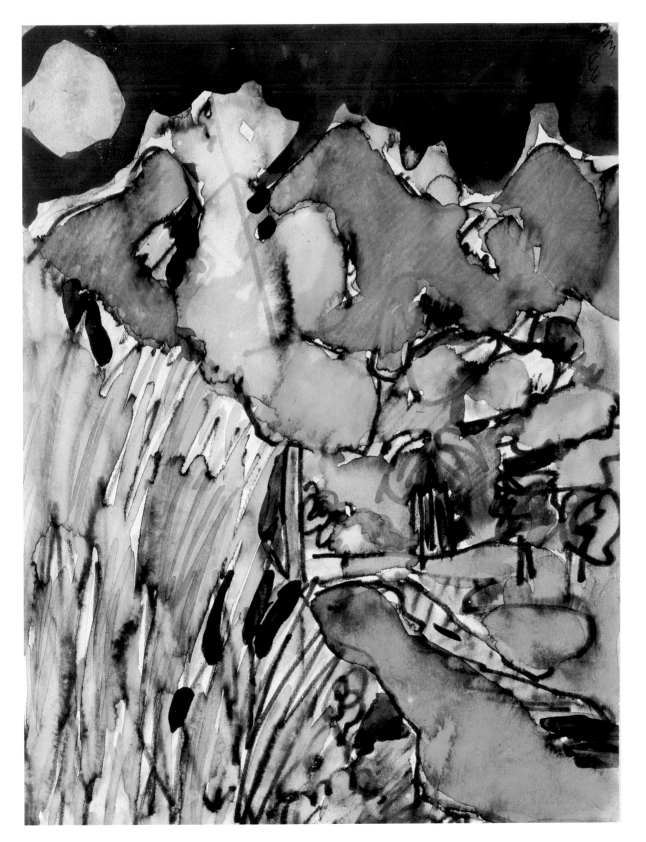

Across the bay in St. Martin – a home for me – is Paradise Mountain. A small village is secure beneath its green skirt. Should I attempt to draw or paint that landscape I would first establish the main shapes and then see to the varying contours and rhythms. Next, I would set a profile of relationships such as clouds to trees, sky to bay water. With these primary concerns ordered, I would have established a space. I could then move realistically or completely non-representationally.

His 1985 piece in the *New York Times* again focused on this favorite mountain.

On quiet St. Martin evenings my wife and I will often sit and watch the drama in the sky. From our home overlooking L'Embouchure Bay we can see a vast area of sea and sky in its singing unity with the turning earth. Clouds off the east Atlantic move westward on their way across the Caribbean Sea – I like to imagine that they are going far off to Aruba and Curacao. When the sun is behind Paradise Peak, the highest point on the island, the great clouds are colored with tints of rose and vermilion as they take their final stare at the crimson sun and move into the night. It was probably at such an

86. *Sunrise off Paradise Mountain* (1981?). Watercolor, 12 ½ × 9 ½". *Photograph courtesy of Romare Bearden Foundation.*

hour that William Blake was inspired to write: "There is a Moment in each Day that Satan cannot find."

Occasionally, lower clouds serrate themselves on Paradise Peak. Friends who have a house near the top of the mountain say that sometimes clouds journey right through their living room. They are among the very few people in St. Martin who have need of a fireplace. It may be very warm at ground level, but it is always cool on Paradise Peak.

When you take the road to Marigot, capital of the French side of the island, you will pass a section called Rambaud. There you will find the road leading up Paradise Peak. If going by car, be sure of your tires and don't let your motor overheat. On the higher approaches, the road is narrow. Even in midday it is rather dark, a perpetual twilight, as if an artist had laid a gray wash over a bright watercolor.

Near the summit of Paradise Peak are cabbage palms, ferns that sway like dancers and large plants called elephant's ears. Just beneath the soil there is coral, a vestige of watery yesterdays when most of the island was under the sea. Knowledgeable people can occasionally discover ancient stone Arawak Indian tools but scarcely anyone can now find the small animal carvings called zemis, which are actually Arawak icons.

From the top of Paradise there is a sensational view of the sea and of the eastern section of the island. |▶ 87| Color fields of blue and blue-green waters wait for the brush of Monet. The flat island of Anguilla twists in the ocean like a green snake. On the western side of the summit, you can see the island of Saba and sometimes even St. Eustatius.

Orient Bay, with its "pounding surf," was another of his fixtures. We know of sixteen paintings that he titled with that name, and he painted what it suggested to him at dawn, at sunset, in the rain, and peopled by various figures wading, swimming, and working. |▶ 88, 89|

Bearden's St. Martin watercolors – other than the Obeah and Carnival series (see below) – bespeak rejuvenation and relaxation. During most of his time on the island, as Al Murray put it,

he wasn't trying to knock off a hit tune. Still, you got that same rich sensibility and creativity working. Because when he makes a line, it's going to be a Bearden line...

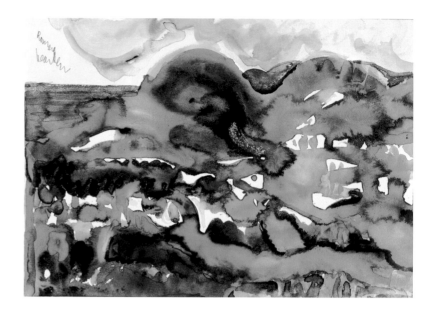

87. *From Paradise Mountain* (1984). Watercolor, 10 × 14 ¼" *Photograph courtesy of Romare Bearden Foundation.*

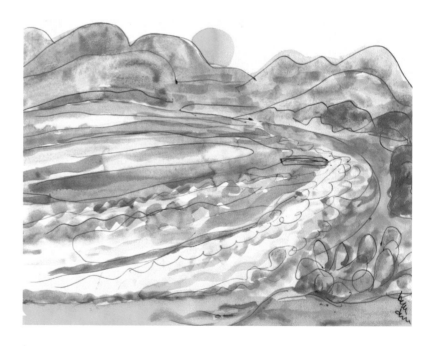

88. *Orient Bay* (n.d.). Watercolor. *Photograph courtesy of Romare Bearden Foundation.*

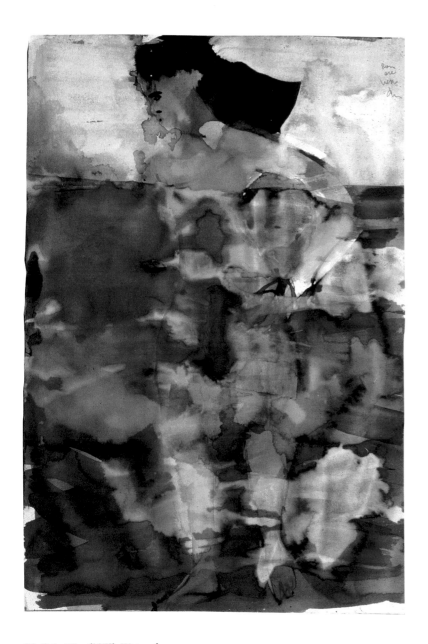

89. *Orient Bay* (1979). Watercolor,
30 × 22". Collection of June Kelly, New
York. *Photograph by Manu Sassoonian, courtesy of
June Kelly Gallery.*

Sometimes you discover – You make new breakthroughs when you think you're just playing, just warming up.

Besides landscapes, some of his favorite themes were sunrises, sunsets, and storms, fishermen at work, market scenes, and tropical flowers and trees, plus the occasional portrait. |▶ 90, 91, 92, 93, 94, 95, 96, 97, 98, 99, 100a-d| Cocks were as much a part of Bearden's Caribbean experience as in his Mecklenburg memories. Fighting cocks and their companions roamed outside the St. Martin house ("Yard is filled with stray cats [and] the fowl community," he wrote to June Kelly in 1986 – see |▶ 29|) and he did several paintings of Caribbean cockpits. |▶ 101| Cocks figured importantly in the Obeah series (see, for example, |▶ 116| and |▶ 127|). For Bearden, they were more than simply symbols of virility, sacrifice, and mystery.

Like cats, they were part of the domestic landscape. |▶ 102| "I have a new friend," he wrote to June Kelly in 1985, "a 'fighting cock' I've named Freddie – he comes at dawn each day, crows til I come out and he flies up to greet me. Chasing all other animals away – then I feed him. A wonderful bird." Soon after, he painted a whimsical portrait of Nanette and his new friend. |▶ 103|

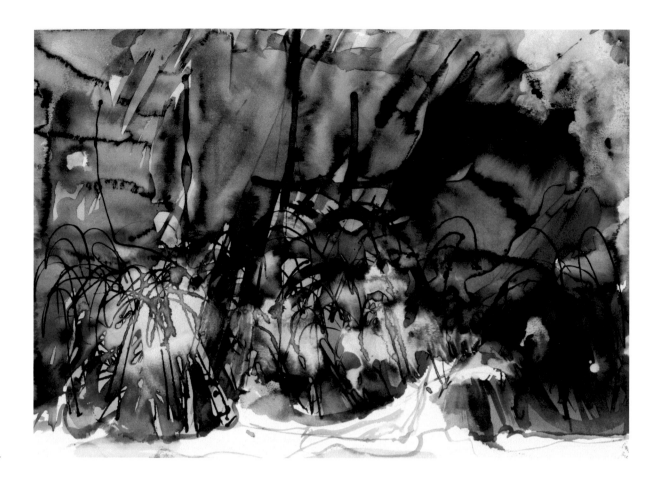

90. *Tropical Storm* (n.d.). Watercolor.
Photograph courtesy of Romare Bearden Foundation.

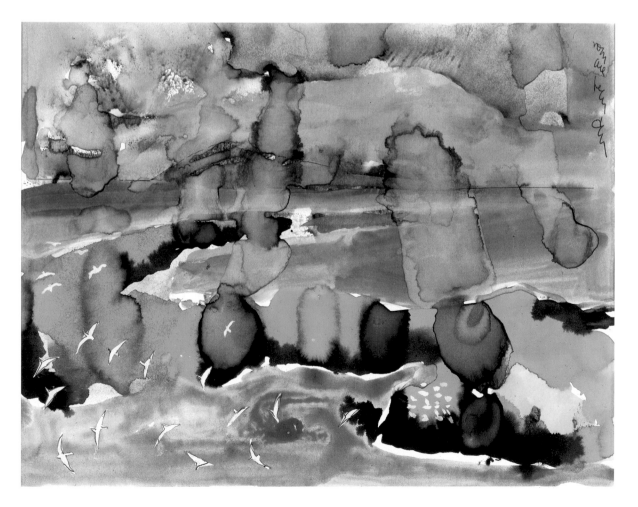

91. *Flight of the Egrets* (1986). Watercolor,
8 ¾ × 11 ¾". *Photograph courtesy of Romare
Bearden Foundation.*

92. *Going to Market/St. Martin* (n.d.).
Watercolor, 19 ½ × 18". Collection of Lyn
and E.T. Williams, New York. *Photograph by
Brooke Williams, courtesy of Elnora, Inc.*

93. *Marigot Market Day* (n.d.). *Photograph
courtesy of Romare Bearden Foundation.*

94. *Going to Market* (n.d.). *Photograph
courtesy of Romare Bearden Foundation.*

95. *Untitled (Sailboat)* (n.d.). *Photographer
Frank Stewart.*

96. *Open Market* (1988).
Watercolor, 24 × 18".
*Photograph courtesy of Romare
Bearden Foundation.*

97. *Going to Market-Marigot Wharf* (n.d.).
Watercolor, 8 × 9 ½". *Photograph courtesy of*
Romare Bearden Foundation.

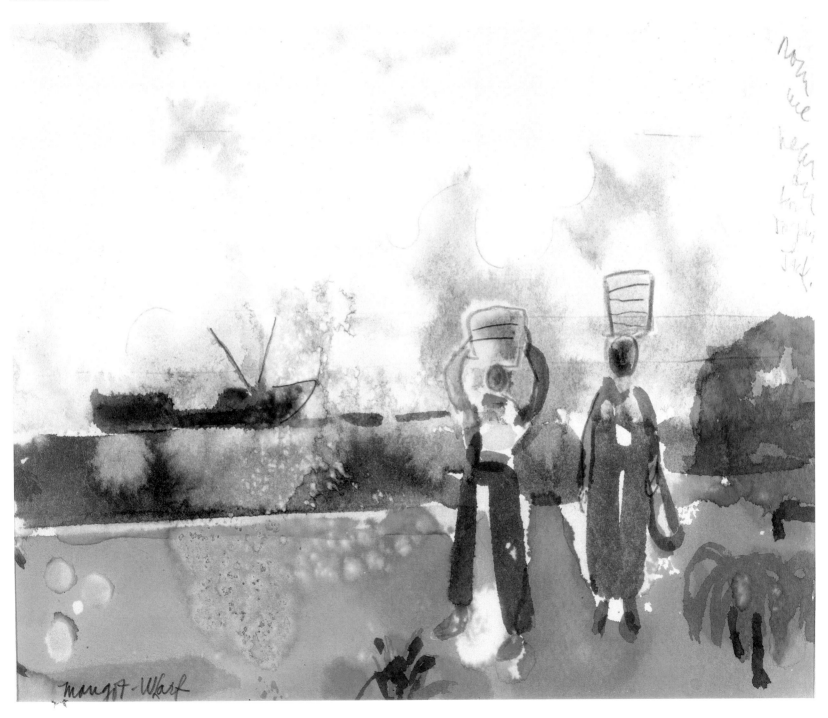

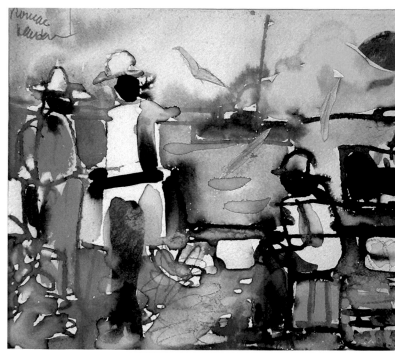

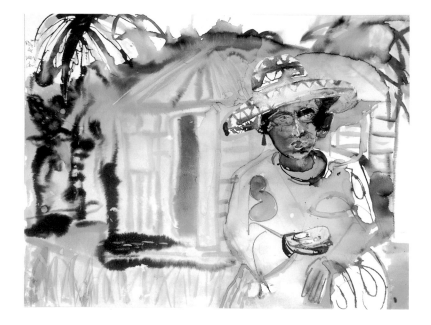

99. *Marigot Market* (n.d.). Watercolor, 7 ¾ × 9". Collection of Marty and Gloria Lynn, St. Martin. *Photograph by Marty Lynn.*

98. *Lady with Mango* (1987). Watercolor with collage, 22 ½ × 30". *Photograph courtesy of Romare Bearden Foundation.*

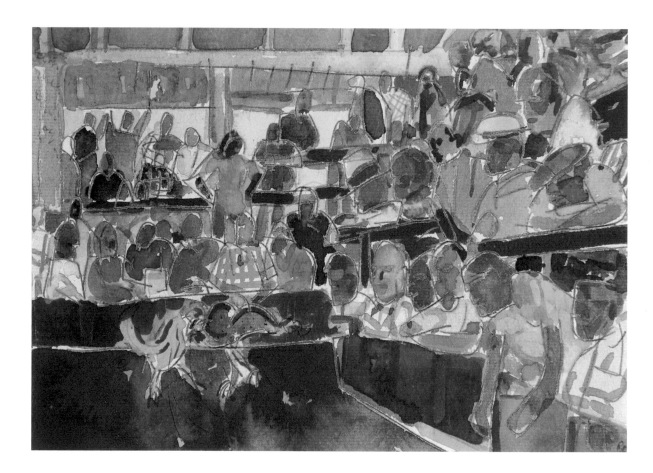

101. *Island Cock Pit* (1982). Watercolor and graphite on paper, 7-3/8 × 10 ½". Collection of Cyndee and Robert Patterson, Charlotte NC. *Photo courtesy of Jerald Melberg Gallery, Charlotte NC.*

100a-d. Untitled drawings (n.d.).
Ink on paper, **(a)** 7 × 9", **(b)** 7 ½ × 9 ½",
(c) 7 ½ × 9 ½", **(d)** 7 ½ × 9 ¼".
Collection of Wendy and Westley
Chapman, New York.
Photographs by Anna Ubell-Garcia, courtesy
of Wendy and Westley Chapman.

a

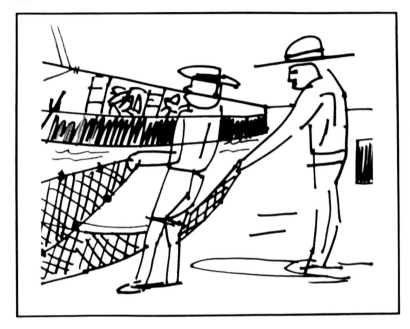

b

c

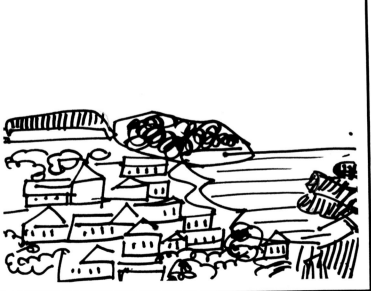

d

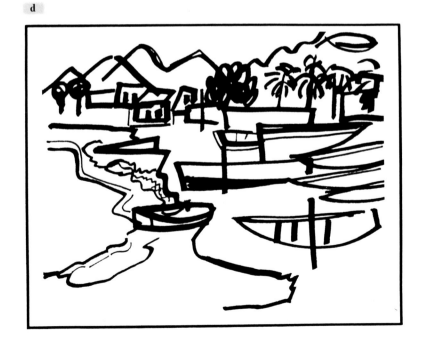

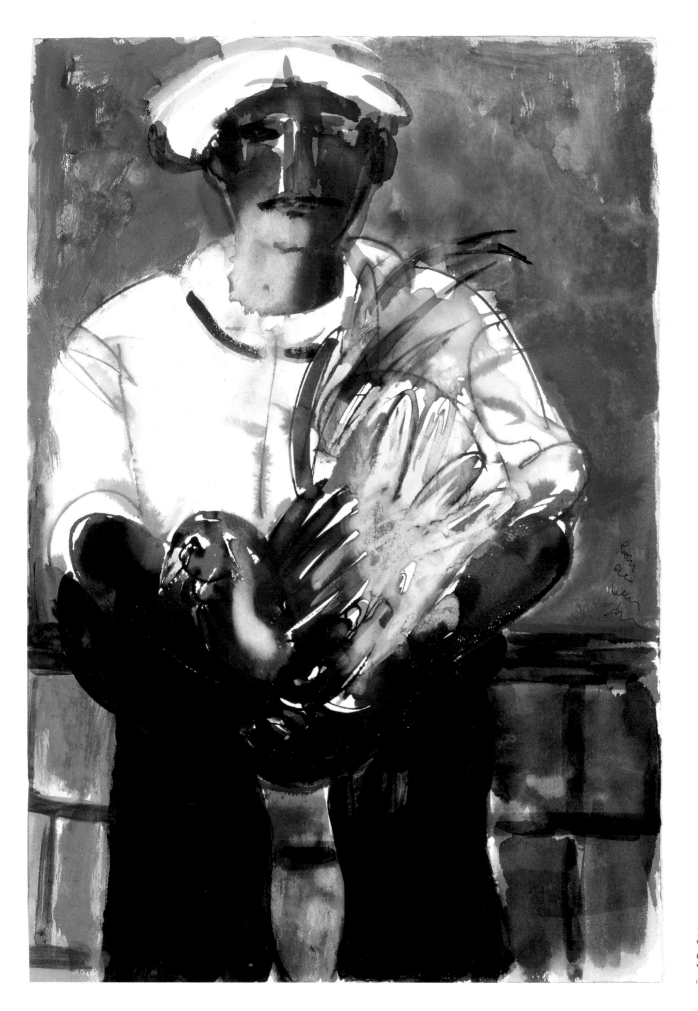

102. *Man with Cock* (1984).
Watercolor, 30 × 20".
Collection of June Kelly, New
York. *Photograph by Becket Logan,
courtesy of June Kelly Gallery.*

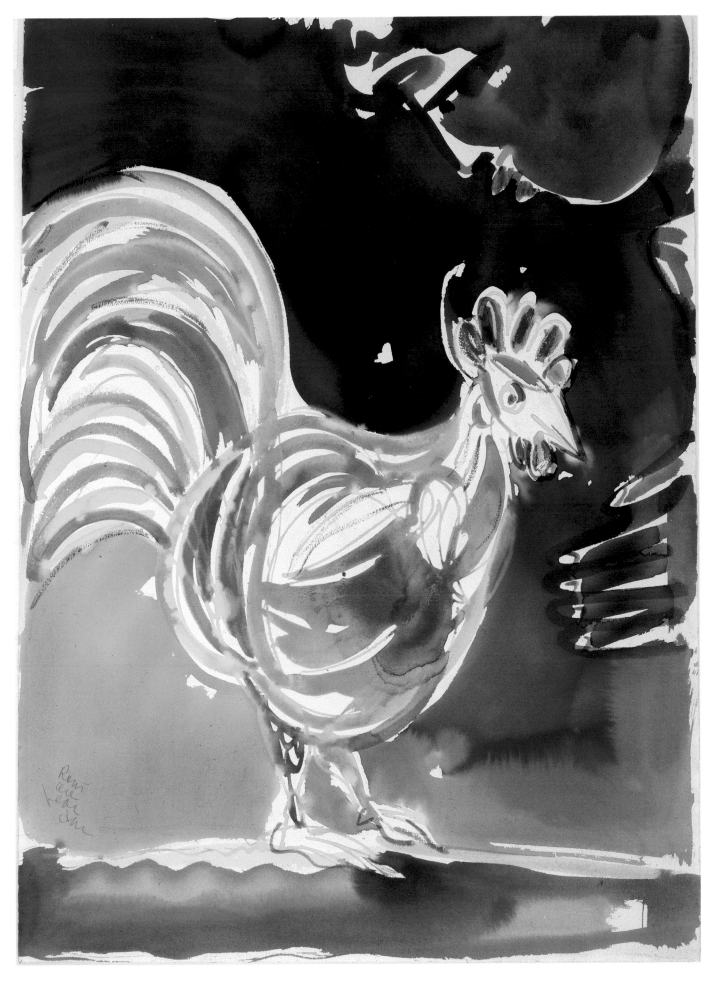

103. *Nanette and Freddie* (n.d.). Watercolor, 30 × 22".
Photograph courtesy of Romare Bearden Foundation.

Going to the Edge: Rituals of the Obeah

In 1984, for a few intense weeks, Bearden became wrapped up in some of the deepest of Caribbean mysteries, exploring the smoky, shadowy, often-invisible spirit-world of "the Obeah." For the first time in his Caribbean work, he dared to follow the approach he had developed during the past two decades in the Mecklenburg and Harlem collages, choosing "to penetrate the interior of the lives he portrayed and, having pierced the skin of those day-to-day lives, connect his people and events to larger more universal themes." On his return to New York, Bearden evinced tremendous excitement and energy as he showed the paintings to Myron Schwartzman, who later recalled:

In October [1984], he exhibited *Rituals of the Obeah*, a striking series of eighteen watercolors, at Cordier & Ekstrom. He had painted each piece using a volatile mixture of water-color cut with benzine, which dried on the paper within minutes. The subject matter of the series, coming at that time, seemed a radical departure to those expecting the Bearden of Mecklenburg memories. This suggests again that Bearden had been ready to switch up, to regain the element of surprise within himself, to go to the edge.

Michael Brenson, reviewing the exhibit in the *New York Times*, used similar language:

The figures seem invaded by magical forces; the paper seems occupied by stains. While the subject of these water colors is a world beyond rational understanding, the water colors seem themselves to have been given form by something outside reason. If the Obeah holds such an attraction for Bearden, it is clearly because its mixture of rules, improvisation, trust and sacrifice is characteristic of art-making itself.

Critic Eric Gibson got closer to the paintings, observing (in *The New Criterion*) that Bearden had abandoned "the calm, ordered world of retro-

spection [characteristic of his Mecklenburg work] and the Cubist-derived syntax of the collage form, for an expressionism that addresses itself to subjectivism of another sort, namely the magical, otherwordly realm of the imagination." For Gibson, the shift from the sharp edges and clearly defined form of collage to the "overlaid washes of pigments within which figures and images are loosely drawn... and emerge from and sink back into a lurid, hallucinatory world, a dreamlike space" is crucial in depicting a world that is not "ordered, rational, and physical." The looser, less structured medium corresponds to the evocation of otherwordly experience. Gibson noted that in Bearden's earlier, autobiographical work the strong dream-like quality corresponded to a memory-state, an "evocation of adolescent sensation," but that the dream-like quality of the Obeah

series was less a vehicle of reminiscence than an instrument to explore a mysterious, invisible world, a world of "visual richness and spiritual unease."

Bearden appreciated Gibson's reaction to his work, calling it "very discerning," and taking the time to write him from St. Martin to enlarge upon the way that the thinking behind these paintings pulled together his Caribbean experience, art historical study, interest in Greek mythology, and ties with the U.S. South.[1]

While the [Haitian] Voodoo ceremony has its African antecedents, the practice is essentially linked to Catholicism. A person's relation with the Obeah, on the other hand, is more person to person. When I studied the Dutch painters to see how to place people and objects in an interior, so many of the works depicted a doctor attending a love-sick young woman. I'm sure you've seen paintings of Jan Steen with the wan young girl her head pillowed on the bed, the doctor feeling her pulse, the wise old

woman smiling to his rear, and if you missed the point there was a painting on the wall of Venus and Adonis. Well substitute an Obeah for the doctor, especially should vengeance be a priority, and you can understand what I mean...

I'm afraid one of the island national treasures the "Obeah" are about doomed, not only by the need for ever more space but also the fact that rationality has entered with its concomitant of a lack of belief in such things as ghosts, jumbies, loas, and all those elemental and evil spirits... The Obeahs keep to themselves, no one wants to be close with them, at least among the still "true believers." In the French Caribbean, I suspect Guadeloupe is their last refuge, before they too join Demeter, Poseidon, and the others in the realm of myth. So as Coleridge referred to "that willing suspension of disbelief," I tried to touch imaginatively on the contours of the Obeahs way of life, just as I tried to depict the old South of my youth without the juleps and mildew.

He elaborated on these themes in a 1984 interview.[2]

In the Caribbean ... people still believe. When you stop believing in the gods, they pack their bags and

1. This is one of Bearden's quintessential statements of what art historian Richard Powell has characterized more generally as the "cross-over impulse in black diasporal arts," which Powell traces to "Sartre's betrothal of Negritude with the universalizing philosophies and symbols of the ancients — especially those associated with the musician and poet Orpheus" (1997:110-111). Bearden is one of those artists, like Walcott, who seems to have found the connections early and largely on his own.

2. Myron Schwartzman very kindly made us cassette copies of the interviews he conducted with Bearden on the Obeah paintings in September 1984 and October 1986. In what follows, we quote from the tapes rather than from Schwartzman's chapter, which more than occasionally smooths out or elides Bearden's words and thoughts.

go someplace else! They say, "You don't believe in me; you don't want me; it's time to check out!" So, Zeus, and Poseidon, and all the rest of them take off. But with [the Obeahs], however, you enter into something else. Freud and Jung and these men who tried to probe the unconscious stirrings that go on in all of us. ... I think these [Obeah] people, and what they believe in, are down deep into our consciousness in that way. Sometimes to consider it all, if you are from a rational perspective, can be rather frightening. My wife Nanette won't go near them!

Much of the power of the Obeah series stems from its resonances, for Bearden, with these ancient and universal themes. But there are further echoes. Al Murray, who was estranged from Bearden during the time he painted and showed these images, nevertheless wanted us to know that, in his view, "The Obeah series was foreshadowed a long time before with the 'first things,' the Conjur Woman.[1] Out of that, [Murray continued,] I invented the theme: 'the

Prevalence of Ritual.' Which I was playing, 'cause this bitch [that RB painted] looked like a witch and it reminded me of the prevalence of *witches*. And so – but then my whole thing is ritual! – 'The Prevalence of Ritual.' And then Romie, he's right on it!" Which he was. Mary Schmidt Campbell noted that the "prevalence of ritual" was Bearden's name for his philosophy of art and that "it remained the unifying basis of his art until the end of his career." Ralph Ellison, in his own words, characterized his friend's images similarly, as "abiding rituals and ceremonies of affirmation."

Ritual and ceremony had always been part of Bearden's life. As Murray writes,

He spent his early years in the bosom of the church, as the old folks in the pews used to say, down home in Mecklenburg County, in the center of Charlotte, North Carolina; and in a transplanted downhome neighborhood in Pittsburgh. In these sur-

roundings, exactly as did those who grew up to become leaders and sidemen of the great bands that conquered the world for American music, Bearden heard and absorbed the spirituals, the traditional hymns, gospel songs and amen-corner moans in context and conjunction with the prayers, sermons, shouts, testifying shuffles and struts that made up the services and the rituals that gave rise to them in the first place. As a child he imitated or choreographed the work chants, railroad rhymes and field hollers, which, along with the music of the kitchen, the wash place, the fire circle, the street corner, the honky-tonks and dance halls, were the secular complements to church music.

In a discussion in which Bearden played a part, his Paris friend James Baldwin elaborated on the ways that African Americans resituated such Christian rituals within what he called "the world before Europe."

It always struck me that out of that church which, after all, we were forced to accept – one thing that black people did with it was to recog-

1. Bearden wrote of this figure that appeared in his work of the 1960s and 1970s:
"A conjur woman was an important figure in a number of southern Negro rural communities. She was called on to prepare love potions; to provide herbs to cure various illnesses; and to be consulted regarding vexing personal and family problems. Much of her knowledge had been passed on through the generations from an African past, although a great deal was learned from the American

Indians. A conjur woman was greatly feared and it was believed that she could change her appearance." (1969:17) And he added, "Even in Pittsburgh, living in the house in back of my grandmother's there was an old woman much feared for her power to put spells on people."

nize all the symbols we were given – birth, resurrection, death – and take them completely out of the Christian context and take them back where they began – the world which was called "pagan" or the world called "Africa," or whatever you want to call the world before Europe.

Bearden had long felt that the surreal – what Alejo Carpentier called *lo real maravilloso* (magical realism) – was an essential part of his own inheritance, just as it was for the people of Haiti for whom Carpentier had coined the concept.

As a Negro, I do not need to go looking for "happenings," the absurd, or the surreal, because I have seen things that neither Dali, Beckett, Ionesco nor any of the others could have thought possible; and to see these things I did not need to do more than look out of my studio window above the Apollo theater on 125th Street. So you see this experience allows me to represent, in the means of today, another view of the world.

So when Myron Schwartzman, struggling to understand Bearden's attitudes about the Obeah, asked whether he was saying that witches, conjur women, and Obeah really should not be thought about in terms of good and evil – and that they don't conceive of themselves that way – Bearden answered: "Exactly. Nor does nature! We feel a storm, or lightning is bad, but it's not so in nature. When some tension builds and it has to be relieved, and we have a storm or lightning, it is just nature reinforcing itself. It might hit us, or burn a building, but nature's not concerned with that." And when Schwartzman asked once again whether there was, in the Obeah, nothing particularly good or evil, Bearden said:

To me, they were beyond that. It's just in another realm, that goes way back. As rationality takes over, or what we call that, obviously they will be gone. But these are the people who are one with this still...
 I don't put a mask on their face because their face is a mask. It isn't necessary to do that. We are all dual personalities... I think that Oscar Wilde said something to the effect that the life many of us have to live is not really our life. And so the Obeah has transformed herself into this masklike figure to be commanding – you see, to have power which they believe over the occult; the ability to turn back certain facts of nature, to stop illnesses, or if you're cut, to stop the bleeding. They believe that. They can have control over this thing. So they have transformed themselves into that which gives them this extra power, the mask. They become a different person from which they started, through these things – initiations, dealing with the ancient powers, living in a certain way which they don't want too much contact with the present world. The things that they have, the bush tea that they would take. They live as someone elemental, or with nature. You know, with snakes, the projection of psychic power.

Bearden consistently spoke of the Obeah as representing something that was at once deeply human, ancient, powerful, irrational, and doomed to disappear before long.

With the Obeah, you had people who were holding on to an irrational set of values that Freud and others feel is still present in man. If it weren't we would no longer have the killing machines, the machines of war... There is this thing that is still present within us, this element that we haven't eradicated yet – the irrational.

A fellow told me that [he and] his mother went to see an Obeah man; I think it had to do with his father: a dispute between the mother and the father over a girlfriend of the father. And the Obeah said, "Yes, this man wants to kill you" to the mother, "because he has fallen in love with another woman." She said, "What can I do?" And he enumerated certain herbs which the mother knew how to get in the mountains. Then it would be put in his tea, in his bath. The Obeah said this would give her control over the situation. She asked, "Would you come home with me, to see what you could do?" And he said, "No, because he knows that I am here, and he wants to kill me." So she said, "No, that's impossible, because I never told him, and he has no way of knowing that you are here." They started walking down the road and about halfway, the Obeah man wasn't there any more. They couldn't figure out how he had disappeared. But when they

got home, his father was sitting on the steps with a machete to kill the Obeah.

So this is what I mean about the Obeah. They live in terms of people who would believe in them. In the face of Western scepticism, their power is lessened. And that's why I say that now they live very much to themselves, because obviously they still believe in themselves.

Bearden's Obeah paintings are the most personal of his Caribbean works. Inspired by island realities, they are far less ethnographic documents or records of things seen than they are expressions of feelings the artist allowed the rituals to conjure out of the depths of his consciousness. The acknowledgment that he was a rank outsider about such matters permeates every utterance Bearden made about the Obeah. When Schwartzman asked him how old he thought "that religion" was, Bearden shot back: "It ain't a religion!... There are initiates into it – but I think

it's *sorcery*... I'm not an expert... I want to get these other things [a video he was expecting to see] because what I'm telling you may not be authoritative." And when Schwartzman tried to get him to describe the special, presumably mystical "frame of mind" he imagined Bearden needed to put himself into in order to paint the Obeahs, Bearden responded immediately, "the frame of mind of an artist."

I can't think of adjusting myself to any particular frame of mind... You do things, you mess up. Because if you had contact with them [the Obeah], or anything, or went to the zoo, you'd have feelings about a bear or an animal that you'd seen. So all that I was trying to do was not to give you a documentary of how they proceed. It's just my *feelings* and how I see them. A lot of things are in that sense invented. But it has to do, let's say, with Obeah life, you see?

When Bearden was asked to elaborate on the idea that he didn't need to put masks on

his Obeah figures, he stressed his own interpretations of their life.

It's because they're living in-now but not-now, in a now that is a not-now. So to live their life and say "I don't want your values and this and this and this" is in the sense that they have to have a mask. They've made themselves into that. ... And they live in their own particular society, their own beliefs, their own initiations, which I don't know at all.

And as we've noted, Al Murray concludes more generally that "However suggestive they [the paintings] may be of persons, places and things or even of situations and events, actual or mythological – [they] are by Bearden's own account always far less a matter of considered representation than the result of on-the-spot improvisation or impromptu invention. ... Imitation of nature is irrelevant to the aesthetic statement that Bearden wishes the picture

to make." Bearden reiterated the theme in regard to the Obeah, in a 1986 interview:

You know Mecklenburg and these new Obeah that you are looking at are different but I think interrelated in that both deal with myth and ritual. The lady, I think "Mrs. Sleet" is what I used, have used, frequently in my work, would be appalled at the Obeah people. You know, they don't go to church, they got all this mystic junk. The way I presented her is not as she was, probably, if you had a photograph of her. But she is not a *figment* – that would be the wrong word – but a *fixture*, I should say, of my imagination. And I've given her ... surrounded by the flowers and things. So it's the same as the Greeks and the Romans who put a goddess in that kind of setting. Flora, I would imagine they would call it. So this is "Mrs. Sleet."... It is up to the artist to make it more real: more real than the reality of things. You try to do it with art.

By the time he decided to paint his Obeah images, Bearden had been living in St. Martin for a dozen years. He would have heard countless stories about

the ways Obeah intervened in people's daily lives – in affairs of love, in moments of intense envy, in rivalries, and in wish fulfillments. Some of the stories involved respectable people – a school principal caught in the snares of an Obeah manipulation, a political scandal. He'd heard a good bit about the campaigns of the French Catholic priest against the *vaudou* temples of the Haitian immigrants, which were destroyed by order of the Prefect in the early eighties. But mostly, in 1984, he was spending a lot of time chewing the fat about root doctors and Obeah with anthropologist Joseph Thomas, who was conducting doctoral research with the Haitian immigrant community and boarding in one of the Bearden houses. Thomas and Bearden shared a heritage of growing up in the black, rural South and relished each other's company. Thomas – who had honed his culinary skills at the

knee of his father, a professional chef – ended up doing a lot of cooking for the Beardens that year.

After the Obeah paintings were shown, Bearden's friends on the island – Fabian Badejo, Lasana Sekou, Ras Mosera – assumed that Thomas had been his cicerone to Obeah ceremonies, his link to the rituals of the Haitians and those few St. Martiners still practicing Obeah. (Badejo assured us, "Thomas collaborated very closely with Romie on the Obeah series.") Indeed they told us of some of the places and people they imagined Thomas must have taken him. But once we finally tracked him down, Thomas himself offered a different perspective, explaining that as far as he knew Bearden had likely never even seen an Obeah – or if he had, perhaps just once. And in any case, he'd never taken him to a ceremony, nor had

Bearden ever told him about such a visit.[1] Thomas explained, however, that during the weeks Bearden was painting these works, the two of them *talked* constantly about related themes and that Bearden would show him, and tell him about, what he was painting. Thomas also said that Bearden was simply enjoying some good storytelling when he told Schwartzman about, for example, the woman and the anaconda (see below) or about the priestess's headdress ("She had lived in Nigeria for seven years, and so she had brought back some of the things that the high priests there had given her"). And Thomas insisted that Bearden, in the Obeah images, "was not documenting ethnographica – he was painting what he imagined the Obeah were about, what they meant to him."

Ras Mosera gave his own personal take on the Obeah series.

Strangely, in his work, I realized he touched the essence of what's supposed to be black, you know? The magic, you know, the magic of a people. Like a person trying to reach Apollo or Zeus, a magic of the psyche... I think his obsession with the Caribbean – he thought the energy's coming from the Caribbean – I think if you're really obsessed with the Caribbean, you couldn't overlook *quimbois*, Obeah or Voodoo. You have to try to understand that, you know. And as an artist, in his magical state as it were, he saw this as a weapon to be used. He was a magician! He was like a kind of doctor, trying to heal the psyche of a people. Show a kind of pride and hold it. So the backyard rituals and the Obeah was his way of saying that.

At the time Bearden was working on his Obeah paintings, St. Martin's population of ritual practitioners (*oungans, mambos, obeahs*) was divided among Haitian immigrants, a few people from the Dominican Republic, and native St. Martiners, with a roughly equal number of men and women. Since the destruction of their temples a couple

1. In tape recorded interviews with Myron Schwartzman in 1984 and 1986, Bearden claimed to have spoken once with a female Obeah and witnessed a seance that involved trance: "I did try — in some of these places ... I did see them go into trance." And Harry Henderson told us, "He said he went to — I'll call them ceremonies, or whatever they were — and that they really gripped him. And he was really glad he'd gone, because it was a real experience. It was not a circus where there were performers. And that he liked

painting those things. This was an *inner* demand on Romie's part." We tend to believe Thomas (who was with Bearden at the time) that these stories were the product of Bearden's well known skill as a storyteller and his gift for portraying scenes that he never witnessed in person; Ruth Fine points out, in a similar vein, that other important sites of his visual world (Chicago, Kansas City, New Orleans, and the Louisiana bayou) were places that he seems never to have visited (2003:8)

of years earlier, Haitians (and Dominicanos, who practiced a similar form of *vaudou*) were engaging in small-scale consultations, in which a practitioner would sit in front of a table, conduct divination, and go into trance – often with the aid of a tape cassette playing ceremonial music from back home. Once the problem was identified, a solution – for example, a ritual bath – would be prescribed. Native St. Martin practitioners were involved in a similar vocabulary of symbols (though they also read tarot cards and gazed into magical mirrors) and prescribed broadly similar remedies.[1] The discourse of Obeah, though never considered "respectable," was nevertheless ever-present, providing the standard hermeneutics of daily life, the stock explanations of why particular relationships, commercial dealings, or political affairs developed as they did.

Bearden's decision to speak generically of "Obeah" (rather than, say, *vaudou*) followed local Anglophone St. Martin usage. As Ras Mosera, born in St. Lucia, put it: "*Vaudou* belongs to Haiti. Shango belongs to Trinidad. Obeah belongs to <u>everybody</u>. And St. Martin has the whole Caribbean in it... I think Bearden is talking about the Caribbean in general. I think he floats."

Bearden was also thinking about Brazil, particularly *Black Orpheus* (1958), with its dramatic and visually-luscious *Macumba* ceremony, which he recalled to an interviewer in 1986 apropos of his Obeah paintings, calling the ceremony in the film, "Obeah." (Richard Long told us about a New Year's Eve he spent at home with the Beardens in St. Martin in the early 1980s. Romie, seeking something festive to do after dinner, pulled out his cassette of *Black Orpheus* and they all trooped over to the house of Nanette's sister, who had a VCR, to bring in the new year watching the film.) Richard Powell has stressed the film's impact on the imagination of Bearden's generation, arguing that it was responsible for establishing the ultimate accord "between blackness and the universality of the Western world's classical heritage."

Adapted for the screen from the stage play *Orfeu da Conceição* (by the Brazilian poet Vinicius de Moraes), *Black Orpheus* transplanted the ancient Greek legend of the ill-fated lovers Orpheus and Eurydice to modern-day Brazil and its mostly poor and illiterate descendants of African slaves. Director Marcel Camus placed this archetypal story about love, death, fate, and perpetuity in Rio de Janeiro during Carnival week. With the added attractions of an irresistible Afro-Brazilian music soundtrack, a talented and handsome cast of black actors, and a part documentary/part theatrical format filmed in dazzling Eastmancolor, Camus turned *Black Orpheus* into an instant film classic and a huge commercial and critical success with

1. We thank Catherine Benoît and Joseph Thomas for some of these details.

international audiences. Camus's borrowing of the title and tenor of Sartre's 1948 essay, along with his unprecedented celebration of both racial and cultural blackness (culminating in his remarkable documentary film footage in *Black Orpheus* of an Afro-Brazilian *Macumba* ceremony), transformed black culture into an entity with world-wide appeal and an aesthetic integrity of its own.

On several occasions, Bearden took pains to make clear that when he painted his Obeah images he was not depicting organized Haitian ceremonies. "I wish I could have done more ceremonial works in which more than one or two persons were depicted, however, we must not confuse the Obeah with those who practice Voodoo." What he usually said he imagined in these paintings – and what was in fact taking place in St. Martin in 1984 – were mainly the kind of intimate one-on-one consultations Bearden often spoke and wrote

about. But it seems clear that as he painted, his impressions of the *loa* of Haiti also intruded on his imagination, as did those mask-like *macumbeiros* of *Black Orpheus*. Bearden recalled the climax of the ceremony in the film: "And if you look at it, his face is that of a mask... He had this cigar, and his face was a mask. And he wasn't in this world at all. The face belonged to some great-great-grandfather, way back." That summer, when he thought ahead to selling his paintings, Bearden first asked Joseph Thomas, and then an employee at the Haitian consulate in St. Martin, to translate each title into Haitian Creole and French, to lend them a flavor of greater authenticity.[1] And he wrote Ekstrom, playfully, to let him know that he had just completed "quite a few large water colors. Some, I've done, have been around the Obeah women

(the French Caribbean counterpart of the Conjur Women) – & maybe I'll do some – the French word I can't spell – of witches – they have them here – But America burned all of them before I came along. We do waste our national treasures."

While protesting his own relative ignorance of the details of Obeah practice, Bearden showed an almost reverential respect for the privacy of practitioners and their right to maintain their difference. (He did see them as "treasures.") In 1986, looking back on his personal and artistic engagement with the Obeah, he concluded,

It's best not to intrude any more, and let their ground be sacred to them. I don't want to get to that attitude that you find so much with Americans, and other people now – people getting grants to come down and study the Obeah. "I'm going to be there and I'm going to make friends with them. I'm going to be really nice and show them I don't intrude on what they're doing." All the right things

1. Thomas told us how he had worked, at Bearden's behest, with Haitian "informants" to develop the Creole versions but that Bearden then went to the Haitian consulate to have them officially edited. The published Creole titles, supplied by Ulrick Lafontant, read like word-by-word translations made by someone unfamiliar with local realities. Haitian immigrants (as opposed to upper-class diplomats) in St. Martin would never have spoken, for example, of "*sorcières*."

104. *Three Obeahs* (*Trois Sorcières, Twa Manmbo*) (1984). Watercolor, 30 ⅛ × 22 ⅜". *Photograph courtesy of Romare Bearden Foundation.*

that they would say, that are wrong. Do you follow? But I will say this: that we all cast a shadow, and sometimes we look backward. And I think this was like the Obeah – they are part of our shadow. That part of me is gone, or killed. That me is over. I think we have a lot of I's or me's – we look backward sometimes and find these things that are not in the light of reason.

We have seen some forty paintings relating to the Obeah – the eighteen that made up the 1984 Rituals of the Obeah exhibit, another (*Secret Initiation*) that Bearden showed and spoke about in the same breath,[1] several that are variants of those in the exhibit, and a number of works with Obeah themes (and titles) that were done in 1985 and 1986, and which Bearden considered less successful.[2]

1. In a September 1984 interview with Schwartzman, Bearden talks about "The Return of the Viper," describing how he'd changed it since Schwartzman last saw it, cutting out her lower body to emphasize the Obeah's face. We've never seen another reference to this title, which seems in the conversation to be a central part of the Rituals of the Obeah series.

2. In a 1986 interview, he spoke about why he had never recaptured the intensity of those 1984 paintings: "I didn't do it so successfully after that, because... I remember reading an interview with Picasso — he'd been to see a garden with lilacs, or something. So he said, 'I had the color purple — it had come out of the garden — but I had to get it out of my system!' And I believe if you're around this [Obeah], you have to get it out, and that's it! To be able to go on and do more, you'd have to associate yourself more with that." (recorded interview with Myron Schwartzman, 10/14/86)

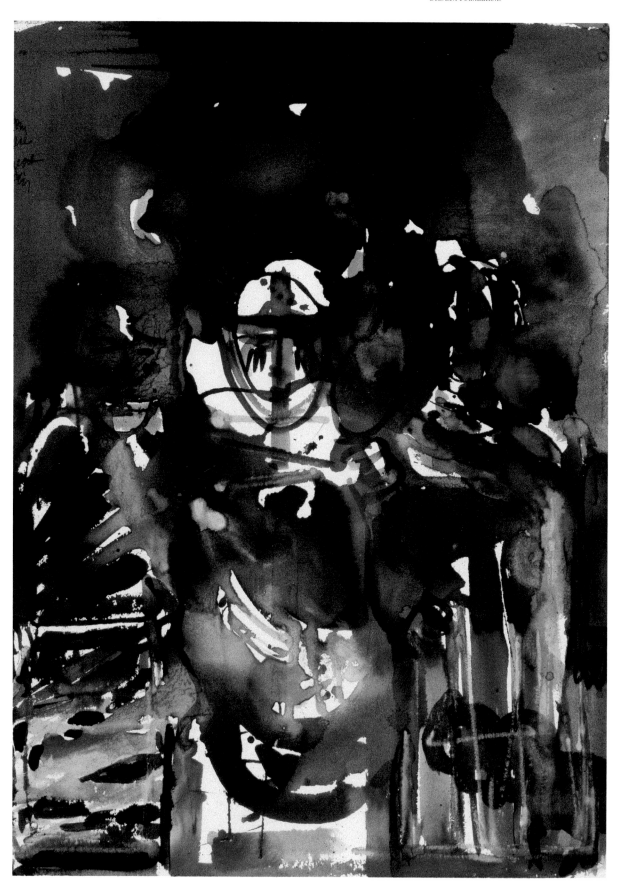

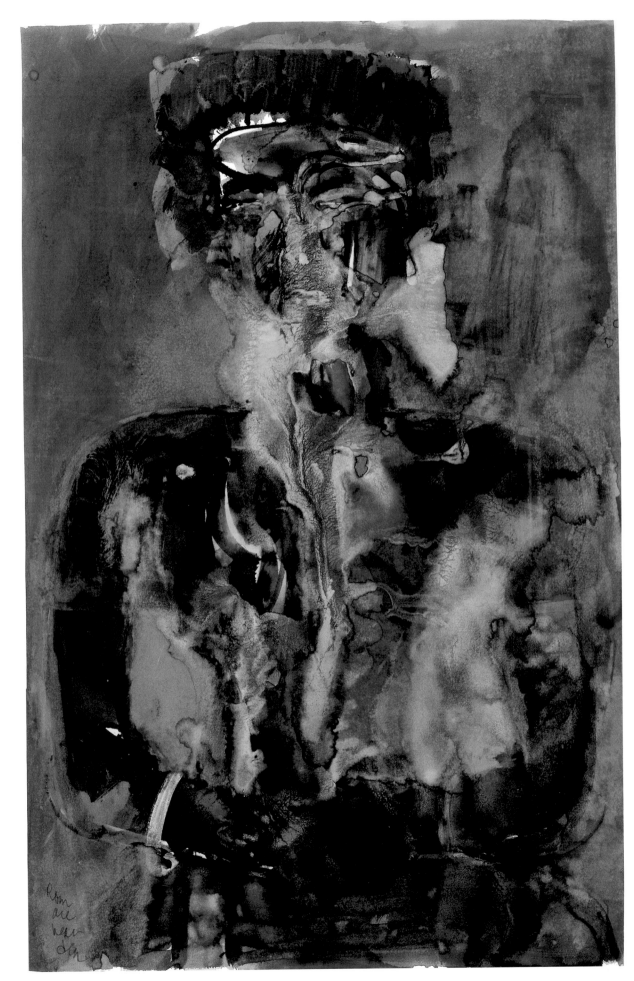

105. *Obeah in a Trance (Possession de la Sorcière, Manmbo-A Procédé)* (1984). Watercolor, 29 5/8 × 19 5/16". Estate of Romare Bearden. *Photograph courtesy of Romare Bearden Foundation.*

The catalogue opened with *Three Obeahs* (*Trois Sorcières, Twa Manmbo*). |▶104| Pointing to the one in the middle, whose arms are upstretched, Bearden noted playfully, "She's about to fly!" Then, *Obeah in a Trance* |▶105| and *Two Obeahs in a Trance*, |▶106| the first perhaps the most astoundingly other-worldly of the series. One critic noted:

As with his teacher at the Art Students League, George Grosz, Bearden pushes the figures right up to the picture plane. There is no air, no space. The figures are stuck where they are, and we cannot get away. As in the water colors of Grosz's contemporary, Otto Dix, Bearden's stains can seem to be the functionaries of evil. They run over the figures, enveloping them in hypnotic fumes. In "Obeah in a Trance," the watery murk that eats into the figure like acid tells us that her personality has been dissolved by her trance.

When Bearden was asked, apropos of *Two Obeahs in a Trance* and then *Obeah in a Trance* whether this was "a com-plete trance," he gave a grunted "Yeah, they're in a trance" to the first but added, "This other one is *gone*, out of this world! ... And how to depict this. She seemed to be just not right. And it was moving in from this into some other person or some other force that was taking possession of her. And this was the best way that I felt I could try to portray that." Two other paintings in the series, *Obeah in a Trance II* |▶107| and *St. Martin Obeah*, |▶108| are further explorations of this theme.

In *Obeah with a Bird Loa*, Bearden switched out of the deep, rich, ink-stained and smoky mode of much of the series to work in a more whimsical style with splashes of color that leave large parts of the paper blank.[1] |▶109| Like *Obeah of High Category*, |▶110| it uses black lines to define forms, recalling some of Bearden's 1940s work.[2] These two paintings also make

1. The shape of the gigantic bird spirit's head is strikingly similar to that of the right-hand figure in a 1964 collage, *Two Women in a Harlem Courtyard*. For a reproduction, see Washington 1973:79.

2. See, for example, the two 1948 paintings illustrated in Schwartzman 1990:150-151.

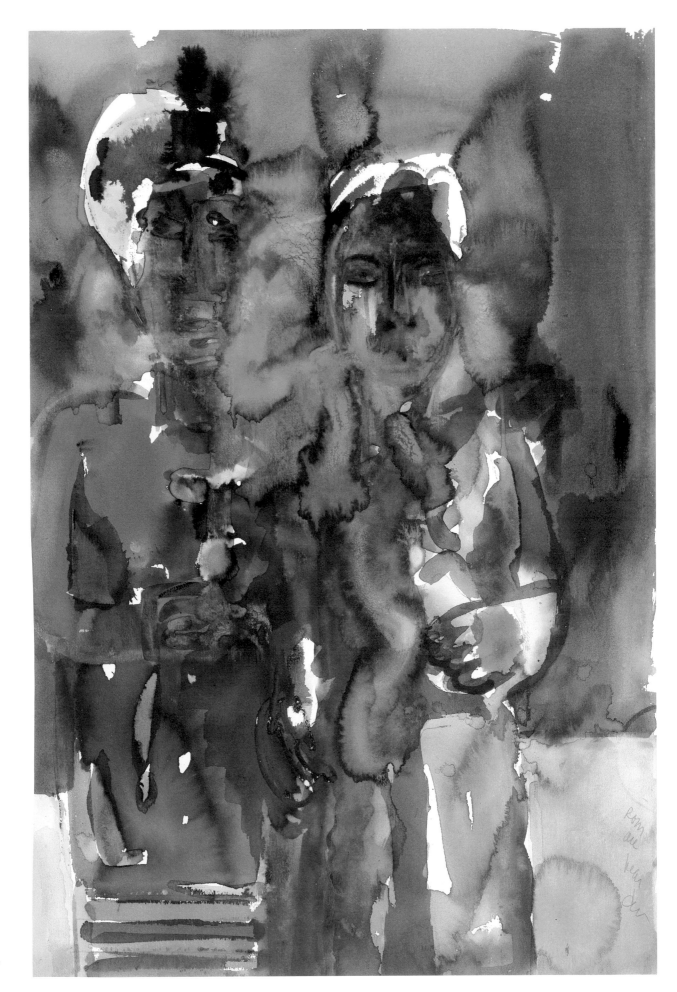

106. *Two Obeahs in a Trance*
(*Possession de deux Sorcières,*
Deu Manmbos Procédé) (1984).
Watercolor, 29⅛ × 20". The
Newark Museum, Newark NJ.
Helen and Carl Egner Memorial
Endowment Fund. *Photograph by The*
Newark Museum / Art Resource NY.

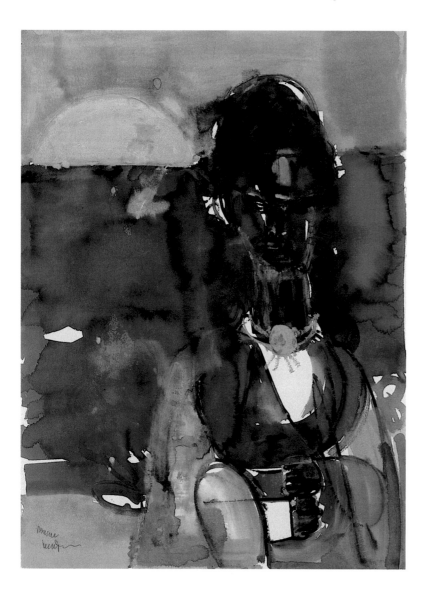

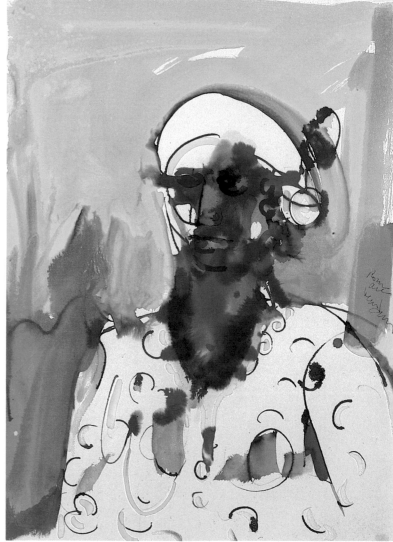

107. *Obeah in a Trance II (Possession de la Sorcière II, Manmbo-A Procédé II)* (1984). Watercolor, 30 ¼ × 22 ⅜". Estate of Romare Bearden. *Photograph courtesy of Romare Bearden Foundation.*

108. *St. Martin Obeah (Sorcier [Sorcière] de St. Martin, Manmbo St. Matin Yan)* (1984). Watercolor, 30 × 22 ¼". From *Romare Bearden: Rituals of the Obeah* 1984.

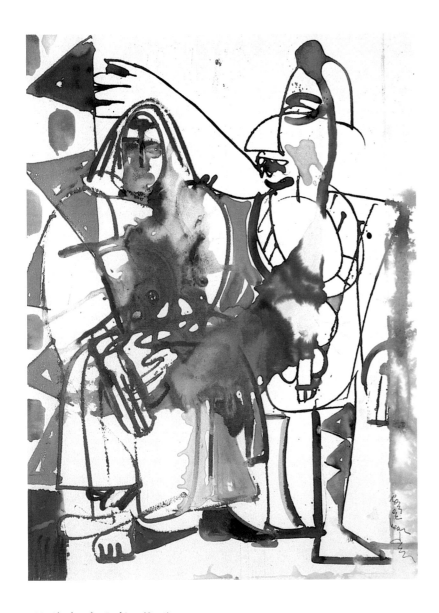

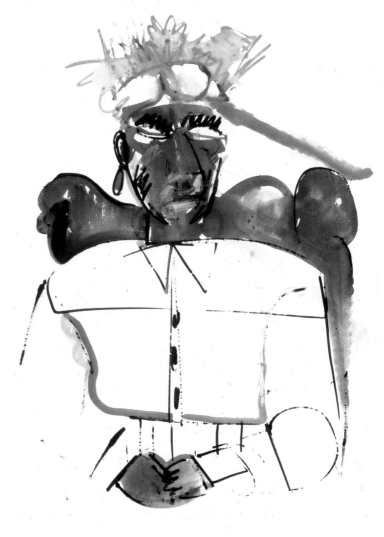

109. *Obeah with a Bird Loa (Sorcière avec un Loa Oiseau, Manmbo-A Avek oun Loa-Zouezo)* (1984). Watercolor, 30 × 22 ¼". From *Romare Bearden: Rituals of the Obeah* 1984.

110. *Obeah of High Category (Sorcière de haute catégorie, Manmbo Ho Dégré)* (1984). Watercolor, 30 ¼ × 22 ½". From *Romare Bearden: Rituals of the Obeah* 1984.

limited use of the even-edged ribbons of color that took on more prominence in several other Obeah-related works not included in the exhibit – *Obeah [Figure] with Snake and Orange Balloon,* |►111| *Sorceress with Apprentice,* |►112| *2 Obeah & a Nite Ghost,* |►113| and *Visit to the Obeah.* |►114|

In *Afro-Carib Obeah Man* |►115| and *Loa Leaves with the First Cock,* |►116| Bearden creates a kind of spectral image, achieved through a combination of rich color and the effects of light, that had long fascinated him. Bearden had been struck by Tanner's depiction of the Angel Gabriel "as radiant light instead of the conventional haloed figure" and written in admiration of how,

Increasingly, Tanner ignored natural appearance in favor of a saturated color that set the pervasive mood he wanted... In fact, he abandoned all that seemed irrelevant to his organic,

all-encompassing inner vision. A great charge of energy seems to direct Tanner's resonant color, so that even the deepest tones seem imbued with an inner radiance.

In both of these Obeah paintings, Bearden floats a central figure in front of or behind the picture plane – there but not-there – with the rest of the setting, the cock in the foreground, and other realistic elements, very much there. The Obeah man holds his glass of rum, the candle shoots out light, and the table/altar and the mirror are solidly present. Bearden, for all his concern about structure and rhythm, also considered narrative elements in these works. In showing Schwartzman *Loa Leaves with the First Cock* in September 1984, he told him apropos of the spirit's actually leaving, "This I've changed since you saw it, because this was at dawn, when the Obeah left, and I had it white up here and

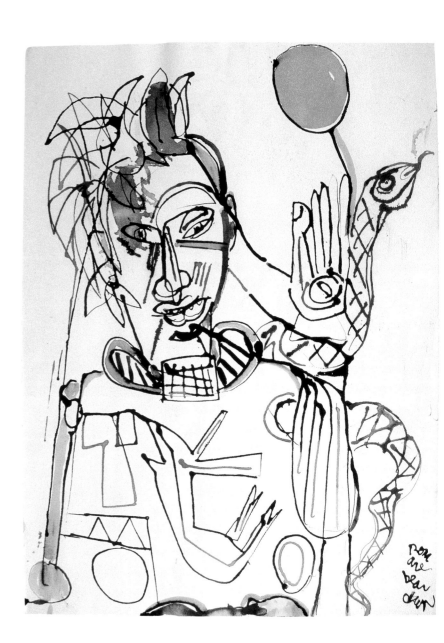

111. *Obeah [Figure] with Snake and Orange Balloon* (n.d.). Watercolor, 30 × 22 ¼". Collection of Romare Bearden Foundation. *Photograph courtesy of Jerald Melberg Gallery, Charlotte NC.*

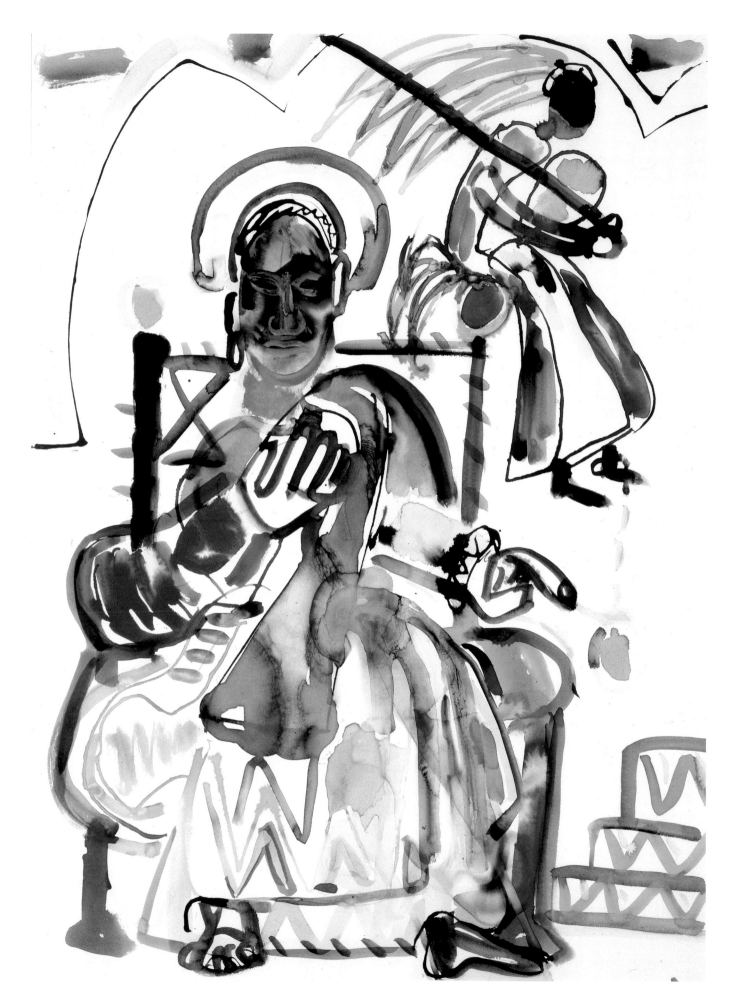

112. *Sorceress with Apprentice* (1984). Watercolor, 30 × 22".
Photograph courtesy of Romare Bearden Foundation.

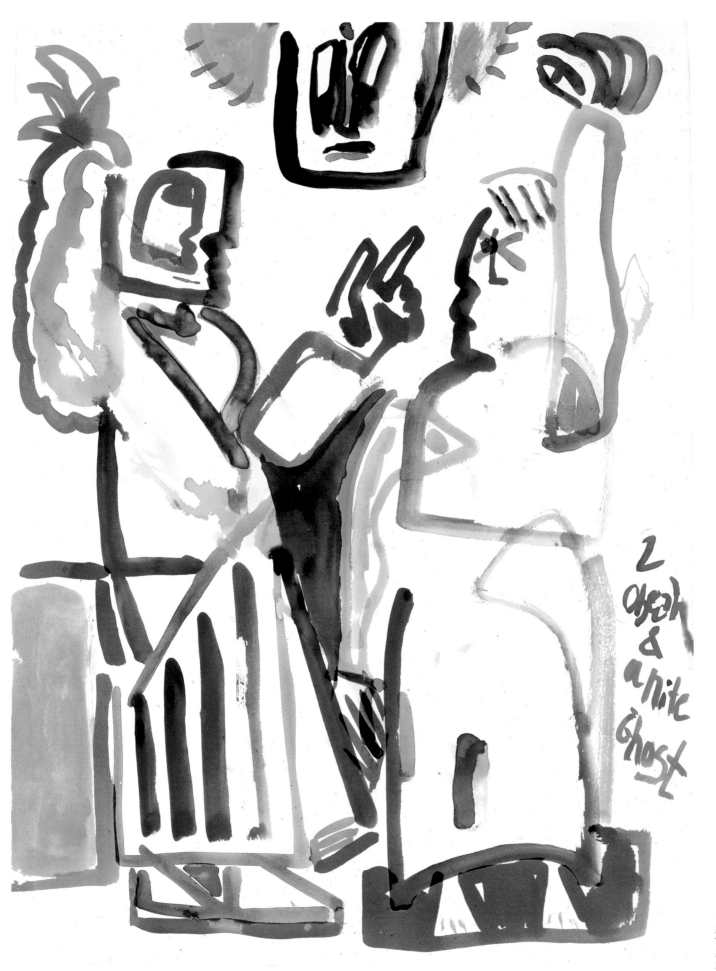

113. *2 Obeah & a Nite Ghost* (n.d.). Watercolor, 30 × 22".
Photograph courtesy of Romare Bearden Foundation.

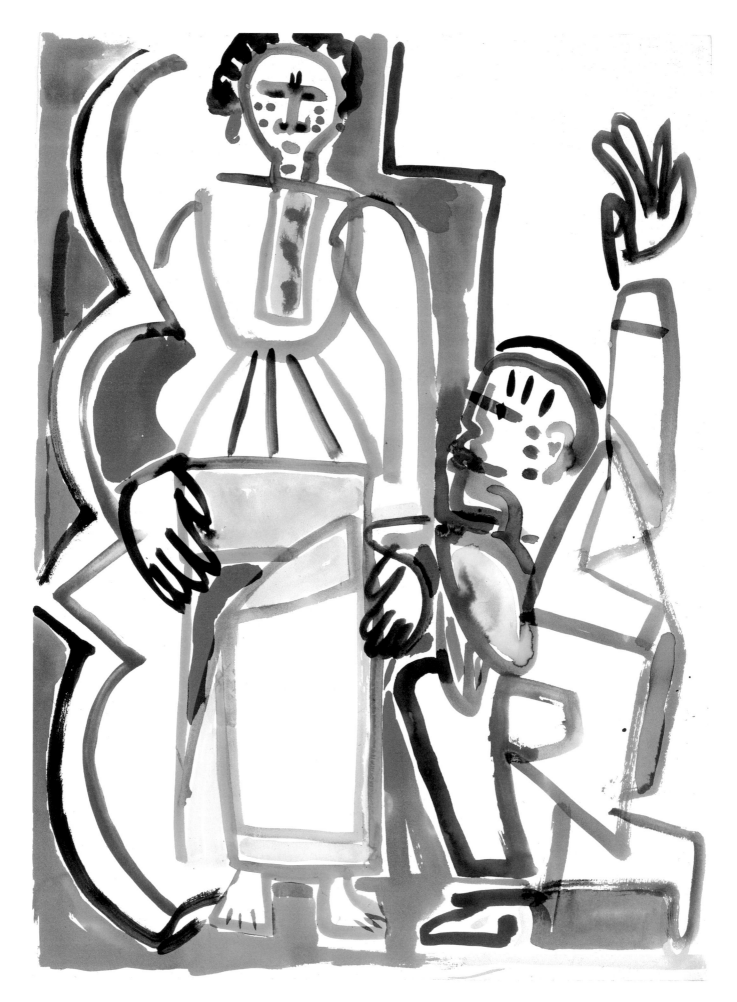

114. *Visit to the Obeah*
(n.d.). Watercolor,
30 × 22". Collection
of Romare Bearden
Foundation. *Photograph
courtesy of Romare Bearden
Foundation.*

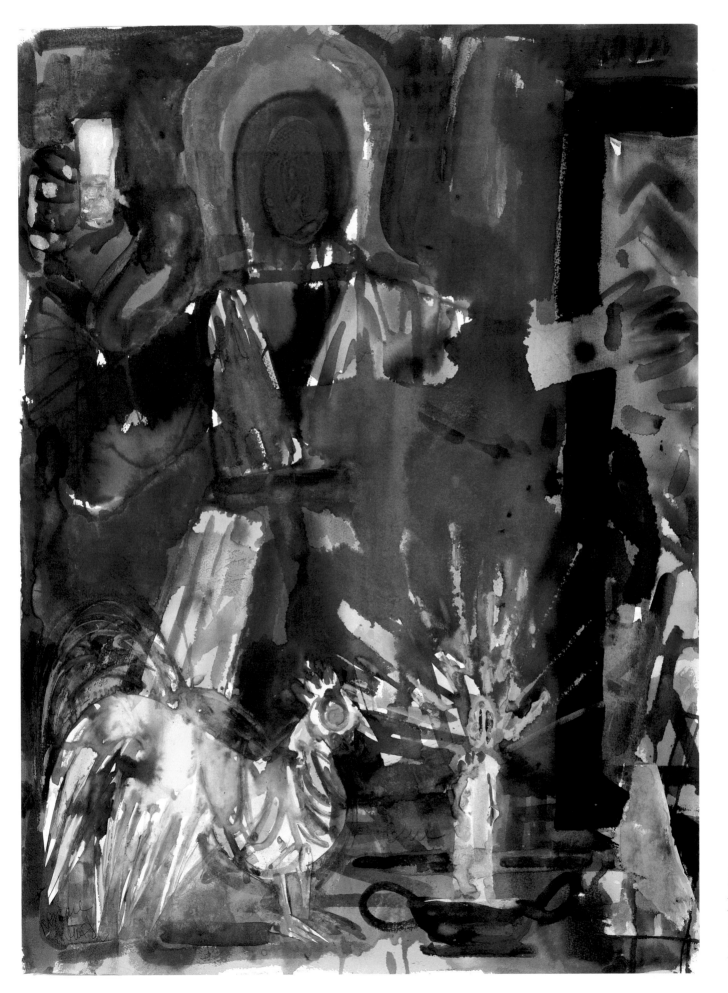

115. *Afro-Carib Obeah Man* (*Sorcier Afro-Caraïbe, Aougan Afro-Karib*) (1984). Watercolor, 30 ⅛ × 22 ¼". *Photograph courtesy of Romare Bearden Foundation.*

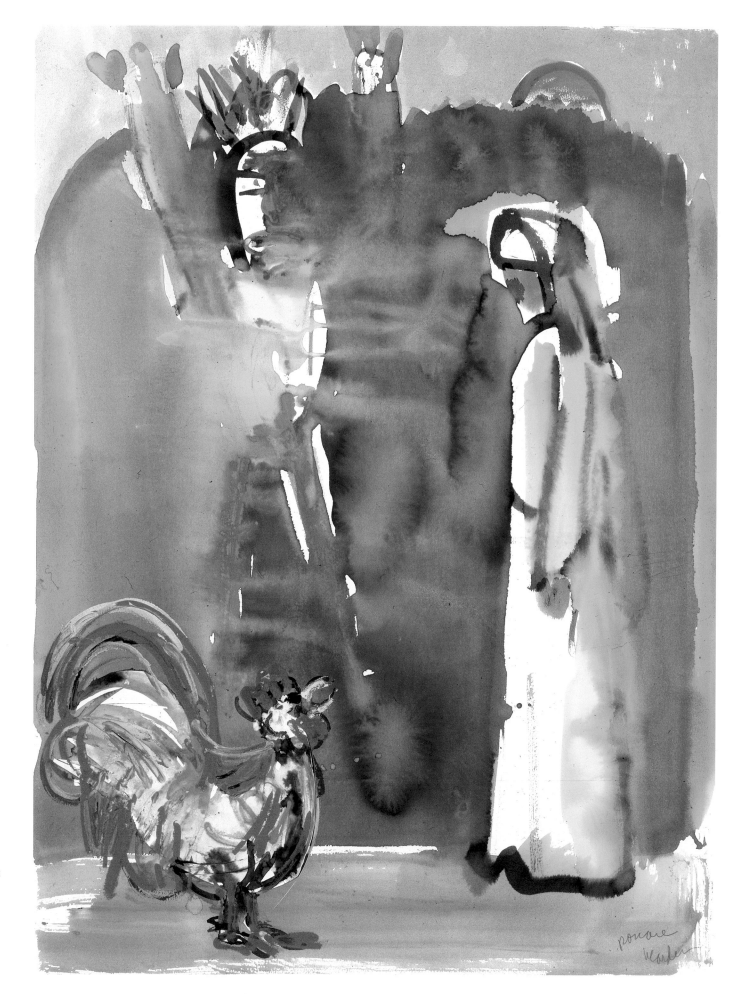

116. *Loa Leaves with the First Cock (Le Loa sort avec le premier coq, Loa-A Soti Avek Premié Kok'La)* (1984). Watercolor, 30 1/8 × 22 3/8".
Photograph courtesy of Romare Bearden Foundation.

it wasn't clear. Now I think the idea that it's dawn and he's leaving is more clear."

Marriage of the Viper, where the light bulb that is the source of light in the nocturnal scene "is the paper itself," is one of the exhibition's most striking images. |►117| Whether from experience in St. Martin (which we think unlikely) or some combination of his visits to Haiti, his knowledge of the importance of constrictors in the ritual vocabularies of Dahomey and Haiti, and the feelings about snakes and primal power that he often expressed (sometimes invoking Freud or Jung), Bearden clearly related Obeah and vipers.[1] Eric Gibson wrote that this doubly-voyeuristic work

places us in the unusual position of being both witness and participant. Here a woman stands passively to the right, hands folded in front of her, while a brilliant orange snake, coiled around her neck, nuzzles its head beneath the arm of a young woman

kneeling at the left. This is perhaps an initiation rite, for the girl is young and nubile, the older woman much plainer. But what is striking is the feeling of witnessing two separate psychological states, each of which embraces us: the detachment of the older woman, who allows the snake to act freely as the agent of this ritual, and the trance-like, subjective abstractedness of the shadowy young girl.

And it was apropos of this painting that Bearden told Schwartzman:

The Obeah woman ... she had this big anaconda in a basket. I didn't know it – I was talking to her, and the basket opened, and here came this big snake, crawling across her! So, you know, I was startled. She said, "What are you afraid of?" in French. I said "The viper!" She said, "You know what fear is?" I said, "Yes, it's that goddamn snake!" And she said, "No, fear is that which is not there." And then she hit me – pow! – someplace like this [in the chest].[2]

To which Bearden's Obeah-confidant Joseph Thomas just smiled and reminded us what a great storyteller Romie was.

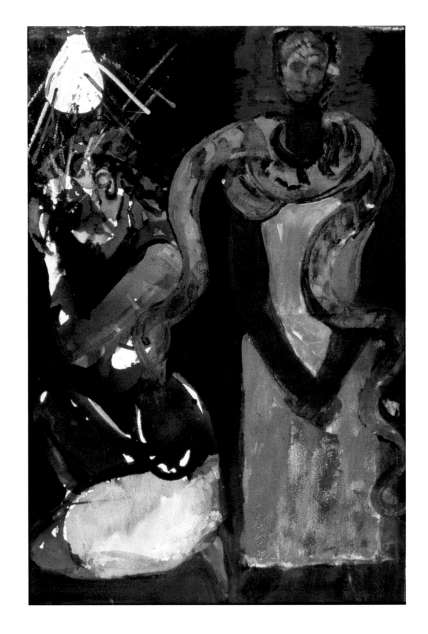

117. *Marriage of the Viper* (*Le Mariage de la Vipère, Mariaj Vipè-A*) (1984). Watercolor, 30½ × 20½". *Photograph courtesy of Romare Bearden Foundation.*

1. There are snakes in some of the Conjur Woman collages (e.g., 1971, 1975 — see Schwartzman 1990:250-251) and one even makes it into a Harlem streetscape, *On Such a Night as This* (see Melberg and Block 1980:66).

2. Bearden told Calvin Tomkins a very similar story about an unrelated incident in New York. "Another time, Bearden invited an exotic dancer to spend the night in his studio. Unknown to Bearden, her luggage contained an eight-foot python (her working costume), which got loose during the night and entwined itself around his easel" (Tomkins 1977:61). Bearden told a different story about *Marriage of the Viper* in a letter to a collector (cited in R. Fine 2003:181).

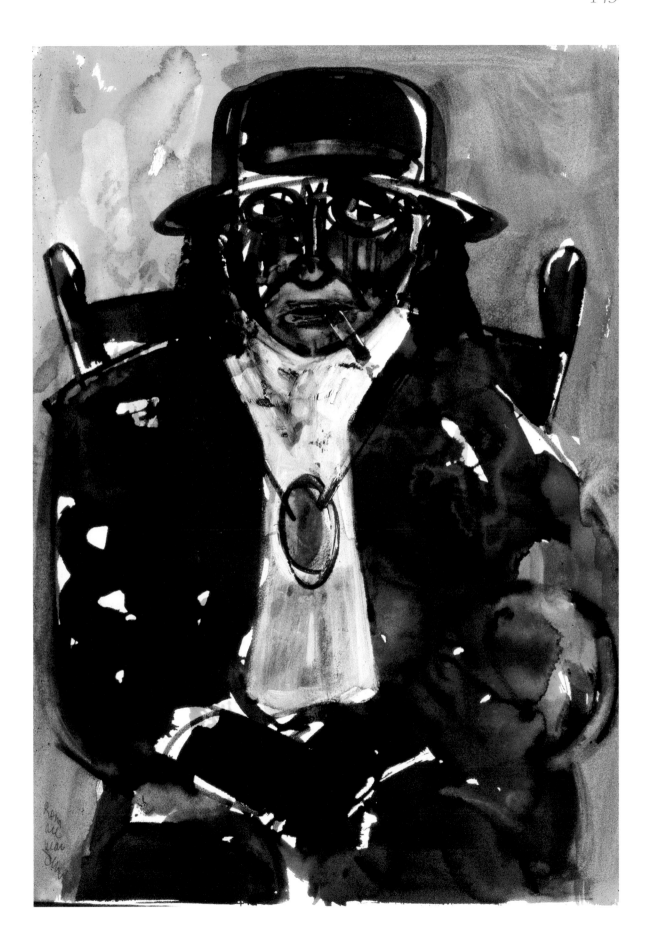

118. *Green Man* (*Homme Vert, Misié Vet La*) (1984). Watercolor, 30 ½ × 21 ⅝".
Photograph courtesy of Romare Bearden Foundation.

Bearden's *Green Man* |▶118| and the *Obeah Man with Cigar* that appears to be a study for it, were homages to *Black Orpheus*, to that mask-faced *macumbeiro* who so impressed the artist. Even as he was telling an interviewer that "Harry Henderson was by and he liked this, but he had a criticism: he thought that the face was too compassionate, that it should have been more fierce," Bearden seems to be laughing to himself – for he (unlike his urbane writer-friend) knew that Obeah didn't need to look scary.

The Obeah's Choice, charged with erotic tension, graces the cover of the *Rituals of the Obeah* catalogue. |▶119| Bearden explained in an interview, "She's chosen this girl, but then she's holding this part of her. And the girl can't go away, do you understand?... Like she's taking some part of her. If she wants to change, go into a man, or some-

body else, she's *got* her. And that was the way I symbolized it." Another strong work in the series (though not part of the initial exhibition), *The Green Bath*, exhibits similar relational tension between the nubile recipient and the older Obeah woman. |▶120| Its title describes the most common prescription of St. Martin Obeahs, a ritual bath in herbs, roots, and perfumes (*bain démarré*). *Obeah Girl with her Loa*, compositionally similar to *The Green Bath*, adds the deep blue electricity of occult activity, as the young woman is energized by the imminence of the fierce spirit. |▶121|

Our Eyes Meet, |▶122| one of the most riveting images in the series, uses the white of the paper to depict a spellbound gaze. As the *New York Times* critic noted, "Making the paper an active force enables us feel a reality behind the figures and the degree to which the invisible

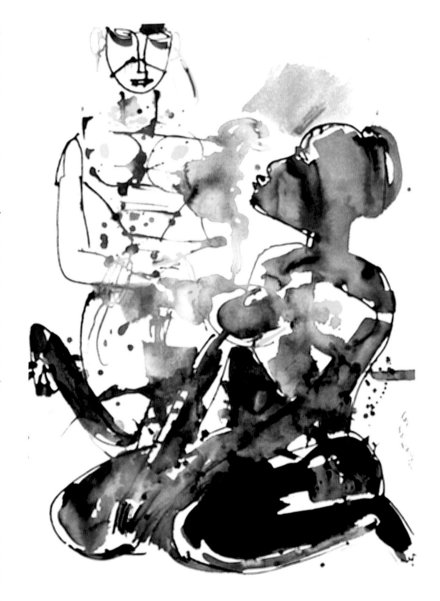

119. *The Obeah's Choice* (*Le choix de la Sorcière, Choua Manmbo-A*) (1984). Watercolor, 30 1/8 × 22 3/8». Collection of Maya Angelou. *Photograph courtesy of Romare Bearden Foundation.*

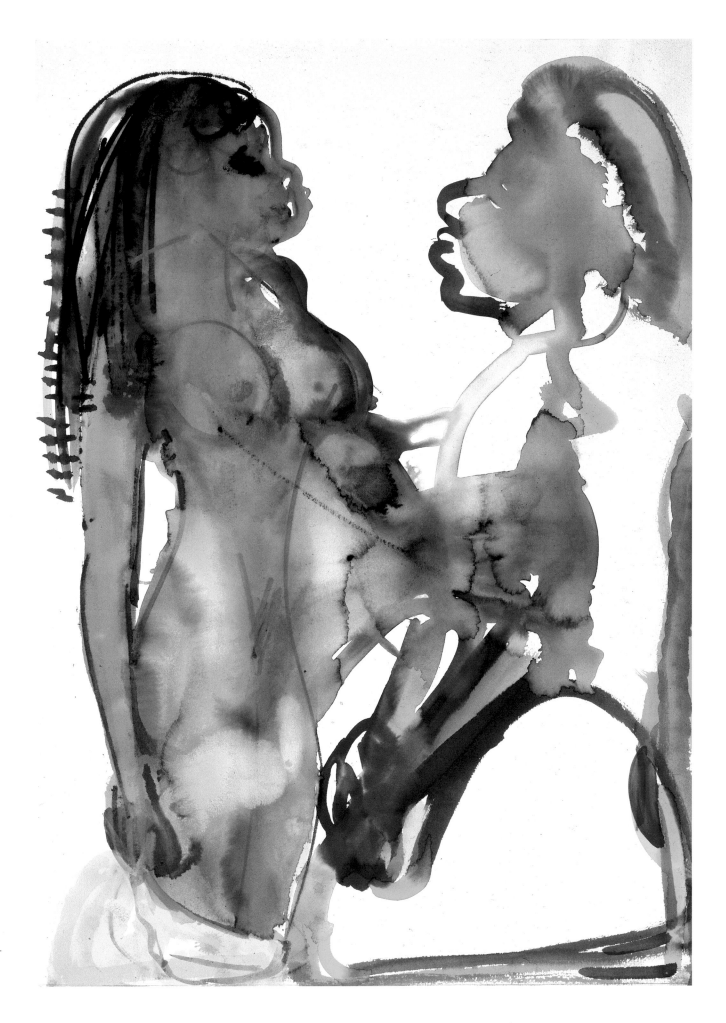

120. *The Green Bath* (n.d.).
Watercolor, 30 × 22"
*Photograph courtesy of Romare
Bearden Foundation.*

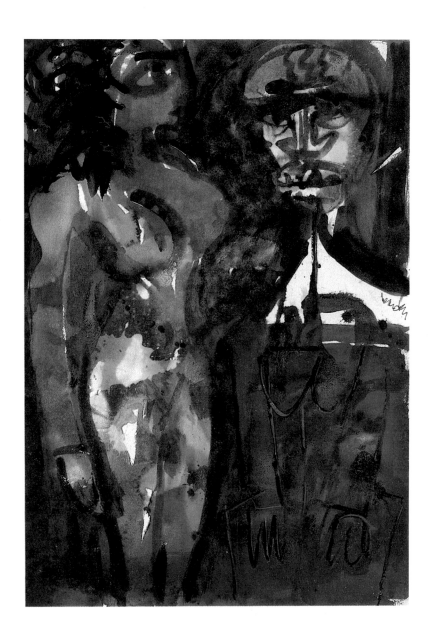

121. *Obeah Girl with her Loa (Fille Sorcière
avec son Loa, Fi Manmbo-A Ak Loa Li)*
(1984). Watercolor, 29 ¼ × 20 ⅝". From
Romare Bearden: Rituals of the Obeah 1984.

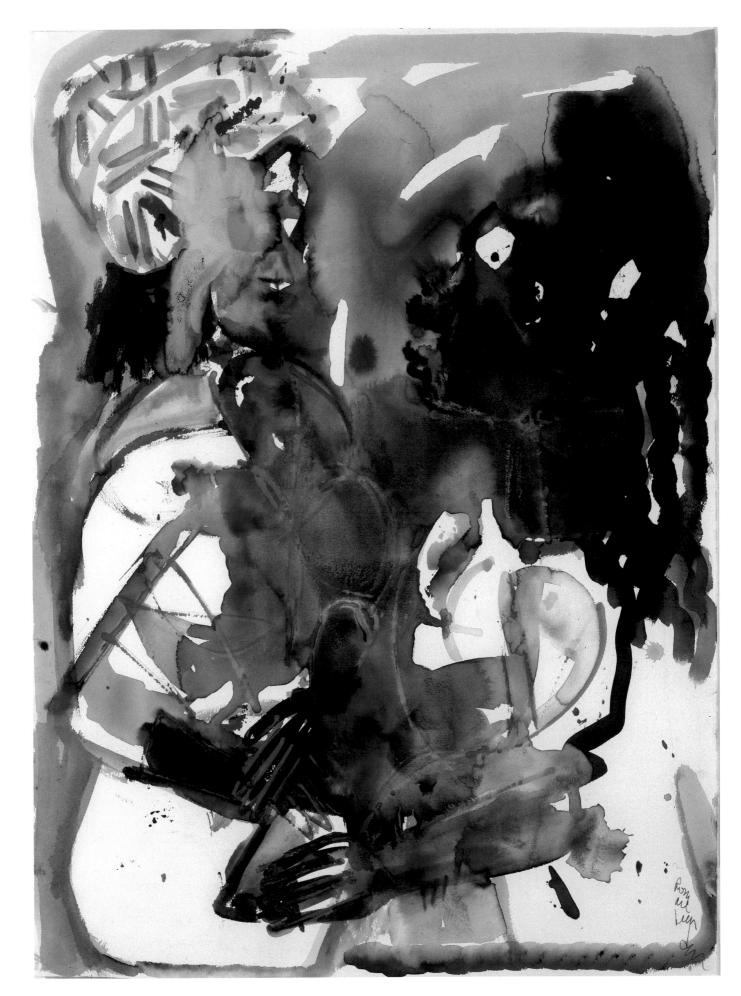

122. *Our Eyes Meet (Nos Regards se croisent, Jé Nou Rancontré)* (1984). Watercolor, 30⅛ × 22⅜". *Photograph courtesy of Romare Bearden Foundation.*

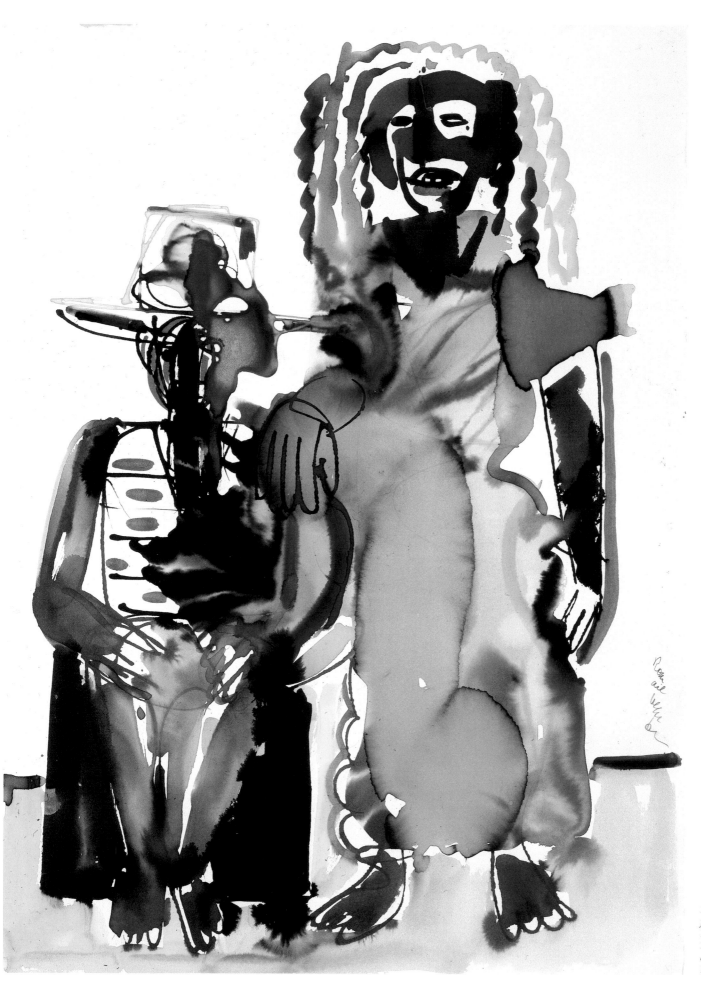

123. *Obeah and her Daughter* (*Sorcière et sa fille, Manmbo-A Avek Fi Li-A*) (1984). Watercolor, 30 × 22 ¼". *Photograph courtesy of Romare Bearden Foundation.*

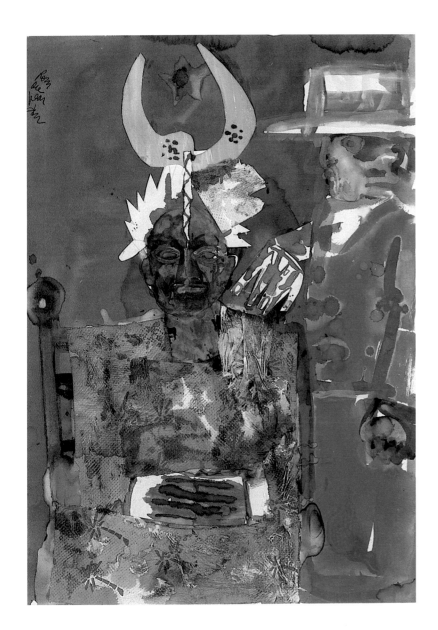

124. *Obeah High Priestess* (*Sorcière haute prêtresse, Lougarou-Gro Manmbo*) (1984). Watercolor, 29⅞ × 21¼". From *Romare Bearden: Rituals of the Obeah* 1984.

permeates the Obeah creed." In *Obeah and her Daughter,* |▶123| the billowing blue-green spirit of the Obeah seeps into the demurely seated daughter, quietly taking possession of her.

Obeah High Priestess is "a figure exuding arcane power. |▶124| With her elaborate horned headdress and hieratic posture, her green face staring out at us, she clearly exists in a world quite different from that of the rather ordinary figure standing at her side." If Thomas is correct that Bearden did not witness the headdress, its imaginative power is all the more striking.

In *No Wish to Know More,* as Eric Gibson noted, the figure "looms out of a vividly colored, uncertain space, like a figure making a sudden appearance in a dream. ... The face ... both mask and natural physiognomy." |▶125|

Secret Initiation, which Bearden showed Schwartzman

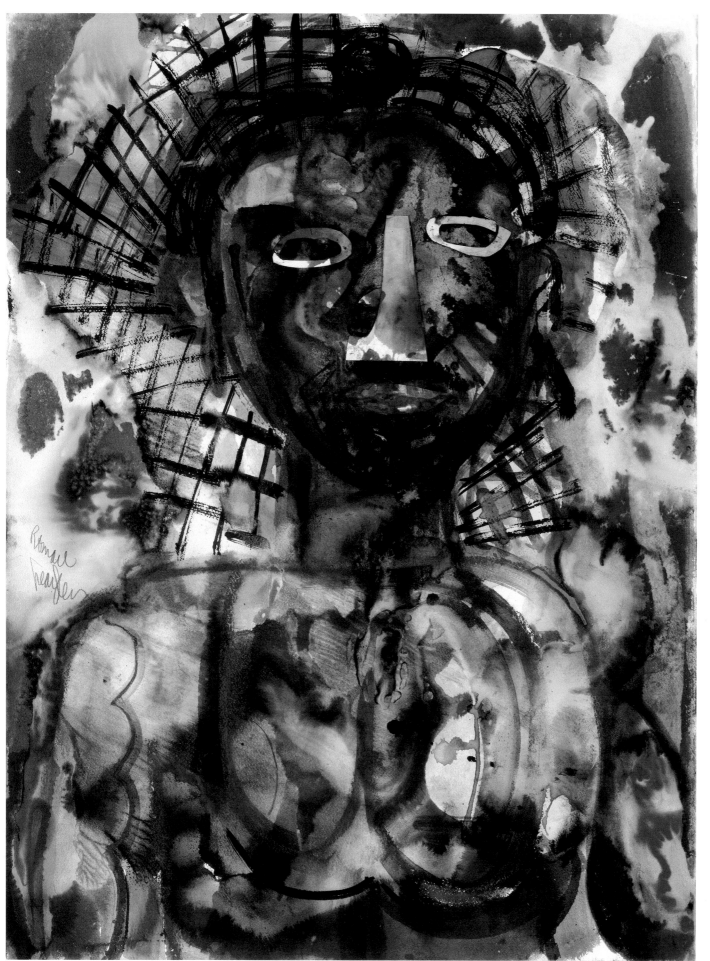

125. *No Wish to Know More (Aucun désir d'en savoir plus, Moin Pa Bezion Conin Plis)* (1984). Watercolor, 29⅞ × 22⅜". Collection of Romare Bearden Foundation.
Photograph courtesy of Romare Bearden Foundation.

along with the other Obeah paintings he was about to exhibit (though it was not, in the end, shown there), is the most voyeuristic, overtly sexual in the series. |▶126| Bearden explained, looking at the painting, "For me, these [Obeahs] are like a cross between our conjur women and our witches. But they burned all our witches! Just like they killed the buffalo. Just destroyed all our good natural resources." And then, pointing at the standing woman in the painting and underscoring his wish not to intrude by depicting people's faces, "Here's a kind of Obeah face with the three dots … which were all I could use here. You see these dots going up to this thing. Therefore, she was not herself unprotected by this." That is, as a sign of respect, he deliberately avoided exposing her identity, and diminishing her mystery and power. Likewise, the face of the supine initiate, holding her wine/rum and candle, is – he indicates in the interview – deliberately occluded by her hair.

126. *Secret Initiation* (1984). Watercolor with collage, 24 × 32". *Photograph courtesy of Romare Bearden Foundation.*

The voyeuristic, sexual associations of initiation rituals had long fascinated Bearden. In his 1978 *Conjur Woman and the Virgin*, a thick wooded area is split by a stream, and on its banks sits the tiny figure of a man – Bearden has said it is him – watching the drama unfolding on the other side: the Conjur Woman, "face masked and turned to the sky, holds a knife, while a young woman reclines in front of her. A pool of blood ... stains the grass." A couple of years earlier, Bearden had told Calvin Tomkins that Conjur Women "used to 'de-virginate' young girls before marriage to get them ready."

Finally, *The Obeah's Dawn*, arguably the greatest of the Obeah paintings. |▶**127**| As the *New York Times* critic wrote:

The most primal image in the show is "The Obeah's Dawn." On the right side, barely visible, is the shadowy presence of a sorceress. She is iden-tified with a crescent moon, which, from the far right edge of the work faces the sun, in the upper left corner. Between the yellow and red sun and the paper white moon, is a squawking yellow, red and white rooster, rising or being hurled into space – proclaim-ing, yet terrified, of the dawn. In this moment between sun and moon, renewal and death, magical, sacrifi-cial powers have been summoned, and there no longer seems to be any-thing that can stop a witches' brew of blood, fire and night.

Eric Gibson described it more succinctly: "A brightly colored airborne rooster and a sun float together in an inky, liquid space, a perfect pictorial representa-tion of the disordered realms of dream experience." And Bearden himself wrote: "An Obeah woman once told me she took in the moon before dawn and held it as a locket on her breast and then threw a rooster out in the sky who spun himself in the ris-ing sun," or as he said on another occasion, "One Obeah woman thought that she made the sun rise. Each night she held back the moon and conceived a rooster which she hurled out into the sky, and it became the sun."

But there are also those insis-tent, more universal echoes, going far beyond the St. Martin Obeah woman to the very edges of the African diaspora. In paint-ing *The Obeah's Dawn*, images from *Black Orpheus* were again on Bearden's mind. As he showed the painting to Schwartzman, he said, "*This* is a great myth. And it shows the arrogance of these [Obeah] people. ... You know, that they would feel that they could make the *sun* come up." Orfeu and his guitar, high up on that *favela* hillside above the bay of Rio de Janeiro, singing up the sun to the joy of those small black boys. ... Fragments from classical Greece, images of contemporary Rio, memories of Mecklenburg, and the words of the St. Martin Obeah woman combine in this swirling affirmation of sacrifice.

When Walcott agreed to compose a poem for the opening page of the catalogue, he chose for inspiration *The Obeah's Dawn*. "I'd never written poems out of paintings," he explained. "But this one came out of a painting, right out of Romare's work."

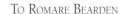

TO ROMARE BEARDEN

How you have gotten it! It's all here, all right.
The lean, long black hand of the night
has swirled the cut throat of the cockerel
of daybreak, and the flecks of its blood splatter
the hills and the sacred ground
where the chalk-circles and the spiked diagrams
are drawn on the Loa's ground.
Dawn bleeds without a sound.
In all religions sacrifices matter,
but to these rituals we ascribe malign reasons,
and primitive dreams, but as was the lamb
to Isaac, the ram to Abraham, all tribes have laid
on the threshold of heaven, cocks, ewes, horned rams
to the force that has made the fountain of the blood
in which we are born, and the harvest of our mortal seasons,
for a shadow comes towards us all, with its clean blade.

127. *The Obeah's Dawn* (*L'Aube de la Sorcière, Douvan Jou Manmbo-A*) (1984). Watercolor, 29 5/8 × 22 3/8". From *Romare Bearden: Rituals of the Obia* (1984).

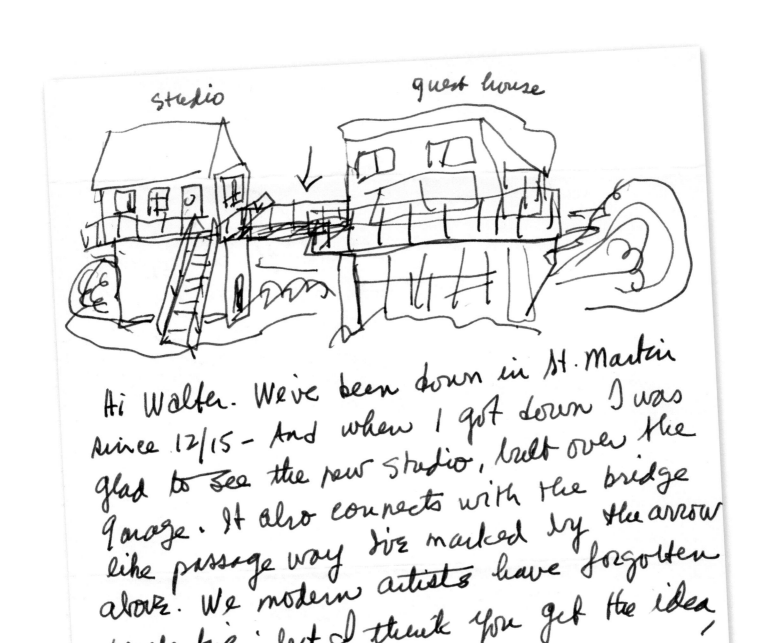

studio

guest house

Hi Walter. We've been down in St. Martin since 12/15 — And when I got down I was glad to see the new studio, built over the garage. It also connects with the bridge like passage way I've marked by the arrow above. We modern artists have forgotten perspective; but I think you get the idea, at least.

They tell me (the doctors at N.Y. Hospital) that I'm making a nice recovery. I'm able to walk up the 109 steps to the Studio & have just about put aside the cane. That aint to say that "ole rockin' chair" isn't often very welcome. But since I am painting

128. Fragment of a January 1987 letter to Walter O. Evans. *The Walter O. Evans Collection of African American Art & Literature, Savannah GA.*

Don't Stop the Carnival

By 1987, Death had become an insistent, stalking presence for Bearden. The year before, as the cancer eating away at his bones made climbing the stairs to their fifth-floor Canal Street apartment impossible, the Beardens had taken a second-floor place and for the first time had cancelled their summer stay in St. Martin. On seeing him in September 1986, Schwartzman wrote "Even for those who saw Bearden frequently, the change was apparent." "I don't know what word he used," said Al Murray, "but he had these devils and so forth – menacing things in the bushes, and he said 'there are thorns.' He was having trouble with his back, and he was talking about his mortality – serious stuff. He told me, 'Once you hit sixty, it's patchwork! For the rest of your life.'"

Nonetheless, in 1986 Bearden decided to have a new studio built behind the one that had sometimes doubled as a guest house. |▶**128**| Nanette's sister Dorothe explained,

Romie called [the original structure] the studio, but it was really a guest house for people who came down to visit them. He was worried the paints would get all over the tiles. So he built this other little structure at the back. It looked just like his Long Island City studio – a bare room with his table. That's all! And his paints. And paper all over it. And a big sink ... You can't paint in a place where you're afraid of messing up the tiles.

On his two final visits to St. Martin in 1987, particularly during the summer stay cut short by his entry into New York Hospital in September, Bearden worked, "as if he were trying to outpaint death," on a series of several dozen Carnival images – exuberant celebrations of life, with the grinning figure of Death lurking in the shadows. These (and undoubtedly a number of others) were shown – and many

sold – at an exhibit in Nanette's Front Street gallery in August.

Even more than his other Caribbean work, the Carnival series draws on a geographically generalized imaginary – Trinidad, Rio, Bahia, New Orleans. Dorothe told us that "Though there is a carnival in St. Martin, he was painting the *universal* carnival." Indeed, throughout the 1970s and 80s, the main St. Martin carnival was held (in Philipsburg) in April/May, a period when the Beardens were always in New York. It seems unlikely, then, that Bearden ever saw carnival in St. Martin.[1] In any case, it seems clear that *Black Orpheus* – that "archetypal story about love, death, fate, and perpetuity in Rio de Janeiro during Carnival week" – once again provided important fuel for his imaginative energies. And other images of Rio-style carnival in

photo books, films, and on T.V., as well as cruise-ship Carnival shows, undoubtedly fed into the picture.

Walcott offered an interpretation of aspects of Caribbean culture that Bearden addressed in his Carnival series.

The narrative tragedy, which is there in the calypso, is based on rhythm, 'cause it's African. You know, no matter how sad the story, it has to be expressed musically. With elation. It has to have joy in the tragedy. ... In other words, the concept of tragic joy, based on percussion rather than melody, means that *the lamentation is exultant*. ... That went out of European culture Christknows how long ago. It must have gone out in the Mediterranean. Because now everything has begun to be divided into what is tragic, what is tragi-comic, and so forth. But we don't have those definitions in the Caribbean. ... To you, everything is a drum beat. It's a joy. A banal, ordinary, predictable kind of thing. But I think that's exactly what Romare meant when he talked about "energy" in the Caribbean. What he found in the Caribbean was narrative. Not the elegiac, suffering-of-

the-people narrative he used in the States. Something else.

The Carnival Begins, with its Homeric ship slowly moving through the exultant crowd of Caribbean revelers, anchors the ceremony in history, forging links between Aegean and Antillean realities. |▶129| But its stately movement also makes clear that a voyage, from one place to another, with all its anticipation, is about to commence.

Several of the paintings have Brazil – particularly Rio – written all over them. Indeed, probably nowhere else in the world at the time could one find models for those particular swirling colors and costumes, and theatrical nudity (all of which were eventually imported into the Caribbean, via Trinidad and Tobago, as defining features of what became known as "skin bands," in the late 1980s and particularly the early 1990s – too late for Bearden to have

1. The island's other, far smaller carnival, held in Marigot before Lent, included none of the flamboyant spectacle depicted in Bearden's paintings.

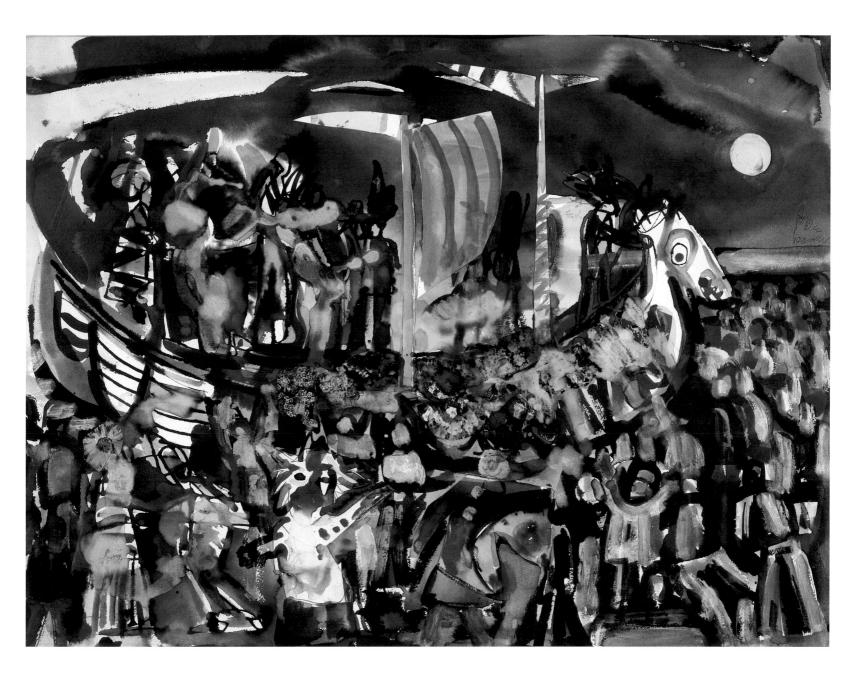

129. *The Carnival Begins* (1987 or 1984).
Watercolor with collage, 21 ½ × 30".
Estate of Romare Bearden. *Photograph
courtesy of Romare Bearden Foundation.*

seen them there): *Carnival Mask,* |▶130| *Carnival Queen,* |▶131| *Carnival Dancer Crimson,* |▶132| *Carnival Dancer,* |▶133| and four untitled paintings (|▶134, 135, 136, 137|).

Another set recalls the Obeah series, in the particular use of wash and color on portraits, the positioning of hands, and the insistence on the face as mask: |▶138, 139, 140, 141, 142, 143|.

One image of a dancing couple – *Carnival Dancers* |▶144| – evokes instead an intimate St. Martin moment. Against the crimson background, an apparently older couple in traditional island dress dance with affection.[1]

Bearden had long been haunted by the image of the "skeleton man" who, in *Black Orpheus*, stalks the innocent Euridice and eventually takes her to the underworld. In 1986 he asked an interviewer whether

he didn't remember the story in the film – how the cigar-smoking Obeah man tells Orfeu where she is, and he then "goes down, he's looking for her, but she's dead. The man with the skeleton killed her. She is there in the city's central morgue." In four images rife with death's-head teeth, two of which (as in the film) reveal their skeleton-man ribs, Bearden depicts the horror, staring out fearlessly at the viewer, once as a comely dancer preens in innocent abandon nearby. |▶145, 146| He makes clear who is going to win, at least in the short run.

1. This may have one of the images painter Ruby Bute had in mind when she wrote her memorial poem, "It is a Comfort (for Romare Bearden, 1914-1988)," on hearing of Bearden's death (Bute 1989:35-36). The third stanza reads: "What a day that was at the Mardi gras / a dancing parade, an explosion of reckless joy, / sounds of music vibrating the air. / I searched for you in the smoke of the crowd / and suddenly there you were calling out to me. / With the rhythm of pan and brass in my head, / I could not resist, / so I joined in with the revelers / and we danced, / and danced / until the coming of dawn."

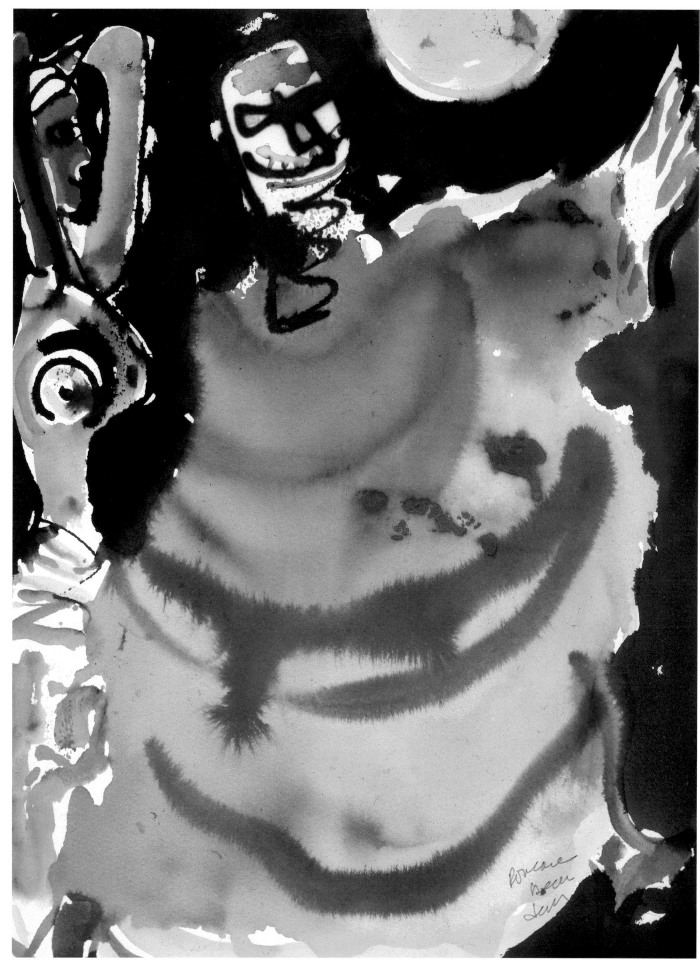

130. *Carnival Mask* (n.d.). Watercolor.
Photograph courtesy of Romare Bearden Foundation.

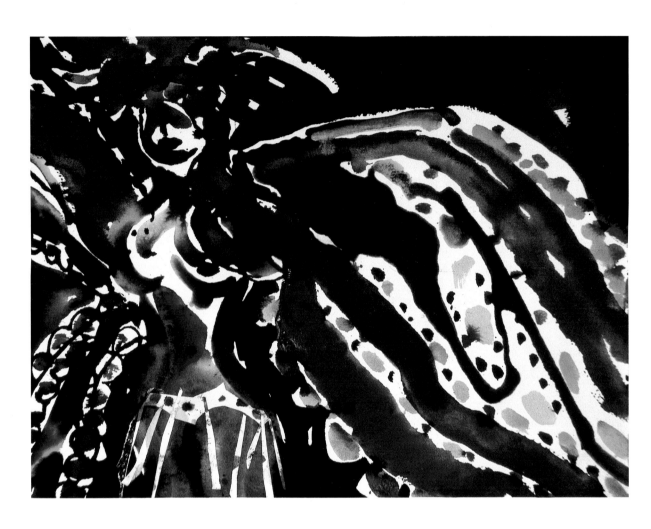

131. *Carnival Queen* (n.d.). Watercolor.
Collection of Gloria Rohan El-Boushi.
Photograph courtesy of Romare Bearden Foundation.

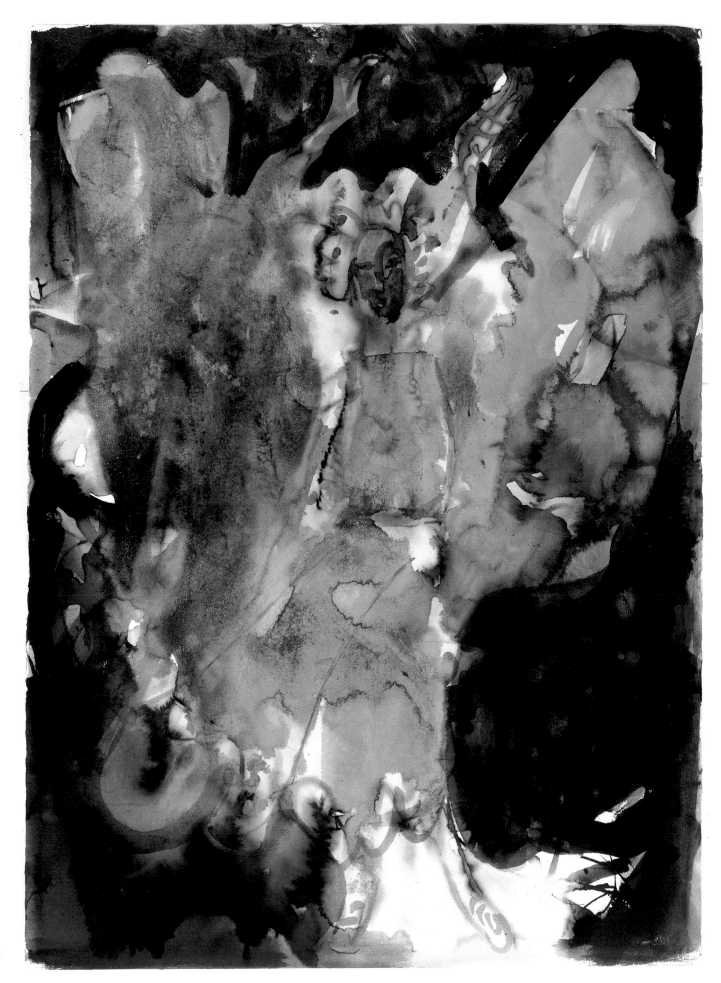

132. *Carnival Dancer Crimson* (n.d.). Watercolor. *Photograph courtesy of Romare Bearden Foundation.*

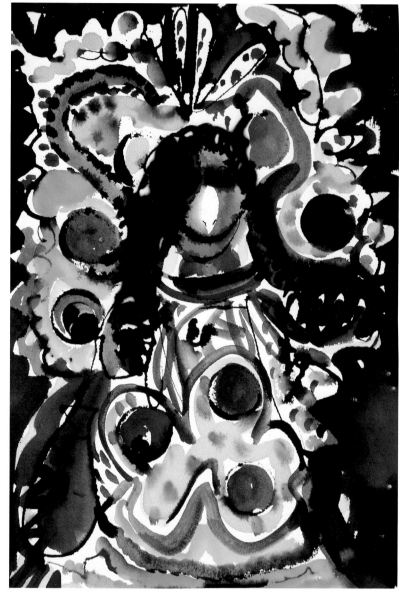

134. *Untitled* (*Carnival Series*) (n.d.).
Watercolor. *Photograph courtesy of Romare Bearden Foundation.*

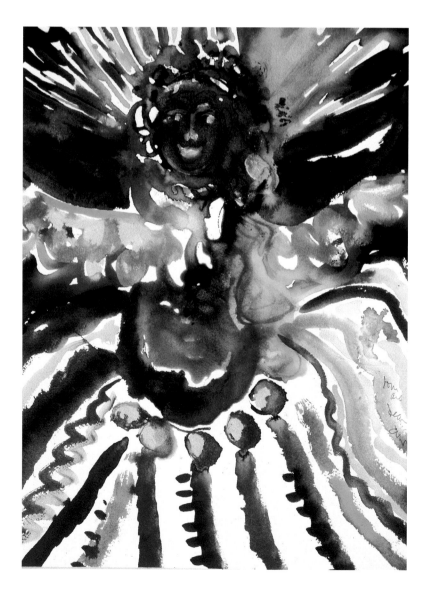

133. *Carnival Dancer* (1987). Watercolor,
30 × 22". *Photograph courtesy of Romare Bearden Foundation.*

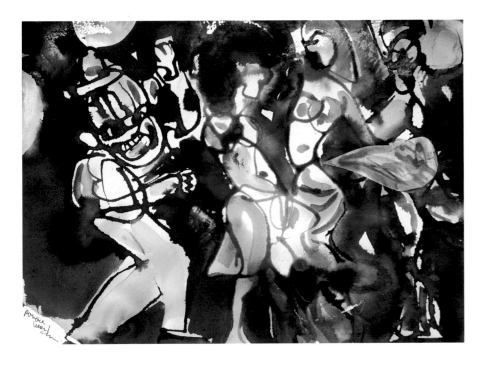

135. *Untitled (Carnival Series)* (n.d.). Watercolor. *Photograph courtesy of Romare Bearden Foundation.*

136. *Untitled (Carnival Series)* (n.d.). Watercolor. *Photograph courtesy of Romare Bearden Foundation.*

137. *Untitled (Carnival Series)* (n.d.). Watercolor. *Photograph courtesy of Romare Bearden Foundation.*

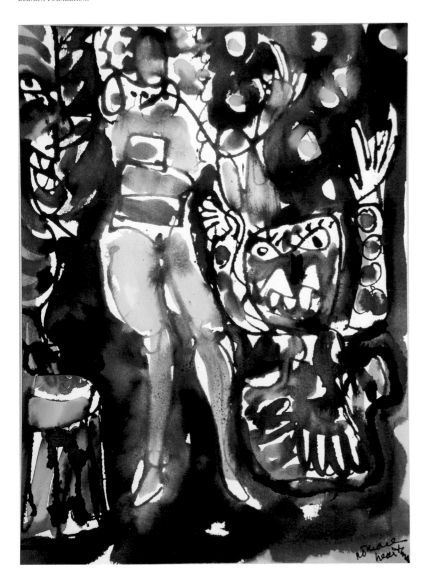

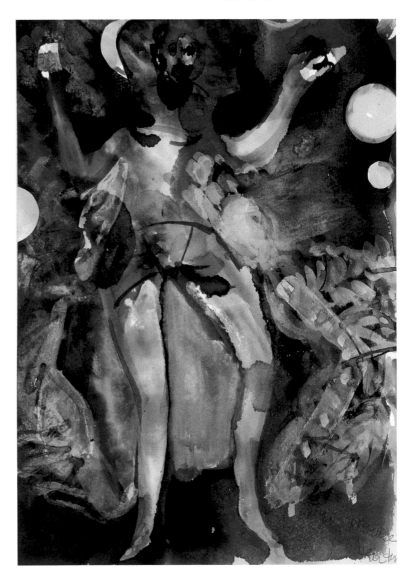

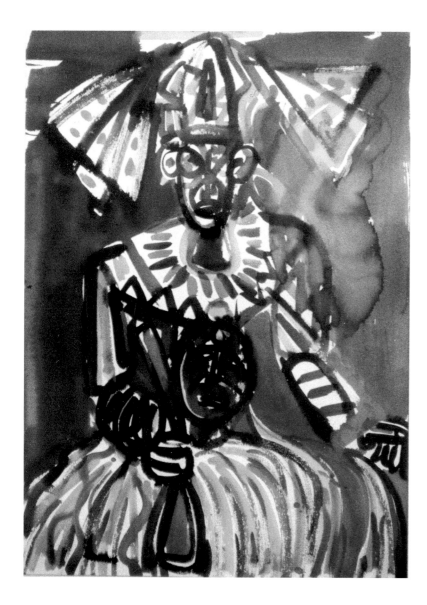

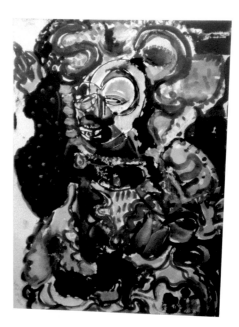

139. *Untitled (Carnival Series)* (n.d.).
Watercolor. *Photograph courtesy of Romare Bearden Foundation.*

138. *Untitled (Carnival Series)* (n.d.).
Watercolor. *Photograph courtesy of Romare Bearden Foundation.*

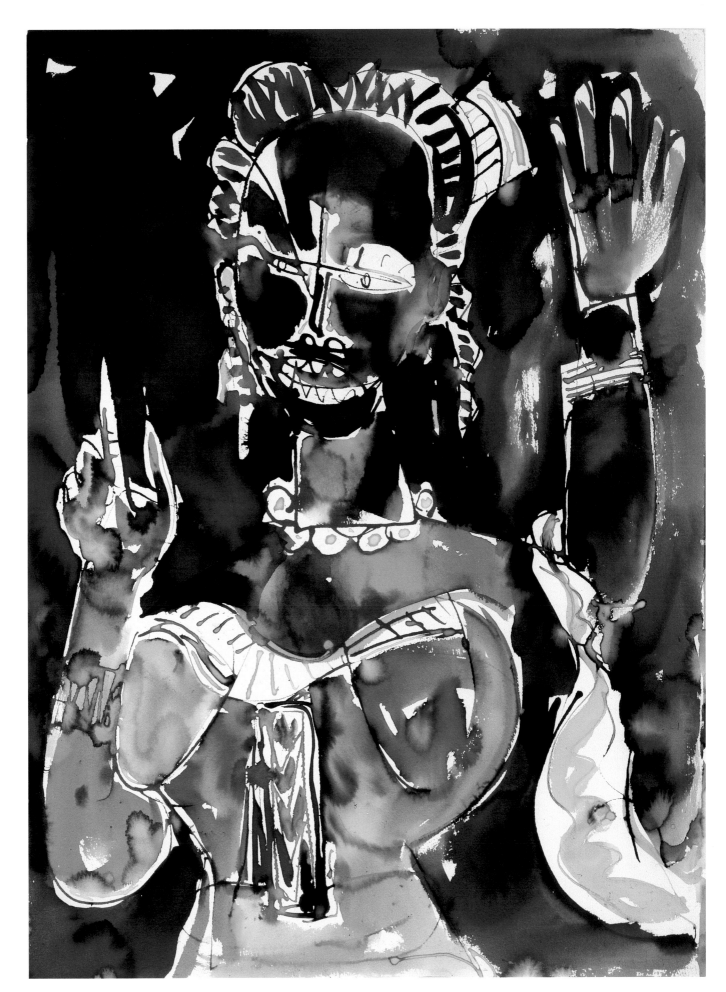

140. *Untitled (Carnival Series)* (n.d.). Watercolor. *Photograph courtesy of Romare Bearden Foundation.*

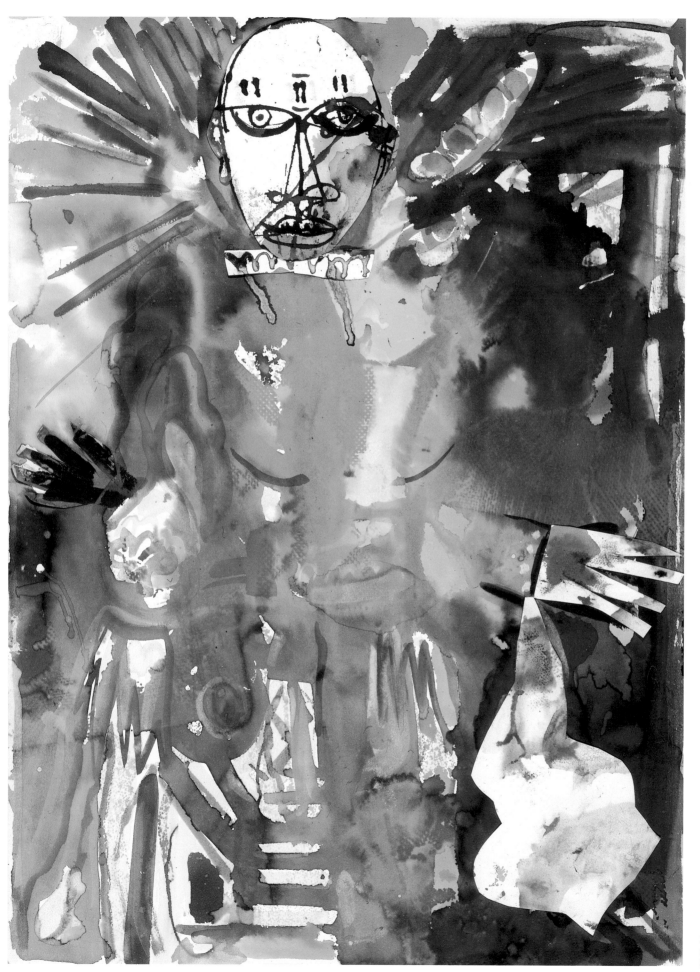

141. *Untitled* (*Carnival Series*) (n.d.). Watercolor.
Photograph courtesy of Romare Bearden Foundation.

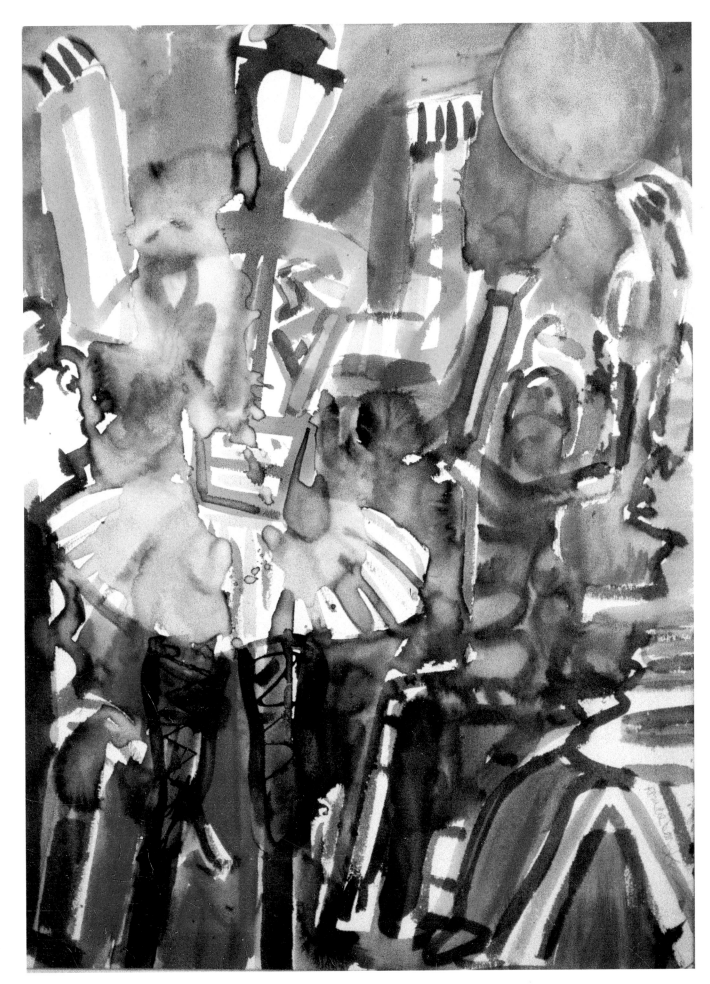

142. *Untitled (Carnival Series)* (n.d.). Watercolor.
Photograph courtesy of Romare Bearden Foundation.

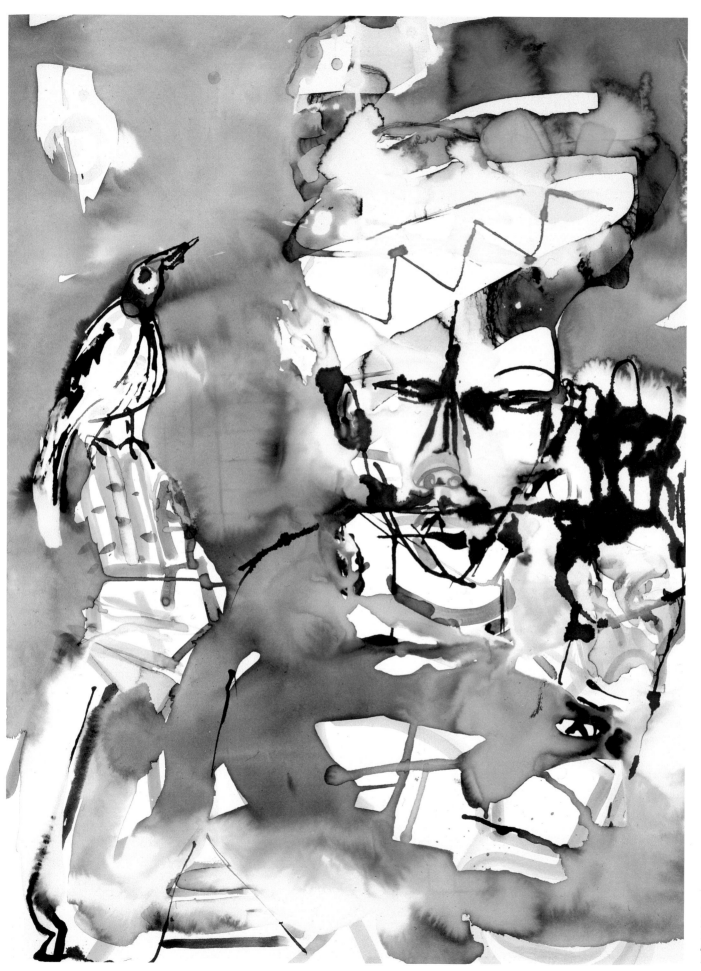

143. *Carnival Figure with Bird* (n.d.). Watercolor, 30 × 22". *Photograph courtesy of Romare Bearden Foundation.*

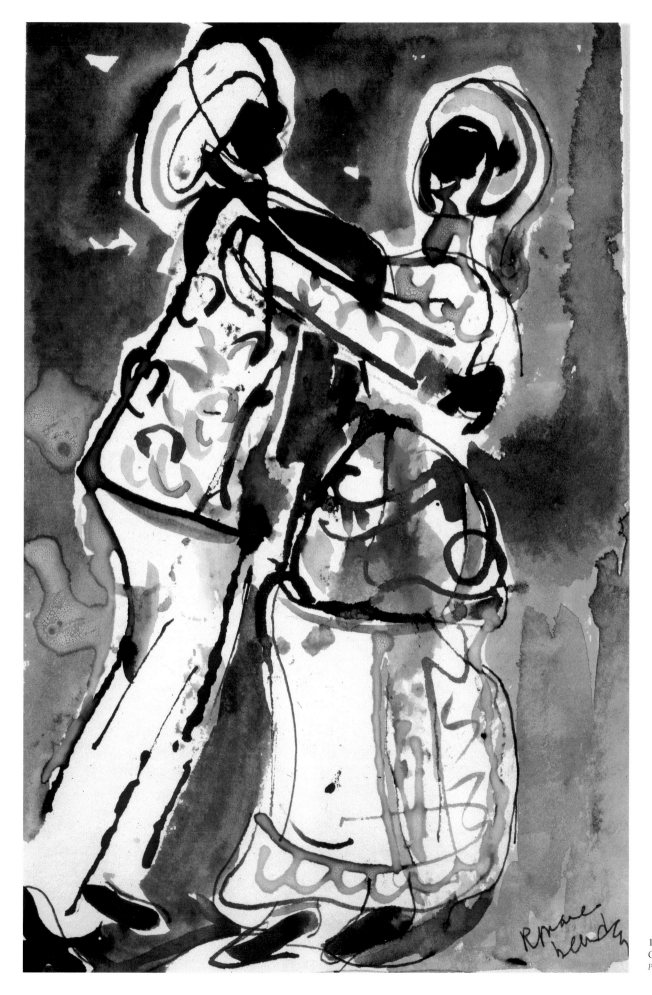

144. *Carnival Dancers* (n.d.). Watercolor.
Collection of Gloria Rohan El-Boushi.
Photograph courtesy of Romare Bearden Foundation.

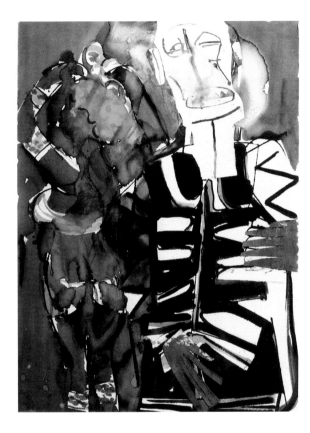

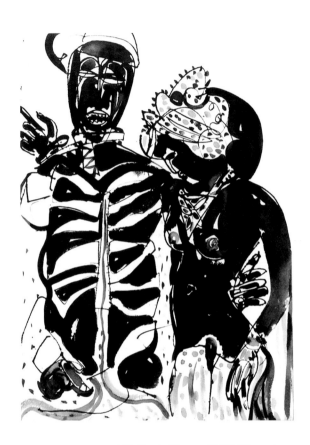

145. *Death and the Dancer* (1987).
Watercolor, 39 ¾ × 31 ¼". From *Memory and Metaphor* 1991:81.

146. *Carnival Dancer* (1987). Watercolor, 40 ¼ × 32 ¼". From *Memory and Metaphor* 1991:82.

At Low Tide

It was during Bearden's final trip to St. Martin, in the summer of 1987, that in a burst of energy he painted the bulk of his carnival series. Earlier that year, after cancer treatment at New York Hospital, he had written Ekstrom from St. Martin, "I'm happy to report I'm making good progress. In fact, I'm able to negotiate the 109 steps leading up to my studio – with a little help from a cane. Otherwise I walk mostly unaided. And I feel very well. ... The constant walking & going, together with the sun, is doing me a lot of good."

In early August, he devoted considerable time to the FOCUS festivities, giving workshops for aspiring artists and participating in a literary seminar with Derek Walcott and local writers Lasana Sekou and Ian Valz, as well as a public discussion with Fabian Badejo about African influences on modern art.[1] But he also revisited for one last time a number of favorite Caribbean themes.

There were several "Martinique" (and closely related) images: *Martinique Morning,* |▶ 147| *Near Three Rivers Martinique, River Martinique, Blue River Edge, In The Forest,* and *Island Waterfall.* He also painted several of his characteristic "enchanted places": *Egret – Wading Pool* (see |▶ 60|), *Purple Eden* (see |▶ 14|), *Lady and the Bird,* and *The New Eden.* |▶ 148| There were two portraits: *Theresa* and *Woman.* And a few seashore scenes: *Near Simpson Bay, Pompey Gut, Rocks on Breaking Surf, Rocky Shore – St. Martin,* and *Casting the Net.* Finally, one strikingly original composition, *Lady and the God of the River,* which is at once playful, voyeuristic, and profoundly African American |▶ 149|

That last St. Martin summer was cut short in early September, when Bearden's

1. Schwartzman is mistaken in claiming that during this final stay on the island, Bearden helped "organize the festivities for the annual Carnaval" (1990:301), as is the National Gallery of Art catalogue, which follows him, claiming that in July 1987, "he helps organize annual carnival celebration" (R. Fine 2003:245). The festivities in question involved the 1987 St. Martin cultural celebration called FOCUS.

health took a turn for the worse and he returned to New York to check into the hospital, staying for two weeks. During the final months of his life, in New York, Bearden had the collaboration of his studio assistant, André Thibault/Teabo, in producing *Eden Midnight* and *Eden Noon* (see |▶49| and |▶50|), collages filled with Caribbean light and allusions. But he worked by himself to produce his playful last painting, *At Low Tide*, where a nude, half immersed in the sea, is standing at the edge of what looks very much like Orient Bay. |▶150|

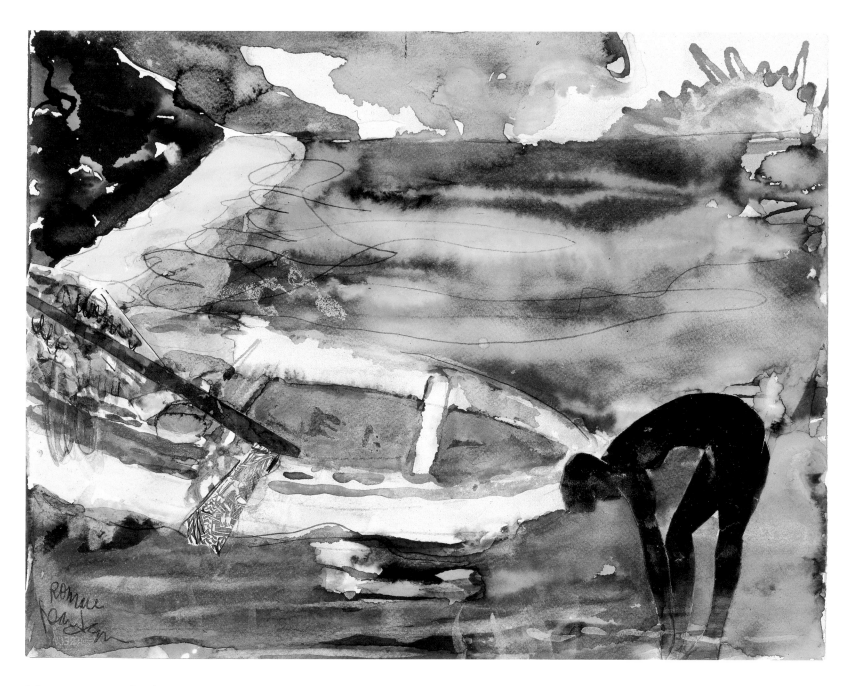

147. *Martinique Morning* (1987).
Watercolor with collage, 13 × 17".
Photograph courtesy of Romare Bearden Foundation.

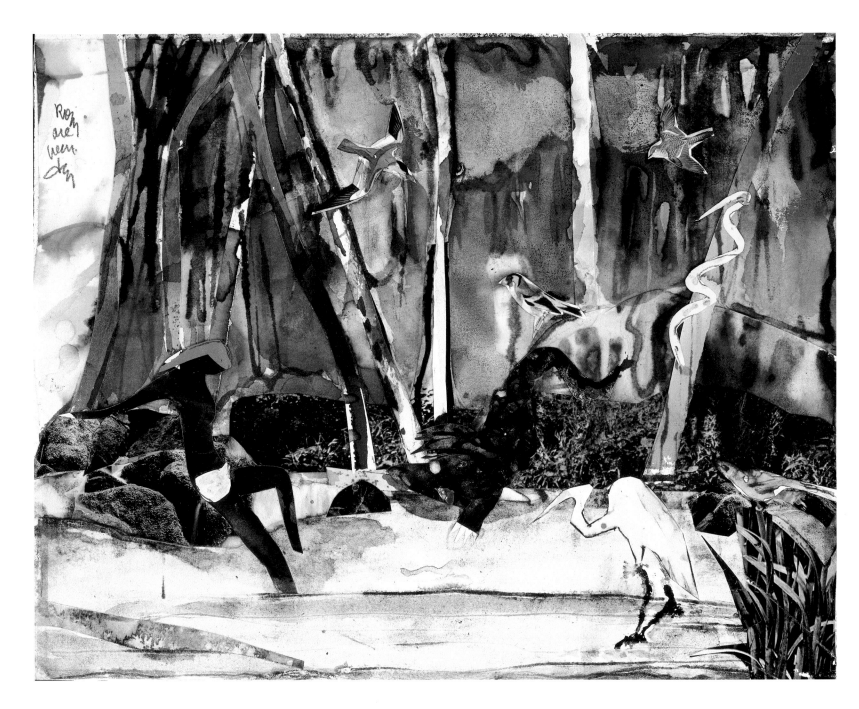

148. *The New Eden (Girl and Bird in Tropics)* (1987). Collage and mixed media on board, 10 ½ × 13 ½". Collection of Florence and Glen Hardymon, Charlotte NC. *Photograph courtesy of Jerald Melberg Gallery, Charlotte NC.*

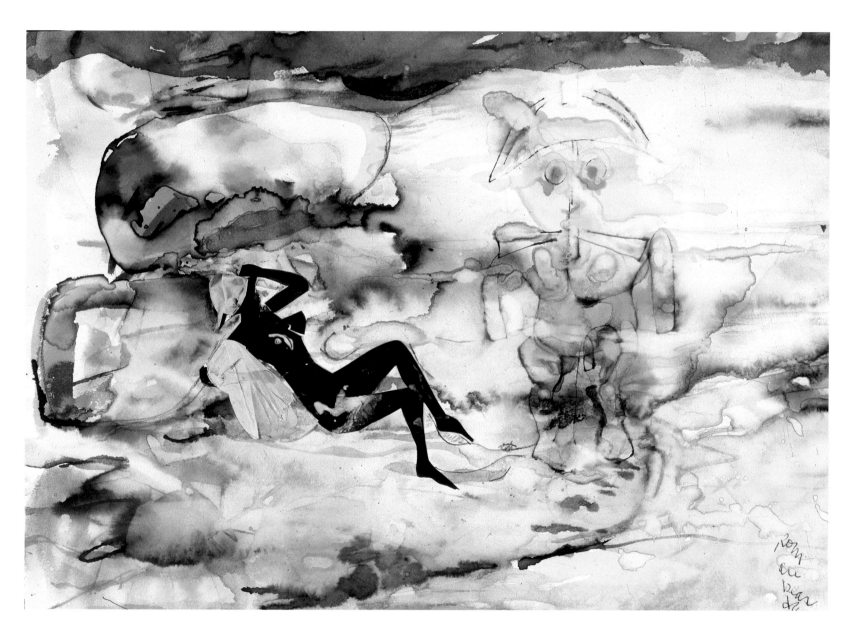

149. *Lady and the God of the River* (1987).
Watercolor with collage, 15 × 21".
Photograph courtesy of Romare Bearden Foundation.

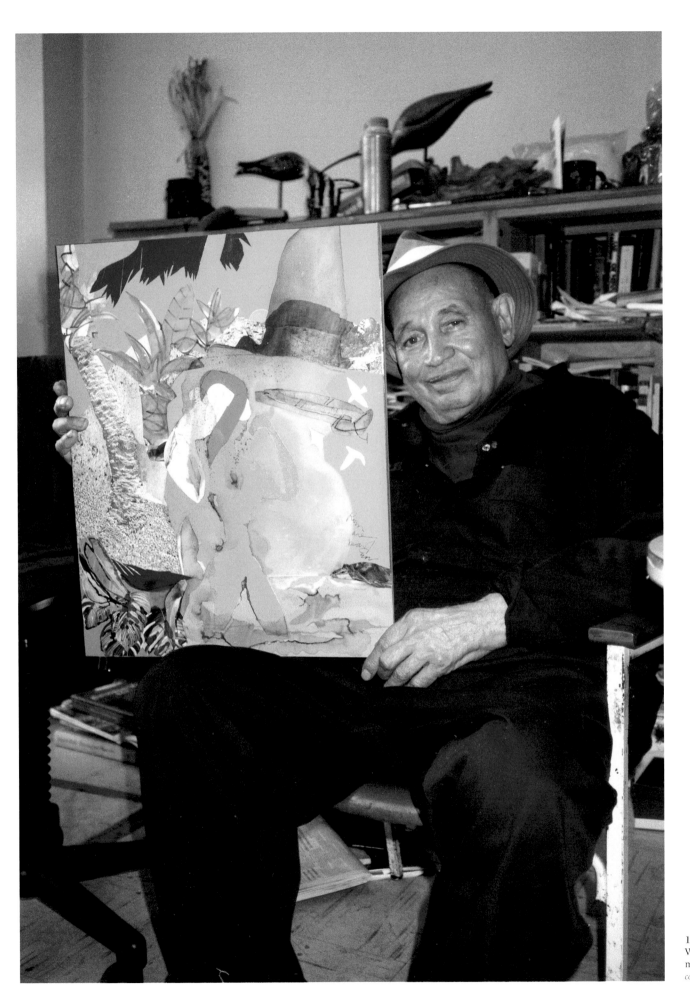

150. *At Low Tide* (1988). Watercolor with collage on masonite, 20 × 16". *Photograph courtesy of Romare Bearden Foundation.*

Take Michael Jordan. You can't say he's a black basketball player. He is basketball! This is what Ralph and I wanted to be – and what we thought Romie had to be, 'cause he was already inclined in that way. So that he could play with the rest of those guys in Yankee Stadium.

Al Murray

Redeeming a Tradition

There is no entry on Romare Bearden in the 34-volume, 32,600-page, $8,800, *Grove Dictionary of Art* (1996, and updated on-line as this book goes to press).[1] When we offered this remarkable piece of intelligence, separately, to Derek Walcott and Al Murray, each took a moment to get over his initial incredulity and then groped for an explanation. And when we added that other black artists were indeed included and that Jacob Lawrence and Horace Pippin had just had major exhibits, they both reacted by saying that the world of art simply has no measure by which to evaluate Bearden's achievement. First, Walcott:

Let's consider any establishment or orthodoxy that says "Yeah, but it's so special – it has to do with black people catching hell in the South, or still being happy in a certain kind of a way." So you have this absurdity of an empire pronouncing its benediction on the very fucking suffering it caused! So it says, "Oh yes, Jacob Lawrence is fantastic." Why is he fantastic? Because he shows all these niggers tryin' to get to heaven, you know, material heaven. And that's why he's fantastic. And we understand the strain to get them there. We understand that. So he's fine. "Horace Pippin is fantastic." Because he's a humble nigger who really couldn't paint very well, but he had that charm that is really a quality of the primitive. But Romare...

Or, as Murray put it: "Of course – because Pippin and Lawr' are *black* painters. But we're talking about Tiger Woods here!"[2]

James Baldwin, sitting with Al Murray and Alvin Ailey in 1978, leaned over to address Bearden directly: "It is very important that you Romy, Al, all of us, we are speaking about a voyage that we all have to make seemingly far away to come full circle. To redeem a tradition that was not yet called a tradition because it was not yet written down except by Bessie Smith,

1. The *Grove Dictionary* is updated periodically on the Internet. As of June 2006 there was still no entry under "Bearden." Other substantial reference volumes on art follow suit. For example, Bearden is given no entry in the 753-page *Yale Dictionary of Art and Artists* (Langmuir & Lynton 2000), the 564-page *Oxford History of Western Art* (Kemp 2002), or the 816-page *Oxford Dictionary of Art* (Chilvers 2004).

2. Walcott stressed to us the interference of American racism in any attempt to assess Bearden's achievement. "Although your book is about the Caribbean, you can't take Bearden out of America. Because when you talk about his erudition, what happens? What happens in terms of a black writer's erudition? What happens to Albert Murray and his erudition? What happens to C. L. R. James and his erudition? What happens to Aimé Césaire and his erudition? What happens? [And then, deliberate and slow:] 'Black -

guys - who - studied - hard!' Not 'genius'!
'Black guys who studied hard.'" (interview
with SP & RP in St. Lucia, 8/17/00)
It was an outsider to America and a
latecomer to the English language –
Joseph Brodsky – who best captured
the twisted relations between racial/
regional prejudice and artistic genius in
the mind of critics. What he wrote about
his fellow Nobel Prize winner Walcott
could as easily be said – if we exchange
"poet" for "painter" – about Bearden:
"For the thirty years that Walcott has been
at it, at this loving the sea, critics on both
its sides have dubbed him 'a West Indian
poet' or 'a black poet from the Caribbean.'
These definitions are as myopic and
misleading as it would be to call the
Savior a Galilean. This comparison is
appropriate if only because every reductive
tendency stems from the same terror of the
infinite. ... The mental as well as spiritual
cowardice, obvious in these attempts to
render this man a regional writer, can be
further explained by the unwillingness
of the gents of the critical profession to
admit that the great poet of the English
language is a black man." (1983:xi)

Duke Ellington, and so forth."
Walcott came at this "redemp-
tion of a tradition" from a differ-
ent angle:

The paintings have such fantas-
tic dignity...They are *moving* and
you say to yourself, "Jesus Christ,
I'm being moved by paper, not by
paint!" That's beyond Matisse. It's
even beyond Picasso. You can look
at a Picasso painting and say, "This
is about that." You can work it out in
terms of the paint. But once you look
at a Bearden, you *assume* the history
that's there in the painting. And the
movement inside you of looking at
the painting is a profound expe-
rience. People have no idea of the
depth of it – and because it's black,
it's more poignant, it's more tragic.
You're talking about Whitman here,
you know![1]

Bearden and his friends
never tired of insisting on
the "Americanness" of their
project. As Henry Louis Gates,
Jr. glossed it:

At the heart of Murray and Ellison's
joint enterprise was perhaps the
most breathtaking act of cultural
chutzpah this land had witnessed

since Columbus blithely claimed
it all for Isabella. In its blunt-
est form, their assertion was that
the truest Americans were black
Americans... For generations the
word "American" had tacitly con-
noted "white." Murray inverted the
cultural assumptions and the ver-
bal conventions: in his discourse,
"American," roughly speaking,
means "black."

Bearden was on that same
train, whether in his collages
or his watercolors.[2] And when
Murray argued that their collec-
tive duty was "to process (which
is to say to stylize) the raw native
materials, experiences, and the
idiomatic particulars of every-
day life into aesthetic (which
is to say elegant) statements of
universal relevance and appeal,"
he was affirming a cultural poli-
tics fully shared by Bearden and
expressed in all his works.

If Bearden's Caribbean
paintings – with the possible
exception of the Obeah series –
never reached the elegiac heights
of the Mecklenburg works

1. Walcott expressed his enduring esteem
for his friend by dedicating his recent
play, *Walker*, "named for David Walker,
the nineteenth-century black abolitionist
from Boston who advocated violent
revolt against slavery," to the memory
of Romare Bearden (Walcott 2002).

2. A year before his death,
Bearden told an interviewer,
"I think of myself first as an American,
and being an American means four things.
One, being in the tradition of Emerson,
Emily Dickinson, Melville, Walt Whitman.
Second, you have to have the spirit of
the whole Negroid tradition. The third
tradition is the frontiersman, like Mark
Twain and Bret Harte, and the fourth
tradition is the Indian." (Anon. 1987)

(because he remained an interested visitor rather than a homeboy in St. Martin), they hold a significant place in his oeuvre. At first mainly landscapes, later a variety of engagements with Afro-Caribbean everyday, spiritual, and ludic realities, the paintings extend Bearden's intellectual and visual horizons into new terrain. The light and colors of the islands found their way back into the work he produced in New York, and his semi-annual sojourns provided physical and spiritual renewal that carried him through the pressures of his stateside work routine. Playwright Barrie Stavis, a close friend, has said "My favorite metaphor for Romy is Thoreau's description of John Brown – 'a volcano with an ordinary chimney flue.'" For the final fifteen years of his life, the Caribbean's volcanic energy, smoldering underneath, played a signal role in fueling Bearden's creative genius.

Source Notes

p. 15. "Bearden's lengthy obituary": Fraser 1988.
p. 15. "the detailed entry on Bearden in the 1999 *Africana* encyclopedia": Appiah and Gates 1999:206-207.
p. 15. "when Charles Rowell conducted a long interview": Rowell 1988:441.
p. 16. "I would say Romie's Caribbean stuff": Albert Murray, interview with SP & RP in Harlem, 8/24/00.
p. 16. "people feel that what you're doing": Derek Walcott, interview with SP & RP in St. Lucia, 8/17/00.
p. 16. "Art will go where energy is": Bearden in Schwartzman 1990:243.
p. 17. "His great-grandfather...soft blond curls.": Schwartzman 1990:70.
p. 17. "a summer with the Pittsburgh Crawfords": Frank Stewart, undated typescript, 1990s, courtesy of Frank Stewart.
p. 18. "the Harlem that was Bearden's briar patch … geared to groove": Murray 1996:121-123.
p. 18. "It was during my period with Grosz": Bearden 1969:11.
p. 20. "How you gonna beat this goddam Paris … You have a chance in Paris": Albert Murray, interview with SP & RP in Harlem, 8/24/00; transcript of 12/15/78 conversation among Bearden, Alvin Ailey, James Baldwin, and Murray, in ACA 1989:20 – see also Berman 1980:66.
p. 22. "creating one hit tune": Schwartzman 1990:174.
p. 22. "Bearden's 'thousands of books'": Berman 1980:66.
p. 22. "This doesn't seem to be the same place": Bearden to Holty, letter dated 28 May on RMS "Queen Mary" stationery, quoted in Schwartzman 1990:169-170.
p. 22. "The city seems to them to be 'sleeping artistically'": Schwartzman 1990:208.
p. 22. "'their goal' of moving 'outward embracing all directions, yet constantly upward'": Schwartzman 1990:209.
p. 23. "in 1968, *Fortune* magazine … uses a Bearden cityscape … and *Time* adapts another": Schwartzman 1990:220-222.
p. 24. "The late 70s bring … commissions from the *New York Times* and the Alvin Ailey Dance Company": Schwartzman 1990:258, 263.
p. 24. "Harry Henderson aptly describes as 'a rushing waterfall'": interview with SP & RP in Croton-on-Hudson, 7/23/00.
p. 24. "He's portrayed on the cover of *Newsday Magazine*": Schwartzman 1990:311, n. 45.
p. 25. "One thing leads to another": Bearden in Murray 1980:18.
p. 27. "You mustn't make it smell of midnight oil": Derek Walcott, interview with SP & RP in St. Lucia, 8/17/00.
p. 27. "Romare was genuinely erudite": Derek Walcott, interview with SP & RP in St. Lucia, 8/17/00.
p. 27. "discipline more closely related to art than one might believe": Bearden and Holty 1969:12.
p. 27. "In a similar spirit … the receding space of the Renaissance": Bearden and Holty 1969:165-168, 109-110.
p. 28. "the way it used 'voids, or negative areas'": Bearden 1969:12 – see also Schwartzman 1990:183-187.
p. 28. "it is not the objects that matter to me": Bearden in Murray 1980:24.
p. 28. "I find I am increasingly fascinated": Bearden 1969:15.
p. 28. "The use of negative space": Bearden and Holty 1969:121.
p. 28. "In Chinese paintings, probably the greatest of paintings": Bearden in Schwartzman 1990:41.
p. 28. "the curious 'inverted space' of traditional Chinese painting": Bearden in Sims 1986:18.
p. 28. "As he wrote to his friend Walter Quirt in the 1940s": letter cited in Schwartzman 1990:127-128.
p. 28. "Volume in painting evokes the same sensation as in music": Bearden and Holty 1969:104.
p. 29. "I listened for hours to recordings of Earl Hines": Bearden 1988.
p. 29. "My approach to rhythms … is the use of space": Schwartzman 1990:288.
p. 29. "Bearden painted a portrait of Roach": see Schwartzman 1990:287.
p. 29. "the finger-snapping, head-shaking enjoyment": Bearden 1988.
p. 29. "playing the *rhythms* of Mondrian against the *structure* of jazz": Ellison 1988:417.
p. 29. "During the war Romie was hanging out": Albert Murray, interview with SP & RP in Harlem, 8/24/00.
p. 29. "The more I just played around": Bearden in Murray 1980:23.
p. 30. "And when artist Gwendolyn Wells asked him": Schwartzman 1990:196.

p. 30. "I think of some light source": Bearden to Holty letter, 1952, cited in Schwartzman 1990:186-187.

p. 30. "As early as 1945, critics were recognizing": Ben Wolfe, in *Art Digest*, cited in E. Fine 1973:157.

p. 30. "I did that with Giotto, Duccio, Veronese, Rembrandt": Bearden in Tomkins 1977:64.

p. 31. "he began to 'give free rein to color'": Berman 1980:67.

p. 31. "Bearden himself wrote that he considered 'color as a place'": Letter to Mary Schmidt Campbell postmarked November 1972, cited in Campbell 1982:564.

p. 31. "the magic by which color became space": Ellison 1988:417.

p. 31. "I felt that by using these tracks of color ... and it makes space": Bearden in Schwartzman 1990:182 and Berman 1980:66-67.

p. 31. "My temperas had been composed in closed forms": Bearden 1969:11.

p. 31. "A shortcoming of this method": Bearden and Holty 1969:198.

p. 31. "So many people ... will say": Bearden in Rowell 1988:433.

p. 32. "I first put down several rectangles of color": Bearden in Berman 1980:63, which also draws on Bearden 1969:14.

p. 32. "Take Vermeer's drawings – you turn them upside down": Bearden in Schwartzman 1990:39.

p. 32. "'Yes,' replies Bearden, 'but it's the music lesson'": Schwartzman 1990:39.

p. 32. "the painter should dominate his subject matter": Murray: 1980:24-25.

p. 33. "the specific reminiscences that now seem so integral": Murray 1996:118-119; emphasis added.

p. 33. "the thumb of the woman on the far left": Bearden 1969:17.

p. 33. "searching for something in the Modern tradition": Bearden in Schwartzman 1990:128.

p. 34. "Cedar Tavern was where": Albert Murray, interview with SP & RP in Harlem, 8/24/00.

p. 34. "the development of Abstract Expressionism ... was a problem for Romie": Harry Henderson, interview with SP & RP in Croton-on-Hudson, 7/23/00.

p. 34. "The subject is important": Bearden n.d.1

p. 34. "Ralph Ellison picked up on this": Ellison 1988:417.

p. 34. "It is precisely by working primarily in terms of ornamentation": Murray 1980:26.

p. 35. "You don't tell the story with a pen and a pencil": Derek Walcott, interview with SP & RP in St. Lucia, 8/17/00.

p. 35. "In my work, if anything I seek connections": Bearden letter to Mary Schmidt Campbell postmarked November 1972, cited in Campbell 1982:564-565.

p. 35. "Visual art is not a verbal thing.": Bearden in Rowell 1988:436.

p. 36. "Romie was at the Coupole": Albert Murray, interview with SP & RP in Harlem, 8/24/00.

p. 37. "I was Romie's intellectual guru": Albert Murray, interview with SP & RP in Harlem, 8/24/00.

p. 37. "The literary scholar Robert O'Meally remembers": Gates 1997:37.

p. 37. "Murray asked [him for his] recollections of specific people and scenes": Bearden in Schwartzman 1990:264-69.

p. 37. "Al Murray would ask me what she did": Bearden in Schwartzman 1990:269.

p. 37. "Murray also stepped in quietly": Gates 1997:38.

p. 37. "He described to us how Bearden once phoned him in 1969": Albert Murray, interview with SP & RP in Harlem, 8/24/00.

p. 38. "For me, it was the train stuff": Albert Murray, interview with SP & RP in Harlem, 8/24/00.

p. 38. "A brochure announcing the 1997-1998 exhibit": Muscarelle 1997.

p. 38. "Romare Bearden's collages interpret the realities of an American life": *Grove Dictionary of Art* (1996) s.v. "Propaganda."

p. 38. "When black functions as a symbolic reference": Murray 1980:24, 27.

p. 38. "Bearden's friend Barrie Stavis was particularly impressed": Schwartzman 1990:131.

p. 38. "Of all the problems facing the Negro artist": Schwartzman 1990:131-32.

p. 39. "is not only an evaluation of his own freedom and responsibility": Ellison 1968:10th page, 5th-6th page.

p. 39. "Romie was never a part of the propagandistic aspects of art": Harry Henderson, interview with SP & RP in Croton-on-Hudson, 7/23/00.

p. 39. "I create social images within the work": Bearden in Childs 1964:25.

p. 39. "Inevitably, perhaps, in the emotional climate of the sixties": Tomkins 1977:75.

p. 40. "There is nothing wrong with protest": Bearden in Rowell 1988:438.

p. 40. "A concrete example of the accepted attitude": Bearden and Henderson 1993:125, citing Bearden 1934.

p. 41. "According to some art histories, the first African-American has yet to pick up a brush": Bearden and Henderson 1993:xii.

p. 41. "Writing of Edmonia Lewis": Bearden and Henderson 1993:66.

p. 41. "Henry Tanner was subjected to persistent racial abuse": Bearden and Henderson 1993:82.

p. 41. "Later in Tanner's career": Bearden and Henderson 1993:89.

p. 41. "When he won a prestigious international award": Bearden and Henderson 1993:93.

p. 41. "And ... despite prizes in Paris and in America": Bearden and Henderson 1993:100-101.

p. 41. "One view took a somewhat demeaning, however sympathetic, sociological perspective": Bearden and Henderson 1993:241.

p. 42. "They illustrate the first of these views ... alongside the needlework of the handicapped": Bearden and Henderson 1993:241, 122.

p. 42. "The more talented the artists were": Bearden and Henderson 1993:122-123.

p. 42. "In 1948, American art historian Oliver Larkin": Campbell 1991:7.

p. 42. "In 1980, Avis Berman": Berman 1980:62.

p. 42. "And even Dore Ashton": Ashton 1980:32.

p. 43. "Romie had trouble working down on Canal Street": Harry Henderson, interview with SP & RP in Croton-on-Hudson, 7/23/00.

p. 43. "the phone would be ringing ev'ry 5 minutes": Bearden letter to June Kelly, 1986, courtesy of June Kelly.

p. 45. "Paris doesn't have the old enchantment": Bearden in Schwartzman 1990:208, 243.

p. 45. "Five years before his death, Bearden wrote a sketch": Bearden 1983a.

p. 48. "Game cocks strutted outside the glass-enclosed dining room": Schwartzman 1990:286.

p. 48. "We were like two small boys together": Frank Stewart, undated typescript, 1990s, courtesy of Frank Stewart.

p. 50. "Right now there should be art – and there is": Bearden in Rowell 1988:443.

p. 51. "Until his death in 1981, Reginald lived in a small house": Bearden 1983a.

p. 52. "what Al Murray calls 'a jazz and blues sensibility'": Albert Murray, speaking of Bearden, interview with SP & RP in Harlem, 8/24/00.

p. 52. "In fact, Bearden claimed that it was McKay": Bearden to June Kelly, undated letter, early 1985, courtesy of June Kelly.

p. 52. "In the mid-twenties, he had lived near a cricket field": Schwartzman 1990:28.

p. 52. "He saw it initially as a vacation-type place": Albert Murray, interview with SP & RP in Harlem, 8/24/00.

p. 52. "Romie ordered everything in French": Evelyn Rohan Jackson and Dorothe Rohan, interview with SP & RP in St. Martin, 6/27/99.

p. 52. "Romie came back from one of those cruises": Harry Henderson, interview with SP & RP in Croton-on-Hudson, 7/23/00.

p. 53. "Dear Nanette by this you will lone": Louis Brooks to Nanette Rohan Bearden, letter dated 3/10/73, Romare Howard Bearden Papers, 1945-1981, Archives of American Art, Smithsonian Institution, Washington D.C.

p. 53. "The house is finished and looks quite handsome": Bearden to Arne Ekstrom, letter dated Summer 1973, courtesy of Nicholas Ekstrom.

p. 53. "If you have your studio right where you live": Bearden in Schwartzman 1990:41, 190.

p. 54. "As Walcott said of the move": Derek Walcott, interview with SP & RP in St. Lucia, 8/17/00.

p. 54. "It is a goldrush, just like in the Klondike": Bredero 1981:4-5.

p. 54. "The next year, *Fortune* magazine featured an article": Demaree 1972.

p. 55. "As one knowledgeable observer put it": Richardson 1992:125.

p. 56. "I remember walking over to Oyster Pond": Langemeyer 1993:17.

p. 56. "dumping and piping in of sewage, waste material and oil": Sekou 1996:108.

p. 56. "You know you can farm fish in that Pond": Bearden in Badejo 1999:128.

p. 56. "The island is still nice": Bearden to Arne Ekstrom, undated letter, postmarked 1984, courtesy of Nicholas Ekstrom.

p. 56. "French restaurants with that foolish translation": Bearden to June Kelly, undated letter, mid-1980s, courtesy of June Kelly.

p. 56. "St. Martin was sparsely populated when I first came here": Bearden to Eric Gibson, letter dated 26 January [1985], courtesy of Nicholas Ekstrom.

p. 57. "Most great art comes from where there's flowing water": Berman 1980:64.

p. 58. "Several years ago I was on a boat": Bearden 1983b:209-210.

p. 59. "He was an artist, I was aspiring to be one": Frank Stewart, undated typescript, 1990s, courtesy of Frank Stewart.

p. 59. "Romare telling a story was *fantastic*": Derek Walcott, interview with SP & RP in St. Lucia, 8/17/00.

p. 62. "Gossip, too, says Frank": Frank Stewart, undated typescript, 1990s, courtesy of Frank Stewart.

p. 62. "The finest creole cooking on the French side of the island": Bearden n.d.2.

p. 66. "Bearden's letters from St. Martin show that he was also a voracious reader": Bearden to Arne Ekstrom, letters dated 1/24/84, 1/14/87, courtesy of Nicholas Ekstrom.

p. 68. "Each one, whether you were in the arts": Fabian Badejo, interview with SP & RP in St. Martin, 6/28/99.

p. 68. "Romare, when he come down": Ruby Bute, interview with SP & RP in St. Martin, 6/28/99.

p. 69. "What impressed me about him was his nonchalance": Ras Mosera, interview with SP & RP in St. Martin, 6/26/99.

p. 69. "He was a simple guy, always walking around in his overalls": René Florijn interview with SP & RP in St. Martin, 6/25/99.

p. 70. "might have been considered radical or revolutionary poetry": Lasana Sekou, email dated 9/2/2004.

p. 70. "Oh yeah, he thought [local saxophonist] Bobo Claxton was another, you know, John Coltrane": Fabian Badejo, interview with SP & RP in St. Martin, 6/28/99.

p. 71. "I found them very very very intriguing": Fabian Badejo, interview with SP & RP in St. Martin, 6/28/99.

p. 72. "They make you feel like you are a god": cited by Catherine Benoît (1999:35), in an article that also describes the shifting "ethnic" tastes of St. Martin brothel patrons through time.

p. 72. "the 250 claimed by the Limited Editions Club": Limited Editions Club 1983.

p. 77. "Romie was always playing around with literary stuff": Albert Murray, interview with SP & RP in Harlem, 8/24/00.

p. 78. "Bearden was very happy to do that book of Walcott's poems": Harry Henderson, interview with SP & RP in Croton-on-Hudson, 7/23/00.

p. 78. "Much of Walcott's sense of being derives from the Caribbean": Bearden 1983b:209.

p. 78. "The publisher wrote that 'the pictures are allusive'": Limited Editions Club 1983.

p. 79. "The figure in *Conjur Woman* (1964) is set against": Washington 1973:Plates 8, 31.

p. 83. "which he told his dealer Arne Ekstrom was inspired by the rainforest of northern Martinique": Campbell 1982:278.

p. 83. "the jet black silhouette of a nude": Campbell 1982:278-279, 283.

p. 92. "by the mid-1980s he was in fact creating Mecklenburg collages": Schwartzman 1990:95.

p. 92. "'In the mid-1970s,' Lowery Sims argues": Sims 1993:3-4 of 5.

p. 92. "Hilton Kramer, in a 1973 review": cited in Campbell 1982:281.

p. 92. "Avis Berman remarked, in his 1980 *ARTnews* feature": 1980:67.

p. 92. "One or two of these pieces, set on African shores": Schwartzman 1990:262.

p. 94. "Bearden's monoprint technique and increasing interest in music ... acquired a tropical feeling.": Patton 1991:63, 66.

p. 94. "She cites such jazz works": Patton 1991:66-67.

p. 94. "the most remarkable difference [from earlier collages]": Richard Maschal in Schwartzman 1990:297.

p. 94. "the highly saturated color evident in": Nancy Princenthal in Schwartzman 1990:298.

p. 94. "I think you can't live in the archipelago": Derek Walcott, recorded telephone interview with Myron Schwartzman, 4/92, courtesy of Myron Schwartzman.

p. 95. "If you take very dramatized ritual": Derek Walcott, interview with SP & RP in St. Lucia, 8/17/00.

p. 96. "Besides its veracity, there is the color": Walcott 1997:236.

p. 96. "the moving sail, alone on the ocean": Walcott 1997:235.

p. 96. "One of the greatest images in the history of literature": Walcott 1997:237-238.

p. 96. "processing the idiomatic particulars of Afro-American experience": Albert Murray, interview with SP & RP in Harlem, 8/24/00.

p. 96. "In terms of *Omeros*, I felt totally natural": Walcott 1997:235.

p. 98. "At the time, Bearden wrote that he and Nanette 'love Martinique'": Bearden to Mary Schmidt Campbell, letter of 9/73, cited in Campbell 1982:562.

p. 98. "Mary Schmidt Campbell describes *The Source*": Campbell 1982:281.

p. 103. "Secrecy and mystery veil faceless women": Patton 1991:67.

p. 108. "When you look outside here, you take out the brush and palette": Bearden in Rowell 1988:441.

p. 108. "The loading of the color": Derek Walcott, recorded telephone interview with Myron Schwartzman, 4/92.

p. 108. "When I went down to St. Martin": Schwartzman speaking to Walcott during recorded telephone interview, 4/92.

p. 108. "The collages are embedded in American history": Derek Walcott, recorded telephone interview with Myron Schwartzman, 4/92.

p. 108. "showing off for me how green green can be": Bearden, cited in R. Fine 2003:87.

p. 109. "Across the bay in St. Martin": Bearden 1983b:209.

p. 110. "he wasn't trying to knock off a hit tune": Albert Murray, interview with SP & RP in Harlem, 8/24/00.

p. 121. "to penetrate the interior of the lives he portrayed": Campbell 1991:9.

p. 121. "In October [1984], he exhibited *Rituals of the Obeah*": Schwartzman 1990:285.

p. 121. "The figures seem invaded by magical forces": Brenson 1984.

p. 121. "Critic Eric Gibson got closer to the paintings": Gibson 1985.

p. 122. "While the [Haitian] Voodoo ceremony has its African antecedents": Bearden to Eric Gibson, letter dated 26 January [1985], courtesy of Nicholas Ekstrom.

p. 122. "In the Caribbean ... people still believe": Bearden, recorded interview with Myron Schwartzman, 9/14/84.

p. 123. "Even in Pittsburgh": Bearden in Patton 1991:40; see also Campbell 1982:238 for Bearden's reminiscences about this particular woman.

p. 123. "The Obeah series was foreshadowed a long time before": Albert Murray, interview with SP & RP in Harlem, 8/24/00.

p. 123. "Mary Schmidt Campbell noted that": 1991:8.

p. 123. "Ralph Ellison, in his own words": Ellison 1968: final page.

p. 123. "He spent his early years in the bosom of the church": Murray 1980:18-19.

p. 123. "It always struck me that out of that church": Baldwin in ACA 1989:20 (transcript of 12/15/78 conversation among Bearden, Alvin Ailey, James Baldwin, and Al Murray).

p. 124. "As a Negro, I do not need to go looking for 'happenings'": Bearden in Patton 1991:44.

p. 124. "To me, they were beyond that": Bearden, recorded interview with Myron Schwartzman, 10/14/86.

p. 125. "With the Obeah, you had people who were holding on": Bearden, recorded interview with Myron Schwartzman, 9/14/84.

p. 125. "I can't think of adjusting myself to any particular frame of mind": Bearden, recorded interview with Myron Schwartzman, 10/14/86.

p. 126. "It's because they're living in-now but not-now": Bearden, recorded interview with Myron Schwartzman, 10/14/86.

p. 126. "However suggestive they [the paintings] may be": Murray 1980:17.

p. 126. "You know Mecklenburg and these new Obeah": Bearden, recorded interview with Myron Schwartzman, 10/14/86.

p. 127. "Thomas explained, however": all quotes from Joseph Thomas come from an interview with SP & RP in Silver Springs MD, 10/15/00, or from emails he sent that year in response to our queries.

p. 127. "Strangely, in his work, I realized he touched the essence": Ras Mosera, interview with SP & RP in St. Martin, 6/26/99.

p. 128. "*Vaudou* belongs to Haiti": Ras Mosera, interview with SP & RP in St. Martin, 6/26/99.

p. 128. "Richard Long told us about a New Year's Eve": Interview in Paris, 5/27/03.

p. 128. "Richard Powell has stressed the film's impact": Powell 1997:110-111.

p. 129. "I wish I could have done more ceremonial works": Bearden to Eric Gibson, letter dated 26 January [1985], courtesy of Nicholas Ekstrom.

p. 129. "Bearden recalled the climax of the ceremony": Recorded interview with Myron Schwartzman, 10/14/86.

p. 129. "And he wrote Ekstrom, playfully": Bearden to Arne Ekstrom, letter dated 1/24/84, courtesy of Nicholas Ekstrom.

p. 129. "It's best not to intrude any more": Bearden, recorded interview with Myron Schwartzman, 10/14/86.

p. 132. "She's about to fly!": Bearden, recorded interview with Myron Schwartzman, 9/14/84.

p. 132. "As with his teacher at the Art Students League": Brenson 1985.

p. 132. "This other one is *gone,* out of this world!": Bearden, recorded interview with Myron Schwartzman, 9/14/84.

p. 136. "Bearden had been struck by Tanner's depiction": Bearden and Henderson 1993:94.

p. 136. "Increasingly, Tanner ignored natural appearance": Bearden and Henderson 1993:96.

p. 136. "This I've changed since you saw it": Bearden, recorded interview with Myron Schwartzman, 9/14/84.

p. 142. "is the paper itself": Brenson 1984.

p. 142. "places us in the unusual position of being both witness and participant": Gibson 1985.

p. 142. "The Obeah woman ... she had this big anaconda in a basket": Bearden, recorded interview with Myron Schwartzman, 9/14/84.

p. 144. "Harry Henderson was by and he liked this": Bearden, recorded interview with Myron Schwartzman, 9/14/84.

p. 144. "She's chosen this girl": Bearden, recorded interview with Myron Schwartzman, 9/14/84.

p. 144. "Making the paper an active force": Brenson 1984.

p. 149. "a figure exuding arcane power": Gibson 1985.

p. 149. "looms out of a vividly colored, uncertain space": Gibson 1985.

p. 151. "For me, these [Obeahs] are like a cross": recorded interview with Myron Schwartzman, 9/14/84.

p. 152. "Bearden has said it is him": Campbell 1982:292.

p. 152. "face masked and turned to the sky": Campbell 1982:293.

p. 152. "used to 'de-virginate' young girls before marriage": Bearden, cited in Campbell 1982:10.

p. 152. "The most primal image in the show": Brenson 1984.

p. 152. "A brightly colored airborne rooster": Gibson 1985.

p. 152. "An Obeah woman once told me": Bearden 1985.

p. 152. "One Obeah woman thought": Bearden 1984:13.

p. 152. "*This* is a great myth": Bearden, recorded interview with Myron Schwartzman, 9/14/84.

p. 153. "I'd never written poems out of paintings": Derek Walcott, recorded telephone interview with Myron Schwartzman, 4/92.

p. 155. "Even for those who saw Bearden frequently": Schwartzman 1990:294.

p. 155. "I don't know what word he used": Albert Murray, interview with SP & RP in Harlem, 8/24/00.

p. 155. "Romie called [the original structure] the studio": Dorothe Rohan, interview with SP & RP in St. Martin, 6/27/99.

p. 155. "as if he were trying to outpaint death": Schwartzman 1990:304.

p. 156. "that 'archetypal story about love, death, fate, and perpetuity'": Powell 1997:111.

p. 156. " The narrative tragedy, which is there in the calypso": Derek Walcott, interview with SP & RP in St. Lucia, 8/17/00.

p. 158. "In 1986 he asked an interviewer": Bearden, recorded interview with Myron Schwartzman, 10/14/86.

p. 171. "I'm happy to report I'm making good progress": Bearden to Arne Ekstrom, letter dated 1/14/87, cited in Schwartzman 1990:298.

p. 177. "Take Michael Jordan": Albert Murray, interview with SP & RP in Harlem, 8/24/00.

p. 177. "Let's consider any establishment or orthodoxy": Derek Walcott, interview with SP & RP in St. Lucia, 8/17/00.

p. 177. "Of course – because Pippin and Lawr'": Albert Murray, interview with SP & RP in Harlem, 8/24/00.

p. 177. "It is very important that you Romy": transcript of 12/15/78 conversation among Bearden, Alvin Ailey, James Baldwin, and Al Murray, in ACA 1989:20.

p. 178. "The paintings have such fantastic dignity": Derek Walcott, interview with SP & RP in St. Lucia, 8/17/00.

p. 178. "At the heart of Murray and Ellison's joint enterprise": Gates 1997:34.

p. 178. "to process (which is to say to stylize) the raw native materials": Murray cited in Gates 1997:35.

p. 179. "My favorite metaphor for Romy": Stavis, cited in Berman 1980:62.

References Cited

ACA
1989 *Romare Bearden 1911-1988: A Memorial Exhibition*. New York: ACA Galleries.

ANON.
1987 The Collage Art of Romare Bearden: Fragmented Images of Black Life. *New York Times*, 3 January, p. 15.

APPIAH, KWAME ANTHONY, AND HENRY LOUIS GATES, JR.
1999 *Africana: The Encyclopedia of the African and African American Experience*. New York: Basic *Civitas* Books.

ASHTON, DORE
1980 Romare Bearden. *In* Jerald L. Melberg and Milton J. Bloch, *Romare Bearden: 1970-1980* (Charlotte NC: Mint Museum), pp. 31-33.

BADEJO, FABIAN
1999 Romare Bearden: An Artist's Destiny. *Discover Saint Martin/ Sint Maarten* 13:128-130.

BEARDEN, ROMARE
1934 The Negro and Modern Art. *Opportunity* 12:371-373.
1969 Rectangular Structure in My Montage Paintings. *Leonardo* 2:11-19.
1983a An Artist's Renewal in the Sun. *New York Times* [Sunday Magazine], 2 October, pp. 46-48, 52.
1983b Artist's Note. *In* Derek Walcott and Romare Bearden, *The Caribbean Poetry of Derek Walcott & the Art of Romare Bearden* (New York: The Limited Editions Club), pp. 209-210.
1984 Interview (9 December). *In Since the Harlem Renaissance: 50 Years of Afro-American Art* (Lewisburg PA: Center Gallery of Bucknell University, 1985), pp. 13-14.
1985 Magic Mountains, Clouds in the Living Room. *New York Times*, 6 October, Section 6, Part 2, p. 80.
1988 Reminiscences. *In Riffs and Takes: Music in the Art of Romare Bearden*. Raleigh: North Carolina Museum of Art. [2 pp., unpaginated]
n.d.1 Some questions and answers on the subject of my "Projections." Undated typescript kindly supplied by Nicholas Ekstrom.
n.d.2 Thanksgiving Dinner with Ma Chance. Undated typescript, Romare Howard Bearden Papers, 1945-1981, Archives of American Art, Smithsonian Institution, Washington DC.

BEARDEN, ROMARE, AND HARRY HENDERSON
1972 *Six Black Masters of American Art*. New York: Zenith/Doubleday.

1993 *A History of African-American Artists from 1792 to the Present*. New York: Pantheon.

BEARDEN, ROMARE, AND CARL HOLTY

1969 *The Painter's Mind: A Study of the Relations of Structure and Space in Painting*. New York: Crown.

BENOÎT, CATHERINE

1999 Sex, AIDS, Migration, and Prostitution: Human Trafficking in the Caribbean. *New West Indian Guide* 73:27-42.

BERMAN, AVIS

1980 Romare Bearden: "I Paint Out of the Tradition of the Blues." *ARTnews*, December, pp. 60-67.

BREDERO, BART

1981 *Boven de wind en onder de gordel: De ontwikkelingshulp aan de West*. Heerlen: Widrego.

BRENSON, MICHAEL

1984 Romare Bearden: "Rituals of the Obeah." *New York Times*, 30 November, p. C23.

BRODSKY, JOSEPH

1983 Introduction. *In* Derek Walcott and Romare Bearden, *The Caribbean Poetry of Derek Walcott & the Art of Romare Bearden* (New York: The Limited Editions Club), pp. ix-xix.

BUTE, RUBY

1989 *Golden Voices of S'Maatin*. Philipsburg, St. Martin: House of Nehesi Publishers. [reprint 2000]

CAMPBELL, MARY SCHMIDT

1982 Romare Bearden: A Creative Mythology. Unpublished Ph.D. Dissertation, Syracuse University.

1991 History and the Art of Romare Bearden. *In Memory and Metaphor: The Art of Romare Bearden 1940-1987* (New York: The Studio Museum in Harlem and Oxford University Press), pp. 7-17.

CHANCE, JEANNE LOUISE DUZANT

1985 *Ma Chance's French Caribbean Creole Cooking* (Art by Romare Bearden, edited and compiled by June Kelly). New York: G.P. Putnam Sons.

CHILDS, CHARLES

1964 Bearden: Identification and Identity. *ARTnews* 63(6):24-25, 54, 61-62.

CHILVERS, IAN

2004 *Oxford Dictionary of Art*. Oxford: Oxford University Press.

DEMAREE, ALLAN T.

1972 When the Money Ran Out at a Grand Resort. *Fortune* (May) 170-173, 240, 242, 245-246, 248, 250.

ELLISON, RALPH

1968 Introduction. *In Romare Bearden: Paintings and Projections*. (Albany: The Art Gallery, State University of New York at Albany), pp. 1-10.

1988 Bearden (Memorial Address). *Callaloo* 11(3):416-419.

FINE, ELSA HONIG

1973 *The Afro-American Artist*. New York: Holt, Rinehart and Winston.

FINE, RUTH

2003 *The Art of Romare Bearden*. New York: Harry N. Abrams.

FRASER, C. GERALD

1988 Romare Bearden, Collagist and Painter, Dies at 75. *New York Times*, 13 March, p. 36.

GATES, HENRY LOUIS, JR.

1997 *Thirteen Ways of Looking at a Black Man*. New York: Random House.

GELBURD, GAIL

1994 *The Painted Sounds of Romare Bearden*. New York: Council for Creative Projects.

1997 Bearden in Theory and Ritual: A Conversation with Albert Murray. *In Gail Gelburd and Thelma Golden, Romare Bearden in Black-and-White: Photomontage Projections 1964* (New York: Whitney Museum of American Art), pp. 53-60.

GELBURD, GAIL (ED.)

1992 *A Graphic Odyssey: Romare Bearden as Printmaker*. New York: Council for Creative Projects.

GIBSON, ERIC

1985 The Minimal and the Magical. *The New Criterion* 3(5):42-44.

JAMES, WINSTON

1998 *Holding Aloft the Banner of Ethiopia: Caribbean Radicalism in Early Twentieth-Century America*. London: Verso.

KEMP, MARTIN

2002 *The Oxford History of Western Art*. Oxford: Oxford University Press.

KENNEL, SARAH

2003 Bearden's Musée Imaginaire. *In Ruth Fine, The Art of Romare Bearden* (Washington DC: National Gallery of Art), pp. 138-155.

LANGEMEYER, F.S.
1993 *Far from the World's Turmoil: St. Maarten 1918-1920.* St. Martin: Lord & Hunter. [orig. 1937]

LANGMUIR, ERIKA, AND NORBERT LYNTON
2000 *The Yale Dictionary of Art and Artists.* New Haven: Yale University Press.

LIMITED EDITIONS CLUB
1983 Windward and Leeward. *The Monthly Letter of the Limited Editions Club* no. 533 (May).

MELBERG, JERALD L., AND MILTON J. BLOCH
1980 *Romare Bearden: 1970-1980.* Charlotte NC: Mint Museum.

MEMORY AND METAPHOR
1991 *Memory and Metaphor: The Art of Romare Bearden 1940-1987.* New York: The Studio Museum in Harlem and Oxford University Press.

MURRAY, ALBERT
1980 The Visual Equivalent of the Blues. *In* Jerald L. Melberg and Milton J. Bloch, *Romare Bearden: 1970-1980.* (Charlotte NC: Mint Museum.), pp. 17-28.
1996 *The Blue Devils of Nada: A Contemporary American Approach to Aesthetic Statement.* New York: Pantheon.

MUSCARELLE
1997 Exhibition Preview: Romare Bearden in Black-and-White. *Newsletter of the Muscarelle Museum of Art*, Williamsburg, Virginia, Fall [unpaginated].

PATTON, SHARON F.
1991 Memory and Metaphor: The Art of Romare Bearden, 1940-1987. *In Memory and Metaphor: The Art of Romare Bearden 1940-1987* (New York: The Studio Museum in Harlem and Oxford University Press), pp. 18-110.

POWELL, RICHARD J.
1997 *Black Art and Culture in the 20th Century.* London: Thames and Hudson.

RICHARDSON, BONHAM C.
1992 *The Caribbean in the Wider World 1492-1992.* Cambridge: Cambridge University Press.

ROMARE BEARDEN: MECKLENBURG AUTUMN
1983 [Exhibition catalogue]. New York: Cordier & Ekstrom.

ROMARE BEARDEN: PREVALENCE OF RITUAL-MARTINIQUE-THE RAIN FOREST
1974 [Exhibition catalogue]. New York: Cordier & Ekstrom.

ROMARE BEARDEN: RITUALS OF THE OBEAH
1984 [Exhibition catalogue]. New York: Cordier & Ekstrom.

ROWELL, CHARLES H.
1988 "Inscription at the City of Brass": An Interview with Romare Bearden. *Callaloo* 11(3):428-446.

SCHWARTZMAN, MYRON
1990 *Romare Bearden: His Life and Art.* New York: Harry N. Abrams.

SEKOU, LASANA M. (ED.)
1996 *National Symbols of St. Martin: A Primer.* Philipsburg, St. Martin: House of Nehesi Publishers.

SIMS, LOWERY STOKES
1986 Romare Bearden: An Artist's Odyssey. *In Romare Bearden: Origins and Progressions* (Detroit: Detroit Institute of Arts), pp. 11-20.
1993 *Romare Bearden.* New York: Rizzoli.

ST. MARTIN MASSIVE!
2000 *St. Martin Massive! A Snapshot of Popular Artists.* Philipsburg, St. Martin: House of Nehesi Publishers.

TOMKINS, CALVIN
1977 Putting Something Over Something Else. *New Yorker.* 28 November, pp. 53-77.

WALCOTT, DEREK
1997 Reflections on *Omeros. The South Atlantic Quarterly* 96:229-246.
2002 *Walker and the Ghost Dance.* New York: Farrar, Straus and Giroux.

WALCOTT, DEREK, AND ROMARE BEARDEN
1983 *The Caribbean Poetry of Derek Walcott & the Art of Romare Bearden.* New York: The Limited Editions Club.

WASHINGTON, M. BUNCH
1973 *The Art of Romare Bearden: The Prevalence of Ritual.* New York: Harry N. Abrams.